RODNEY GRAHAM:

ORGANIZED BY
ART GALLERY OF ONTARIO, TORONTO
THE MUSEUM OF CONTEMPORARY ART, LOS ANGELES
VANCOUVER ART GALLERY, VANCOUVER

CURATED BY
GRANT ARNOLD, JESSICA BRADLEY, AND CORNELIA BUTLER

ADDITIONAL TEXTS BY
LYNNE COOKE, DIEDRICH DIEDERICHSEN, SARA KRAJEWSKI,
AND SHEPHERD STEINER

A LITTLE THOUGHT

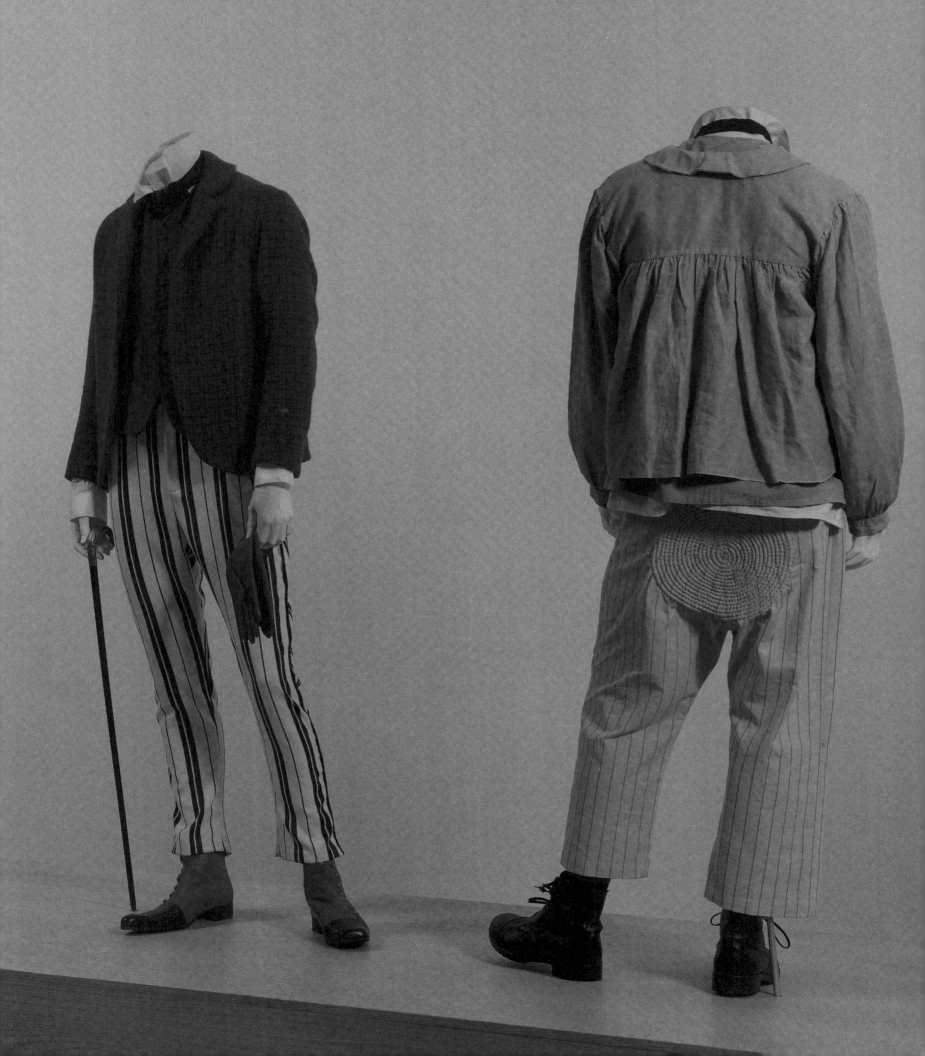

Over the past decade the profile of contemporary art has risen enormously, reaching unprecedented audiences. Canadian artist Rodney Graham is among those who have risen to international prominence within this period, most notably following the spectacular reception of his video installation *Vexation Island* (1997) in the Canadian Pavilion at the 1997 Venice Biennale. While Graham's work is widely supported and collected in Canada and Europe, his exposure to date in the United States has been relatively limited. "Rodney Graham: A Little Thought" constitutes the first major monographic exhibition of Graham's work in North America.

Contemporary art increasingly encompasses a range of media, and the most innovative artists working today embrace the challenge of this diversity. For nearly three decades Graham has engaged a wide variety of media and subject matter, inventing new approaches to landscape, literature, and sound. While his work can be read through its numerous literary and philosophical references, its humor and references to popular culture are equally engaging. "Rodney Graham: A Little Thought" focuses on the last decade of Graham's video and film work, tracing its origins back to his first projection events, which took place in outdoor settings.

This exhibition represents the collaborative efforts of three institutions: the Art Gallery of Ontario, Toronto (AGO); The Museum of Contemporary Art, Los Angeles (MOCA); and the Vancouver Art Gallery, Vancouver (VAG). This partnership is a testament to the enthusiasm and commitment that Graham's work inspires—evidenced also by the fact that each museum maintains the artist's work in its permanent collection. We proudly acknowledge the curators of this exhibition—Grant Arnold, Jessica Bradley, and Cornelia Butler—whose sensitivity and dedication to the artist's work is apparent throughout. Formerly curator of contemporary art at the AGO, Jessica Bradley assumed an originating role, pursuing the partnership and working closely with the Madison Museum of Contemporary Art (MMCA) to ensure our mutual benefit in procuring equipment when a portion of this exhibition's film and video component of this exhibition was shown there. We are indebted to MMCA Director Stephen Fleischman and former curator Sara Krajewski for conceiving the initial film and video presentation and for approaching the AGO to participate as a partner. MOCA Curator Cornelia Butler's ongoing interest in Graham's work prompted her to bring the exhibition to Los Angeles and embrace collaboration with her Canadian counterparts. VAG Curator Grant Arnold has maintained a longstanding relationship with the artist, and his participation enabled the exhibition to be presented in Graham's hometown of Vancouver. Besides representing their respective museums and communities, these curators

bring a wealth of experience and acumen to bear on this exhibition, for which we are grateful.

Of course, exhibitions of this quality would be impossible without the steadfast support and unwavering generosity of our trustees. They enable us to bring the best contemporary art has to offer to ever-wider audiences. We take this opportunity to thank the trustees of all three institutions.

In addition to our trustees, we rely on the vision and munificence of our sponsors to realize such ambitious projects. Few individuals are as passionate and committed to contemporary art as Carol and David Appel and Audrey M. Irmas. As the primary sponsors of "Rodney Graham: A Little Thought," their leadership advanced this project at a crucial moment in its development, and we offer our sincere gratitude for their support. The institutions also recognize the contributions of the Department of Foreign Affairs and International Trade, Canada, for support of the exhibition's tour.

Finally we thank Rodney Graham, a remarkable artist whose work encourages us to cross borders of all kinds. His intelligence, curiosity, and humor have enhanced every aspect of this exhibition.

Kathleen S. Bartels, Vancouver Art Gallery, Vancouver
Jeremy Strick, The Museum of Contemporary Art, Los Angeles
Matthew Teitelbaum, Art Gallery of Ontario, Toronto

Rodney Graham is one of those rare artists whose new work is eagerly anticipated by numerous international artists and curators captivated by the capacious intellect, sharp wit, and delightful unpredictability running through his entire oeuvre. Together we were impelled to organize this exhibition by mutual interest, as well as the sense that the time had come to make Graham's extraordinary work better known on this side of the Atlantic. Although his work has been collected and shown in his native Canada, it has until recently been followed most closely in Europe. Our initial discussions focused on the artist's shift from the literary and conceptually based early works to the cinematic works he has been producing since the early 1990s, short costume dramas in which he is the lead actor. We were convinced that the richness and volume of his media productions merited an exhibition that would feature them in relation to selected earlier works. Our thanks go to Art Gallery of Ontario (AGO) Director and CEO Matthew Teitelbaum and Chief Curator Dennis Reid; The Museum of Contemporary Art, Los Angeles (MOCA), Director Jeremy Strick and Chief Curator Paul Schimmel; and Vancouver Art Gallery (VAG) Director Kathleen S. Bartels and Chief Curator/Associate Director Daina Augaitis for supporting our vision.

In addition to the exhibition, we were committed to producing a substantial publication that would deepen understanding of Graham's fascinating, multidisciplinary production over the past three decades. To this end, *Rodney Graham: A Little Thought* includes the first annotated and illustrated chronology of the artist's career, as well as texts by esteemed colleagues who have long been committed to his work. Our admiration and thanks go to Lynne Cooke, Diedrich Diederichsen, and Shepherd Steiner, whose intelligent and insightful essays make a vital contribution to the existing literature on Graham. We would also like to thank Sara Krajewski for her thoughtful text in which the artist's earlier film and video works are considered in relation to his recent cinematic trilogy. This text was adapted from one that originally accompanied an exhibition of these works she organized for the Madison Museum of Contemporary Art (MMCA) in 2003.

We have all benefited from the enthusiastic leadership of Lisa Mark, MOCA's director of publications, who, together with Editor Jane Hyun and Assistant Editor Elizabeth Hamilton, managed the many details of this publication with patience and dedication. Thanks also to John Alan Farmer for his assistance with proofreading, and James Gussen for his excellent translation of Diederichsen's essay. Graphic designer Michael Worthington brought sensitivity and a wonderful affinity with Graham's interests to the design of this publication,

beautifully capturing the range and spirit of the work. MOCA Curatorial Associate Rebecca Morse also assisted with myriad catalogue- and exhibition-related details.

For their patience and expertise in overseeing this exhibition, we are grateful to Iain Hoadley, exhibitions manager at the AGO; Stacia Payne, manager of exhibition programs and curatorial affairs at MOCA; and Jacqueline Gijssen, head of museum services at the VAG, who worked together on the often complicated administrative aspects of our collaboration. We also thank our respective development personnel: Lisa Landreth, manager of individual giving at the AGO; Paul Johnson, former director of development at MOCA; and Emma Starritt, corporate development and foundations specialist at the VAG, for their tireless efforts in securing the necessary funds to mount such an ambitious project. Thanks are also due to those who have assisted in promoting the exhibition, including Andrea Seaborn and Antonietta Mirabelli (AGO); Katherine Lee and Heidi Simonian (MOCA); and Diane Robinson, Colette Warburton, and Julie-Ann Backhouse (VAG).

Many other individuals at all three institutions have contributed to this project. We thank the registrarial staff at the AGO, especially Curtis Strilchuk and Dale Maher for bringing the works together and orchestrating the successful shipment and tour of the exhibition. Trevor Mills and Tim Bonham of the VAG photo imaging department generated many of the images reproduced in this publication. We also thank the staff at the VAG for liaising directly with the artist. The demands of creating specialized viewing spaces for many works in this exhibition have required the creativity of exhibition designers Jim Bourke (AGO) and Brian Gray and Jang Park (MOCA). We are also indebted to our audio-visual technicians Gregory Baszun (AGO), David Bradshaw (MOCA), and Wade Thomas (VAG) for their expertise and collaboration.

Organizing this exhibition would have been impossible without the generous assistance of Graham's various galleries. In particular, we are indebted to Donald Young and Emily Letourneau of Donald Young Gallery, Chicago. We would also like to recognize the generous advice and assistance with loans provided by Nicholas Logsdail and Elly Ketsea of Lisson Gallery, London; Philip Nelson of Galerie Philip Nelson, Paris; Lisa Spellman of 303 Gallery, New York; Florian Berktold of Hauser & Wirth, Zürich; and Galerie Johnen & Schöttle, Cologne. Yves Gevaert, a longtime supporter of Graham and publisher of many of his bookworks, provided extraordinary archival material.

This exhibition would not have been possible without the following lenders, many of whom have parted with major works for an extended period: 303 Gallery,

New York; AGO; Yves Gevaert, Brussels; Israel Museum, Jerusalem; Galerie Johnen & Schöttle, Cologne; Phil Lind, Toronto; MOCA; Morris and Helen Belkin Art Gallery, University of British Columbia, Vancouver; Musée d'art contemporain, Montréal; National Gallery of Canada, Ottawa; Jeanne Parkin, Toronto; Yves Savoie and Steve Young; Gerald Sheff and Shanitha Kachan, Toronto; VAG; and Donald Young Gallery, Chicago. We are thrilled that the exhibition will travel to the Institute of Contemporary Art, Philadelphia, thanks to the efforts of Director Claudia Gould and Senior Curator Ingrid Schaffner.

In addition, we extend our gratitude to Scott Livingstone, Graham's assistant, whose commitment to the artist's vision facilitated many interactions with the staffs at our institutions. We thank him wholeheartedly for his forbearance in responding to our many questions and for his goodwill. Credit is also due to Shannon Oksanen for her inestimable support and knowledge of Graham's work.

Finally, our deepest thanks go to Rodney Graham. From the openness and enthusiasm he showed at our first joint meeting to the trust and commitment he has demonstrated throughout the organization of this exhibition, Rodney has been a pleasure to work with. His generosity and intelligence have immeasurably enriched our collaboration.

Grant Arnold, Vancouver Art Gallery, Vancouver
Jessica Bradley, Art Gallery of Ontario, Toronto
Cornelia Butler, The Museum of Contemporary Art, Los Angeles

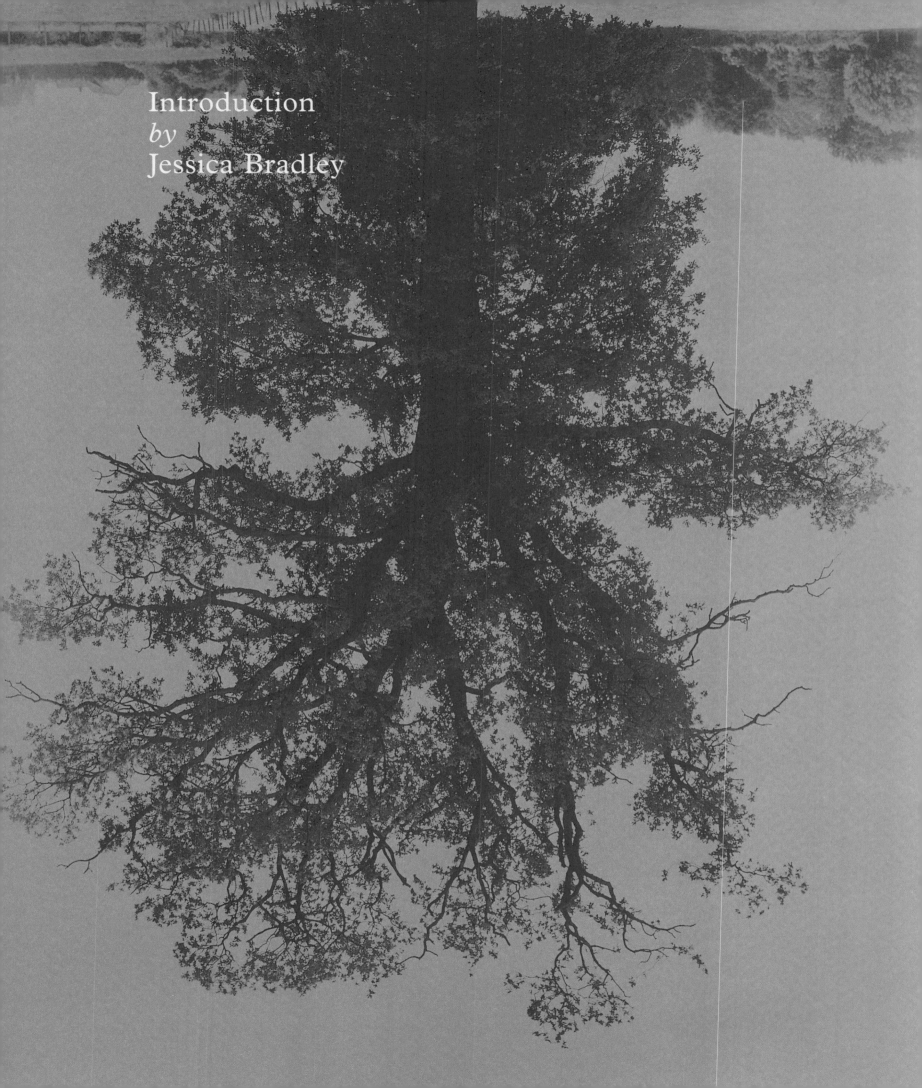

Introduction
by
Jessica Bradley

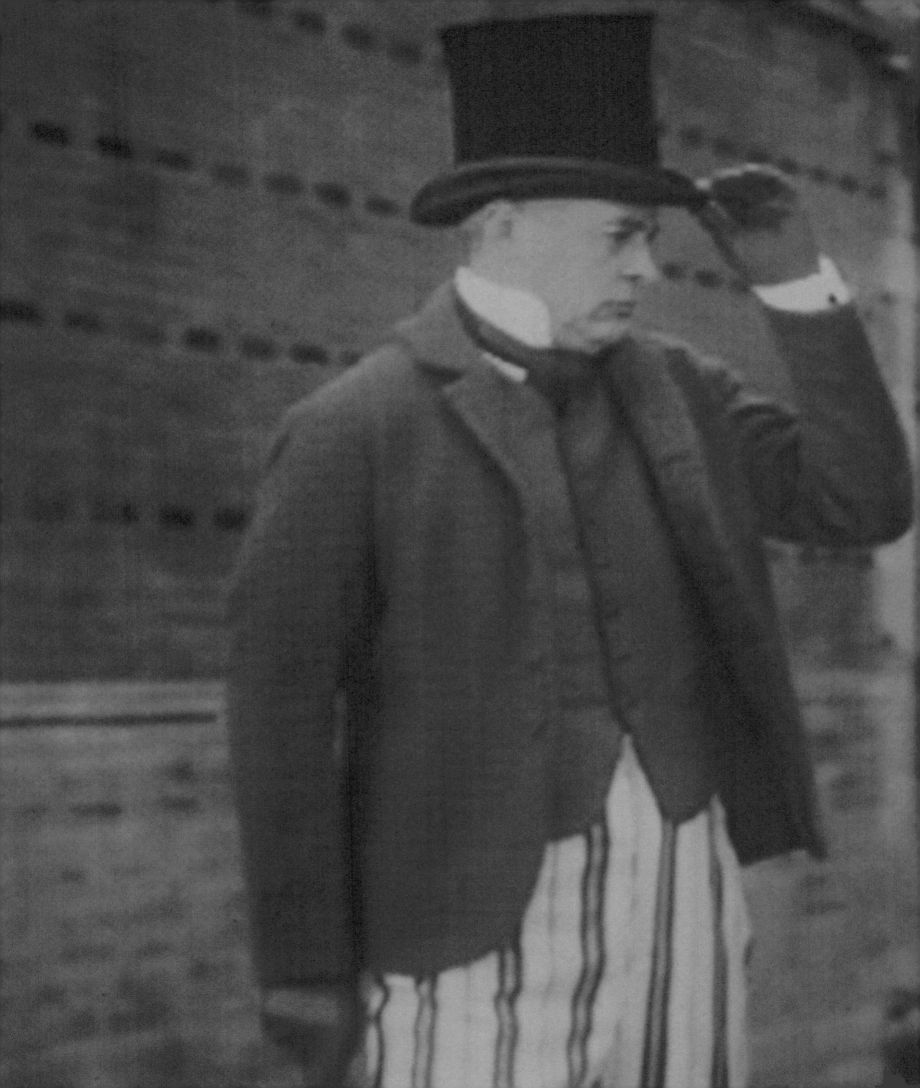

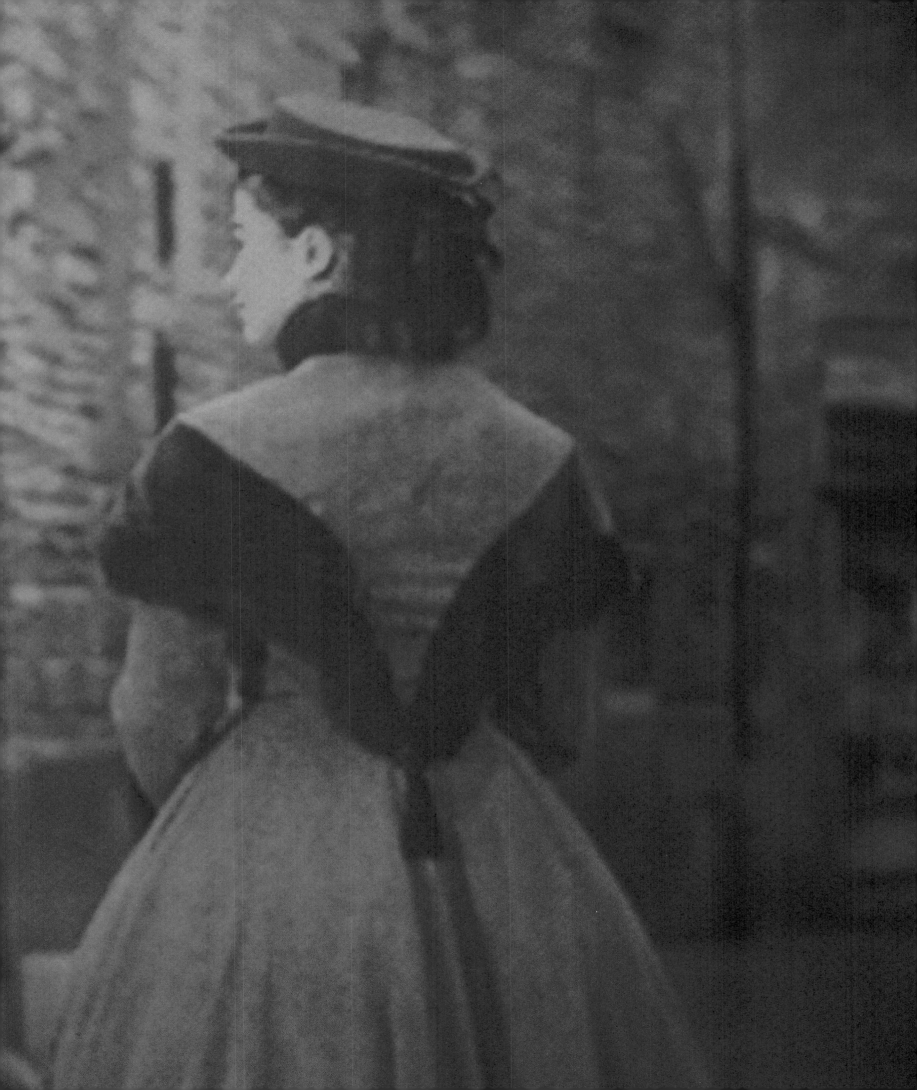

Rodney Graham's ideal studio might, one suspects, be rather like the two adjoining studies of the Brothers Grimm that appear in a 1992 suite of drawings the artist exhibited at Documenta IX that same year. These handsomely appointed rooms, which mirror each other, open into one another through a communicating door. Their self-enclosed disposition conjures the interior world of the imagination. Comfortably insulated from the world beyond, they invite the pleasures of contemplative work and the adventures set in motion when reverie diverts the mind in unexpected directions. Here Graham would be free to pursue an idea propelled by "a little thought" unhurriedly to its full amplitude.

Five Interior Design Proposals for the Grimm Brothers' Studies in Berlin (1992) originated in a fortuitous link between Graham's memory of a passage in Søren Kierkegaard's book *Repetition* (1843), which describes an enchanting double chamber, and his discovery of Moritz Hoffmann's 1861 series of watercolors depicting the Grimm Brothers' adjoined studies, presumably where they collected and transcribed their famous fairy tales. Graham's series of views is rendered in the manner of nineteenth-century decorators' drawings. It unfolds like a musical composition, as the theme of a room dedicated to abundant intellectual activity recurs through finely tuned variations. From one view to the next he reorients the rooms and moves their contents, playing upon their initial doubling to make other rooms that also reflect each other. As Graham's graphic tour of the studies moves around an imposing desk laden with evidence of work in progress, he engages the viewer in a circular parlor game of visual transference and condensation.

No matter that Graham's own studio is an unremarkable, slightly forlorn office above a row of tawdry shops on a downtown Vancouver street. His alterations to the Grimms' studies evoke the self-contained world of shifting associations and refined referential networks that have informed his work over almost three decades. In this body of work the remarkable presence of repetition functions variously as humorous irritant, comforting replay mechanism, or melancholic entrapment, and operates as a lens

Details of *Five Interior Design Proposals for the Grimm Brothers' Studies in Berlin*, 1992
Five pairs of drawings in India ink in walnut frames with passe-partout and caption in letterpress
67 x 58.5 cm (26 x 23 in.) each
Yves Gevaert Éditeur, Brussels

through which phenomenal realities and psychological states, as well as time itself, are transformed into vivid mental models.

Graham began his practice in Vancouver during the 1970s, when the work of American artists Dan Graham and Robert Smithson figured influentially in an artistic community enlivened by the internationally informed, theoretically rigorous leadership of artists Jeff Wall and Ian Wallace. Rodney Graham was stimulated by this milieu and continues to cite these beginnings in recent work, but ultimately his art has taken a more arcane, idiosyncratic path. Though he is commonly described as a Conceptual artist and his systematic, research-oriented methods often resemble those found in Conceptual art, his singularly entwined artistic and intellectual pursuits have given rise to an oeuvre whose scope is considerably wider. Defying categorization, his self-reflexive and humorous art embraces an extraordinary and at times elusive variety of approaches and forms. Among these are altered books and musical scores, films, compact discs, window displays, architectural models, and public sculptures. Through several distinct series, his oeuvre loops back upon itself, restating structural devices and themes that borrow from a range of nineteenth-century scientific experiments and twentieth-century pop culture, as well as from the literary innovations and artistic legacy of modernism.

This exhibition features Graham's recent body of film, video, and photographic productions in relation to selected earlier works. It follows a trajectory that links his "lighting events," in which he used illumination to stage nature dramatically as an uncanny representation, to the later work in which he adopts a number of Hollywood cinematic conventions and appears in the guise of various generically familiar film personae. As an integral part of this development, the exhibition also traces the evolution of Graham's use of sound, his recent return to playing the guitar, and his current devotion to songwriting. Yet to ascribe a chronological progression to his oeuvre would be misleading, for as the viewer will inevitably experience, to enter any one of Graham's works is to become pleasurably lost in a labyrinth that offers myriad directions.

An artist-cum–writer/musician/actor, Graham could be described as a serious dilettante. Research is not so much a means for him as it is the medium in which his work gestates. He has immersed himself in the

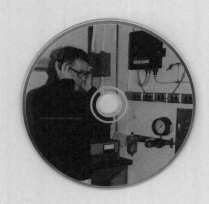

I'm a Noise Man, 1999

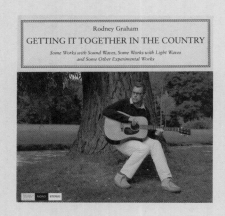

Getting It Together in the Country, 2000

principal texts of modernism, such as Sigmund Freud's magnum opus *The Interpretation of Dreams* (1899), which notably precipitated a year and a half of reading and eventually led to a series of related pieces. Similarly, an abiding interest in the nineteenth-century Belgian scientist Joseph Plateau and his experiments with the persistence of vision informs several other works. But Graham's eclectic passions also playfully embrace the adolescent fantasies of Ian Fleming's James Bond novels and other forms of popular entertainment. His songwriting and recording have often occupied him for protracted periods to the exclusion of his visual art projects.

The literary innovations of Symbolist poet Stéphane Mallarmé and the hermetic linguistic systems of Raymond Roussel, the eccentric author celebrated by the Surrealists, suggest intricate structural models upon which Graham builds. Edgar Allan Poe's last story, "Landor's Cottage: A Pendant to *The Domain of Arnheim*" (1850), and the schizophrenic breakdown of Georg Büchner's romantic hero in *Lenz* (1838) are among the first narratives he appropriated as cultural artifacts, performing subtle textual maneuvers or supplementing them with his own writing. Graham's interventions may be seen as both an homage and a willful obfuscation of authenticity and authorship, but they may also be a form of wish-fulfillment arising from his early novel-writing ambitions. While ideas and inventions of the late nineteenth century are often a point of departure, his work is never far from our own time. As Graham sings on his debut 1999 CD *I'm a Noise Man*, "So let me read from the part where the twentieth century ends…"

In his songwriting Graham indulges in a stylistic sampling of pop music, ranging from Hank Williams to Pink Floyd. By his own admission, he is literally seeking a voice that allows for more direct expression than his complexly layered works in other media. In so doing he creates a soundtrack for contemporary life that is at once—and self-consciously so—earnest expression and pure pastiche. In a photograph printed on the *I'm a Noise Man* disc, he is seen listening intently to a playback of his efforts during a recording session; on the cover for his vinyl album *Getting It Together in the Country* (2000), whose design mimics the albums of German classical-music label Deutsche Grammophon, he strums his guitar under a tree, a sentimental square in chinos and desert boots. Though unmistakable, Graham's compositions lull the listener with familiar tones the way his projection works enthrall

even as they dismantle the apparatus of film before our eyes, dissembling stock fantasies and prompting a smile of recognition at our own complicity.

Throughout his work Graham tampers with genre by turning it upon itself through appropriation and quotation. For example, in the 1980s he made structures slyly resembling Minimalist artist Donald Judd's iconic modular sculptures but functioning as bookcases. Recalling Judd's work with architecture and furniture design, Graham's adaptation of these pure abstract forms was a practical and delightfully naughty solution for displaying books in a gallery context, many of them canonical texts introducing linguistic, social, and psychological theories of interpretation at the forefront of post-modernist thought. By inserting these volumes into forms emblematic of the break from modernism's tradition of the autonomous art object, Graham colonized the artistic heritage of his generation with characteristic wit. More-over, he claimed a place alongside the acknowledged master, with whom he incidentally shares a reputation as a bibliophile.

The utterly engaging homemade simulation of evanescent cosmic imagery in his *Coruscating Cinnamon Granules* (1996) recalls the flickering fantasies of early cinematic experiments. Yet, as if reincarnated in an enchanting galactic afterimage, Smithson's legendary *Spiral Jetty* (1970) seems to make a brief appearance. Alternatively, one may be reminded momentarily of Marcel Duchamp's Rotoreliefs. Similarly, in *Halcion Sleep* (1994) Graham's regressive drug-induced surrender to a dreamy nocturnal voyage from suburb to city has sinister connotations of film-noir abduction scenes, albeit through a real-time documentary-style presentation. His renunciation of artistic control in this work also has antecedents in 1970s performance art, gently recalling, for example, the more radical helplessness that accompanied risk in some of Chris Burden's renowned performances, such as *Deadman* (12 November 1972), for which Burden, covered with a tarp, lay beside a car on La Cienega Boulevard in Los Angeles accompanied by two flares to alert passing traffic.

L'Interprétation des rêves, 1988
Aluminum, green Plexiglas, and book
(Sigmund Freud's *L'Interprétation des rêves*)
20.1 x 50 x 36 cm
(7 5/8 x 19 11/16 x 14 3/16 in.)
Courtesy of the artist

One of the most persistent themes in Graham's work is nature and the problem of representing it. With its timeless, cyclical flow and unpredictable threats, nature figures alternately as pastoral idyll (the lone cowboy wandering into the sunset in *How I Became a Ramblin' Man* [1999]) or dark, impenetrable force assailed by technology (the unsettling forensic

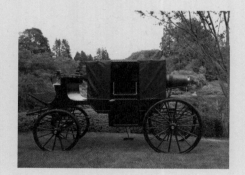

Detail and installation view of *Millennial Time Machine*, 2003
Eighteenth-century landau carriage, concrete, and glass
Landau: 198 x 396 x 182 cm (78 x 156 x 71 1/2 in.); pavilion: 366 x 1158 x 731 cm (144 x 456 x 288 in.)
Collection of the University of British Columbia. This project has been made possible through the support of the Canada Council for the Arts, Morris and Helen Belkin Foundation, British Columbia 2000 Recognition Plan, and the University of British Columbia.

gaze of the hovering helicopter in *Edge of a Wood* [1999] that illuminates the British Columbian forest only to reveal its obstinate density). Nature's majestic presence is often diminished to a disorienting glimpse, and at times its appearance infers an ambivalence toward the Canadian west coast, an area renowned for its natural beauty but isolated until relatively recently from modern development.

Beginning in 1979 with his first camera obscura, Graham's preoccupation with the tree as archetype of nature's continuous regeneration drove an ongoing series of related works. Among these is his model for a utopian time machine, *Millennial Project for an Urban Plaza* (1986), a camera-obscura theater atop an elaborate viewing tower. The model proposes that a sapling brought from the woods to the city would be viewed from this vantage point and, over time, grow. As the city continues to encroach upon its natural environs, the tree, in turn, would eventually dominate the plaza like a civic monument, filling the camera's view. The lone tree is also the subject of several series of photographs recalling the French photographer Eugène Atget's iconic early twentieth-century studies; however, like the projected image in a camera obscura, Graham's trees are inverted as they would also have initially appeared on the viewing glass of the large-format field camera used to photograph them. But unlike the tree rescued metaphorically from the primordial growth of the wild woods in *Millennial Project*, the trees depicted in series such as *Flanders Trees* (1989) and *Oxfordshire Oaks* (1990) are stately survivors, sources of scenic punctuation in a bucolic landscape groomed over the ages by civilization.

Graham's most recent camera-obscura works are housed in mobile vehicles. They propose a leisurely approximation of film wherein the viewer would be transported through the "unnatural" landscapes they are sited in and observe their passing features from comfortable confines. *Camera Obscura Mobile* (1996), a replica of a 1904 U.S. mail carriage, is installed in an arboretum in France to spy upon trees from America that were planted in the nineteenth century. Another work, a reprise of Graham's *Millennial Project for an Urban Plaza* titled *Millennial Time Machine*, was installed in 2003 on the grounds of Vancouver's University of British Columbia. A sapling planted on the modern landscaped campus is registered on a two-sided screen suspended between the occupants seated in this custom-built landau.

When he made his way through the underbrush of Vancouver's suburban woods in 1976, using the camera's flash to light his way as well as to illuminate the random images of vegetation he seized, Graham set in motion another related strand in his work that presages the camera obscura and his later use of film. The work in question, *75 Polaroids*, was all about a paradoxical moment: the fading of the momentary negative afterimage experienced as a result of the flash and the simultaneous appearance of a positive image in the exposed emulsion of the Polaroid print.

Illumination—as both physical event and mental state (a sudden flash of recognition) and, inevitably, as metaphor for the Enlightenment— returns at several points in Graham's work. In his earliest film, *Two Generators* (1984), two gasoline-powered generators provide lighting, but their deafening mechanical roar aggressively drowns out the soothing natural sound of rushing water just as its source, a river in the mountain forest, becomes visible. The experience of disorientation and the paradox of illumination—that it may both blind and reveal—also foreshadows the prevalence of altered states of consciousness in later works. For example, it informs the staging of consciousness and the unconscious in *Vexation Island* (1997), the first in his cinematic costume trilogy. Graham, a marooned Robinson Crusoe–like character, awakens to the prompting of his parrot. Shielding his eyes from the blinding sun shining through the windblown canopy of a nearby palm tree, he looks up at a coconut, which will strike him unconscious again when he shakes it loose from the tree. In this continuous loop, Graham and the viewer are prisoners of a cycle in which the promise dashed repeatedly is not of escape, but of revelation.

The lyrics "modern life remains a bitter pill and country life's a magazine" from "What Is Happy, Baby?," the title track of Graham's 2000 CD, cite a recurring opposition in Graham's work between the urban and the rural and the conflicting desires they represent. As he suggests sardonically, nature has become unobtainable, a clichéd representation that in reality offers none of romanticism's promised solace or sublime transcendence, while the city symbolizes modernity's exhilarating but chaotic acceleration toward radically new models of time, space, and consciousness. (Graham's own penchant for productive digression and association recalls the flâneur's delight in the multiplicity of experiences and diversions offered by urban life.)

Two Generators, 1984

City Self/Country Self (2000), a vignette in which a peasant is the object of derision, humorously captures something of the turbulence of Europe's economic, cultural, and social transition from agrarian to industrialized society. Inspired by an image from an *Épinal* pamphlet (a popular print form in France during the eighteenth and nineteenth centuries), this mini costume drama features a hapless country bumpkin who, taking in the town on a leisurely stroll, is rudely awakened by a kick in the pants from an imperious dandy. The encounter is repeated in a continuous loop with Graham playing both innocent victim and sophisticated perpetrator, a divided subject absurdly caught between two worlds.

The same year Graham produced his large two-part photograph *Fishing on a Jetty*, in which he returns incognito to his native Vancouver. In this scenario, a nod to Alfred Hitchcock's *To Catch a Thief* (1955), a thinly disguised Graham attempts to pass himself off as another actor, Cary Grant, the hero in the film who, wrongly accused of a series of burglaries, avoids the police by pretending to be a sport fisherman. Inserting himself into this spiraling play of mistaken identities and replacing the movie's view of Mediterranean Nice with Vancouver's modern skyline, Graham reenacts a pull in his work between Europe and the end of the line, Terminal City (as Vancouver is known colloquially). He is, after all, an artistic angler whose artifice can hardly avoid reference to the constructed photographs of fellow Vancouver artist Wall. Facing away from the water ambiguously and letting his line drop out of sight, Graham waits for a bite.

In Graham's most recent productions, doubling, the mirror image, and the continuous loop become increasingly trenchant and comedic models for the vicissitudes of the psyche and identity, though his role-playing is surely also a trope for the artistic predicament of creative reinvention. Twinned as a dynamic piano-playing duo in his two-part photograph *Fantasia for Four Hands* (2002), he is present as both performer(s) and artist. Like two consecutive film frames, the photographs capture near-imperceptibly different moments and, laterally reversed as in a mirror image, they suggest a cycle of action and reaction. As if in a circular burlesque encounter, a furiously intent Graham and his self-absorbed alter ego appear to play together and against each other at once.

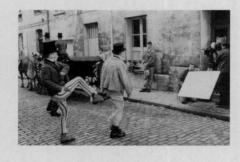

Production still from *City Self/Country Self*, 2000

In *Loudhailer* (2003), a recent dual-screen projection whose halves are slightly out of sync with each other, Graham plays a cop stranded on the pontoon of a floatplane bobbing offshore. Using a megaphone, he appears to holler for assistance. However, his message is a faintly audible barrage of verbiage unrelated to his visible predicament but for the intermittent interjection: "Send out a dinghy." As he gestures hilariously to his uniform, his bulky life jacket and the apparent futility of his pleas undermine the authority he attempts to claim.

A Reverie Interrupted by the Police (2003), which was made at the same time as *Loudhailer*, is in many respects a companion piece. In this work Graham switches roles, appearing in a vintage prison uniform and handcuffs. In a scene reminiscent of a Charlie Chaplin melodrama or a Marx Brothers comedy, a guard watches over the convict seated at a piano on a velvet-curtained proscenium. His awkward performance consists of a series of atonal percussive forays on the keyboard that are laughably hindered by his handcuffs. The absurdity of the scene is heightened by the performance's resemblance to John Cage's avant-garde music for "prepared piano," which revolutionized musical composition during the 1940s. As intervals of silence increase, Graham plays for time, the incorrigible prisoner of his own act.

Graham's devotion to absurd incident and his obsessive pursuit of minor narratives belie the historical and philosophical range of his work. Though his own writings about his work are matter-of-fact, sometimes resembling the dignified and detached diary entries of a nineteenth-century scientist or gentleman traveler, they are never mere explanations. Instead he maps sources and ideas, making the work disarmingly transparent. Yet the content of Graham's work is more densely and elegantly woven than a description of its origins or methods can convey.

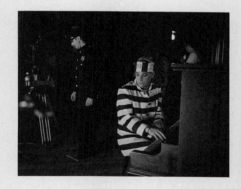

Production still from *A Reverie Interrupted by the Police*, 2003

Rheinmetall/Victoria 8 (2003) brings Graham's work full circle. In this silent film installation—reminiscent of early works such as *Coruscating Cinnamon Granules*, in which the mechanics of cinema are exposed—he relinquishes his starring role to an elegant 1930s typewriter whose modernist contours, writ large, fall under our gaze. Elsewhere in the room, a 1960s film projector with a looping mechanism imposes its gigantic presence as the source of this projected image. As the projector lumbers on, the typewriter gradually becomes shrouded in flour (an old special-effects technique to

simulate snow or dust). The letters on the keyboard, a potential source of language, become obscured, and the obsolete machine is transformed into a mountainous landscape. The typewriter's gradual disappearance reverses the process of illumination in *Coruscating Cinnamon Granules*. As if cut from a self-replicating organic whole, Graham's work is steadfast in its promise to reward our attention with an astonishing breadth of associations.

The Trip Is the Thing:
The Cinematic Experience
in Rodney Graham's Films
by
Sara Krajewski

THE TRIP IS THE THING: THE CINEMATIC EXPERIENCE IN RODNEY GRAHAM'S FILMS

Hollywood movies intensely occupy the imagination, presenting the conscious mind with a respite from the reality of deliberations, decisions, and consequences. Rodney Graham explores the nature of cinema's powerful hold as he tweaks the technical conditions of film production and sheds light on the material conditions of presentation and reception. On the one hand, Graham endeavors to demystify the cinematic image by exposing the ephemeral world onscreen as the sum of physical parts: film stock, light source, lenses, reels, speakers, and laborers.[1] On the other hand, his films also firmly engage the imagination. Indeed, the compelling cognitive appeal of the cinematic experience and our compulsive attention to the moving image are what fuel Graham's project. As viewers, we cycle between logical awareness and sensory seduction, becoming party to the artist's fascination with the loop as a material, temporal, and symbolic structure.

Two Generators (1984), Graham's first film, sets the stage for his investigation of the medium by ambitiously dissecting the phenomenon of projected image and sound into a chain of objective circumstances. The 35-mm black-and-white film relates to the artist's ongoing interest in what he calls "lighting events." The work opens onto darkness with a soundtrack of rushing water. This brief, blind meditation is interrupted by the noisy, labored start of a diesel generator. With the roar of another generator, lights flare, illuminating a river. We now see the water, our view afforded by the lights and generators positioned outside the camera's frame. For a few minutes we watch the river flow, accompanied by the droning of the generators' engines. Finally one engine is cut, then the other, returning us to darkness and the sound of the river (which strangely resonates as a quieter version of the generators).

Screened in a movie theater, the film was conceived as an event. Amidst an assembled crowd, a projectionist enters the cinema, dims the lights, draws back the curtain, loads the film reel, and begins the projection. Upon its end, he or she rewinds the film, closes the curtain, and brings up the house lights. The sequence is repeated again and again, the number of screenings predetermined by a formula involving the event's total budget and

the hourly rates of the screening room and projectionist. Graham explained his intention was "to create a burlesque travesty and a spectacle that would inspire negative thoughts about cinema, which I neurotically hated at that time."[2] Recently he elaborated, "I was jealous of cinematic authors who, as practitioners of the dominant art form of the 20th century, could claim to affect a much larger audience in a deeper way."[3]

The challenges set forth by *Two Generators* resonate deeply in its theater setting. Here, Graham infiltrates the space representative of the cultural phenomenon he attempts to debunk. He foregoes a narrative, instead creating a film whose content mimics its own form as artificial illumination. The artist further exposes the artifice through poor quality mono sound played at maximum volume and by revealing the mechanical projector. The work also discloses the economics of the film industry, as the audience observes the projectionist laboring repeatedly with mundane, technical tasks. Excess activity and information distract the viewer and ultimately negate the expected contemplative, pleasurable experience.

Graham's next filmic work, made ten years later, is less preoccupied with the mechanisms of presentation and more attentive to the narrative conventions and plot-advancing devices typically found in Hollywood movies. Like *Two Generators*, *Halcion Sleep* (1994) also marks an event in real time. Shot in video (primarily for practical purposes), the work opens by dramatically presenting the title in white capital letters against a black backdrop, suggesting classic film-noir suspense. The title fades out, giving way to an introductory text:

> *On the night of October 25, 1994, I went to sleep in a rented room in a motel on the outskirts of Vancouver after taking .5mg of a sedative whose brand name—Halcion—evokes peaceful memories of the past.*

The screen fades to black, and a second text frame fades in.

Still from *Halcion Sleep*, 1994

> *Later that same night I was moved by my brother and a friend to a waiting car. I was driven, as I slept, to my apartment in the center of the city and put into my own bed, where I slept until the morning.*

The first scene opens to show a man (the artist) neatly curled up along the back seat of the car. Visual clues again suggest film noir: the black-and-white film, the rainy night, the sleeping man in stylishly retro silk pajamas—all of which evoke a strange scenario in which someone slipped him a mickey and then carted him off. But as we await the action, we begin to notice the activity outside the vehicle more than what's happening inside it. At first only a few headlights or streetlights are visible through the back window. Suddenly a string of cars passes in the other direction, and the flurry of their taillights offers some hope of a leap in plot development. But it's not to come: for the entire twenty-six-minute take, neither the camera nor the man waver.

Because we are accustomed to the progressive action of movies, Graham risks losing our attention, since *Halcion Sleep* extends into real time what usually exists only in the compressed time of a movie's narrative. Further frustrating our desires, the fixed camera position flouts the filmic convention of variable framing. Here the unguided imagination wanders through the single shot, alternately intrigued by the "screen" of the back window and the sleeping figure. If one is patient enough to experience the entire video, a heightened awareness marks the subtle shifts outside the window as a substitute for a plot.

The work abounds with references, not only to film noir, but also to childhood memories of family road trips, the fabled bird Halcyon, the Freudian unconscious, and even a joke on artists' dreams as part of the creative process. *Halcion Sleep* also puns on cinema's ability to transport the imagination. Graham's body is literally transported, and the "coruscating 'city lights'" suggest his mental transcendence by appearing "less as reality and more as a dream-projection or thought-balloon."[4] Graham is captivated, but he is also captive. What does this portend for us, then, the audience? Critiquing cinematic experiences, Robert Smithson saw helplessness in the face of film's hypnotic capacities: "the ultimate film goer would be a captive to sloth. Sitting constantly in a movie house, among the flickering shadows, his perception would take on a kind of sluggishness…. He would not be watching films, but rather experiencing blurs of many shades. Between blurs he might even fall asleep."[5]

Continuing his fascination with the play of light, Graham staged another lighting event for *Coruscating Cinnamon Granules* (1996).

To create this homespun structuralist film, Graham sprinkled granules of the spice on the coil of an electric stove in a completely darkened kitchen and turned the element on high.[6] As the burner gradually heats, the small grains flare up brightly in a "glittering mini-spectacle that resembles a constellation of stars that appear before one's eyes after a mild blow to the head."[7] For nearly a minute, the screen appears to present a spectacular night sky before the burner becomes too hot, revealing itself as an illuminated coil and putting an end to the celestial vision. As it cools down and the final sparks pop, the image again entices the imagination with impressions of galactic entropy and other cosmic energy cycles.

 Near homophones, "cinnamon" and "cinema" point out the transformation of the real domestic space into a public space where artifice propagates. On one level, this work reveals the cinema's ability to present the illusion of something larger than life. For exhibition, the artist specifies building the screening room the size of the original kitchen. Intentionally left as a frame construction, the two-by-fours and drywall of the exterior define the structure as real architecture, but the theater seats and screen inside tip us off to the interior as host to a grand mirage. Even though Graham established physical limits—a single roll of 16-mm film to determine the length of the action, the modest kitchen setting apparent in the film duplicated by the compact viewing room—he still achieves an ethereal vision. Exiting past the projector and distinctive film looper positioned outside the space, we are brought back to earth, made aware of the mechanism that creates the illusion.

 Graham further complicates the escapism inherent in movie-going with *Vexation Island* (1997), *How I Became a Ramblin' Man* (1999), and *City Self/Country Self* (2000). This trilogy exploits our collective cultural familiarity with Hollywood genres—the adventure, the western, and the period drama—seducing us with lush, familiar images and sounds captured on 35-mm film by industry professionals. But Graham ensnares us in contemplation of universal questions. Each short, looped film abandons the typical story line comprising an orderly progression from problem to resolution and dénouement. Instead, beginning, middle, and end fall away so that only a single event plays out again and again.

 Vexation Island opens with a bird's-eye view of a tiny tropical island with a green core of vegetation and a white sand beach. On the island,

Still from *Coruscating Cinnamon Granules*, 1996

the fronds of a palm tree sway against a sky punctuated by a single passing cloud, and waves crash on the beach under the tree's shadow. More than a minute into the film, the camera moves around an outcrop of tall grass to reveal a motionless figure lying beside a parrot perched on a barrel. The camera abruptly cuts to a view of the tree from below, panning down the trunk to close in on the man lying in its shade. A long slow scan moves from his shiny silver-buckled shoes, along his spotless white knee stockings and black knickerbockers, to his scarlet waistcoat, finally arriving at his worn countenance, pausing at his deeply wounded forehead.

The pace of the camera's movement is at first slow and deliberate, with equal time given to filming the man, the tree, and the bird. The shots cut between the three until finally, six minutes into the film, the parrot squawks, "wake up, please!" Another minute passes before the man heeds the bird's second call. He rises achingly, dazed and quizzically surveying his environs. Now the progression of shots speeds up. He spies the coconut-laden tree, lumbering toward it and shaking the trunk until a coconut crashes down upon his forehead. Knocked unconscious, he falls backward cartoonishly. The camera follows as the coconut rolls down the beach, and, after we take a final look at the man back where he began, we watch as the coconut floats off into the surf. The next shot is an aerial view of a tropical island, and the film loop begins again.

The setting, costume, and props conjure up associations from the literary (Daniel Defoe's *Robinson Crusoe* [1719]) to kitsch (Walt Disney's *Treasure Island* [1950]). These familiar images lull and amuse us; for a moment the futility of the man's plight is buffered by our sense of nostalgia. Ultimately the film's circuitous camera work guides us to ruminate on the cyclical nature of being. Image after image, Graham's "stripped-down island adventure" unfolds diagrammatically to render the "catastrophic events that conjoin states of consciousness (shots)."[8] The camera's shots symbolize moments of awareness (or unawareness), and the use of variable framing concentrates our attention on what he identifies as the "Natural Fluxes—bird-centered, man-centered and tree-centered—that divide and reform repeatedly according to the principle of the loop."[9]

The second work of the trilogy, *How I Became a Ramblin' Man*, opens with a distant view of mountain foothills backlit with warm, pink

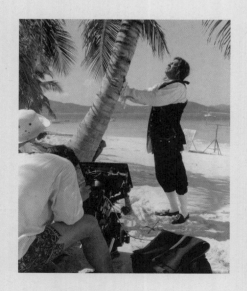

Production still from *Vexation Island*, 1997

sunshine. A horse and rider approach leisurely along a valley trail below. Subsequent shots follow the pair through prairie and shallow stream. Close-ups of the sparkling water, riverbank, and yellow flowers enhance the warm mood. Framed between tree trunks, the cowboy is seated on a log, strumming his guitar and singing a sweet song. Slowly the shots alternate between the earnest cowboy and his horse grazing lazily. After a while he finishes his song, swings his guitar around to his back, and mounts up, returning along the same path in a series of shots that mirror the opening sequence.

The cowboy is caught in a narrative digression, as if he has wandered from the main action of a spaghetti western to give us further insight into his character. The calculated appearance of the widescreen format, the golden tones of the prairie setting, and the Foley sound of the clopping hooves induce contemplation of the figure romanticized both as a folk hero and an advertising icon. His song promises, "when folks can bear the sight of a solitary type, I'll tell you how I came to be…," but, wandering in circles, the rambling man will never arrive at an explanation. With us alongside, he is always adrift, "in the canyons of my wasted time," never to find a purposeful direction.

The final work of the trilogy, *City Self/Country Self* features Graham playing two roles, a star turn found throughout movie history. The most ambitious and richly detailed of the three, it opens with a black silk hat coming to rest on a cobblestone street in an old European town. Graham, as Country Self, picks it up, brushes it off, and puts it on his head. Cut to Graham, as City Self, striding purposefully down a narrow street. Country Self, after pausing at his reflection in a window, continues his stroll. Filming him from behind, the camera drops down to reveal a large target-like patch in his pants seat. Returning to City Self, the next shot features a shoeshine boy brushing the dandy's extravagant red and black shoes. Slowly the camera pans up along his striped trouser leg and stylish plaid jacket before coming to rest on his bored face beneath a black top hat. The shot once again jumps quickly to Country Self, who, ambling along, looks up at the town clock (it's 11:55) and then glances at the church bell tower, perhaps anticipating the strike of midday.

Still from *How I Became a Ramblin' Man*, 1999

The camera breaks from tracking the two to pull back for a wider street view with a horse-drawn carriage and passing pedestrians.

As Country Self pauses below a stone statue of a martyr with its decapitated head in its hands, City Self approaches briskly. A series of frames then alternates between the men and the now-audible approaching carriage. After the carriage passes, the country gent steps into the street as the dandy follows him; the carriage drivers glance sharply back at them. As the clock's hand sweeps to noon, the dandy's leg swings to meet the bumpkin's derrière. Country Self stumbles and his hat tumbles to the ground. The kick repeats and repeats, captured from many angles. The film, which becomes silent at the stroke of twelve, resumes its soundtrack as the clock ticks to the next minute. The loud clopping of hooves returns as the carriage rolls on; the dandy takes a turn down a side street. Immediately afterward the opening shot appears again, with a black silk hat coming to rest on the cobblestones.

City Self/Country Self reflects a bygone era, a story already told, elaborated by period costumes and medieval village. Yet the film emphasizes the present tense. From the brisk pacing of images and sound—the clock, hoof beats, bell tower, men's strides—the loop keeps us constantly measuring this moment: a Laurel and Hardy–like sight gag that culminates the action. Or does the kick start it? Do we witness a becoming or an undoing? The loop posits an impossible riddle that disorients our cognition.

In *The Phonokinetoscope* (2002) Graham brings the sophisticated aesthetic and technical qualities of the trilogy and the emphasis found in his earlier work on the mechanics of cinema together with a dual looped structure. The filmed action in this work arose from the artist's interest "in the idea of representing (or not representing) a kind of external manifestation of an interior experience."[10] To this end, Graham ingests a tab of lysergic acid diethylamide (LSD) and bicycles through Berlin's Tiergarten. The ride recalls the circumstances in which the Swiss chemist Albert Hofmann first experienced the psychotropic effects of the chemical while bicycling home from his lab in 1943.

Graham reminds us that early experiments in cinema integrated sound and image, like Thomas Edison's kinetophonograph of the 1890s. Graham's device comprises an LP turntable and a 16-mm film projector mechanically linked so that the projector starts when the needle is placed on the record. But unlike Edison's invention, the image and soundtrack are not synchronous, nor were they designed to be. In fact Graham embraces the

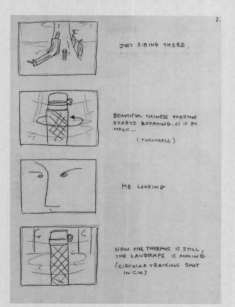

Studies for *The Phonokinetoscope*, 2002
Pencil on paper
21 x 28 cm (8 1/4 x 11 5/8 in.)
Collection of the artist

disparity of duration between the moving image (five minutes) and the music (fifteen minutes). The innumerable juxtapositions of sound and image create "myriad music videos," according to the artist (who wrote and performed the acid rock–inspired soundtrack partly in tribute to the genre's tragic ground-breaker, former Pink Floyd singer Syd Barrett).[11]

The Phonokinetoscope sits in the viewing space so that when we enter the room, we immediately encounter the functioning appliances that generate the projection. Spotlit, the projector and record player appear like sculptures, implying their importance as works of art or even ritual objects. As such, the machines become fetishes transformed beyond utilitarian function into symbolic vehicles of magical transport, much the same way drug paraphernalia, acid rock, or turntables hold this promise to fixated devotees.

True to Graham's style, he leaves us with a conundrum. If his installations break down film's ephemeral apparitions into material parts and technical sequences, why do they still fascinate us? The powerful narcotic effects of film as it floods the senses are not fully comprehended and are still hotly debated among film theorists and cognitive scientists. Graham plays in this gap. Akin to Smithson, who disparaged that "to spend time in a movie house is to make a 'hole' in one's life,"[12] Graham seems to suggest that this moment is like being knocked out or having a mind-altering experience — a temporary hole in your consciousness. In this liminal state our senses act differently, time proceeds abnormally, and external reality is momentarily suspended. In popular cinema, this is how the mind escapes. In Graham's movie-going ruse, it just might lead to self-determination.

1: Alexander Alberro, "Demystifying the Image," in *Rodney Graham: Cinema Music Video*, exh. cat. (Vienna: Kunsthalle; and Brussels: Yves Gevaert Verlag, 1999), 79–80.

2: Graham, "Siting Vexation Island," in *Island Thought: Canada XLVII Biennale di Venezia*, exh. cat. (Toronto: Art Gallery of York University; and Brussels: Yves Gevaert Verlag, 1997), 11.

3: Graham, interview with Anthony Spira, Whitechapel Art Gallery newsletter, September 2002, 11.

4: Graham, "Siting Vexation Island," 13.

5: Robert Smithson, "A Cinematic Atopia" (1971), in *Robert Smithson: The Collected Writings*, ed. Jack Flam (Berkeley, California: University of California Press, 1996), 141–42.

6: Graham commented that "surely someone's done this before," in conversation with the author, 9 March 2003.

7: Graham, "Siting Vexation Island," 12.

8: Ibid., 16.

9: Ibid.

10: Graham, in Rachel Kushner, "A Thousand Words: Rodney Graham Talks About *The Phonokinetoscope*," *Artforum* 40, no. 3 (November 2001): 117.

11: Ibid.

12: Smithson, quoted in Kerry Brougher, "Hall of Mirrors," in *Art and Film Since 1945: Hall of Mirrors*, exh. cat. (Los Angeles: The Museum of Contemporary Art, 1996), 82.

Alice's Adventures in Wonderland, 1987
Tin slipcase and book
19.5 x 16 x 2.8 cm (7 1/2 x 6 1/4 x 1 1/8 in.)
Collection Jan Vercruysse

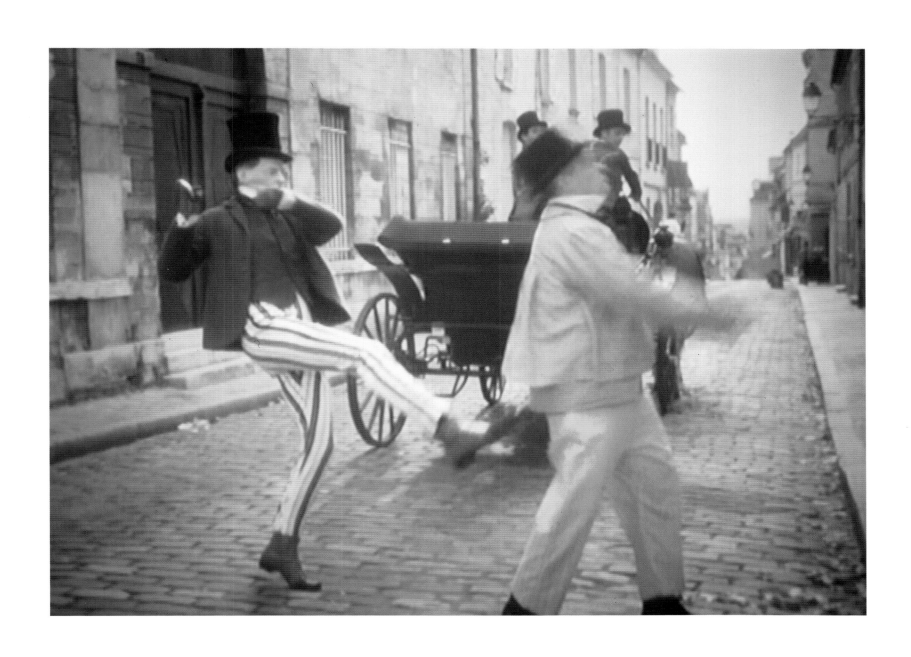

Stills from *City Self/Country Self*, 2000

Detail of *City Self/Country Self (wallpaper)*, 2001
Colored, hand silk-screened wallpaper on pulp/latex-blend
paper with a pigmented, clay-based coating
Roll: 274.3 cm (108 in.)
Courtesy Donald Young Gallery, Chicago

Details of portfolio from *A Design for a Mirrored Slipcase for*
Les dernières merveilles de la science, 1991
Sculpture: Slipcase in nickel-plated brass, glass, and mirrored
glass for a book (Daniel Bellet's *Les dernières merveilles de la
science* [Paris: Garnier, c. 1900]); portfolio: reproductions of
the chromolithographs contained within the book, and one
folded sheet with three isometric projections of the slipcase
and a reproduction of the cover
Dimensions variable
Yves Gevaert Éditeur, Brussels

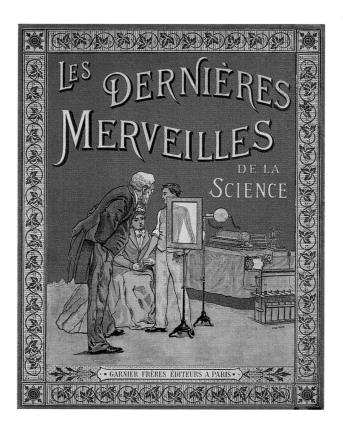

MONSIEUR GRAHAM BELL INAUGURANT LA GRANDE LIGNE TÉLÉPHONIQUE
DE CHICAGO

UN PHARE ÉLECTRIQUE DANS LA NUIT

LE CHEMIN DE FER ÉLECTRIQUE QUI MONTE A LA JUNGFRAU

UNE AUDITION DU PHONOGRAPHE LIORET

EDISON DONNANT UNE REPRESENTATION DE SON GRAND KINETOSCOPE
A PROJECTIONS

COMMENT TOMBE UN CHAT

*Five Interior Design Proposals for the Grimm Brothers'
Studies in Berlin*, 1992
Installation, Documenta IX, Brüder Grimm-Museum,
Kassel, Germany, 1992

Detail of *Five Interior Design Proposals for the Grimm
Brothers' Studies in Berlin*, 1992
Five pairs of drawings in India ink in walnut frames
with passe-partout and caption in letterpress
67 x 58.5 cm (26 x 23 in.) each
Yves Gevaert Éditeur, Brussels

Casino Royale—Sculpture de Voyage Deluxe, 1993

Detail of book from *Casino Royale—Sculpture de Voyage Deluxe*, 1993

Millennial Project for an Urban Plaza, 1986

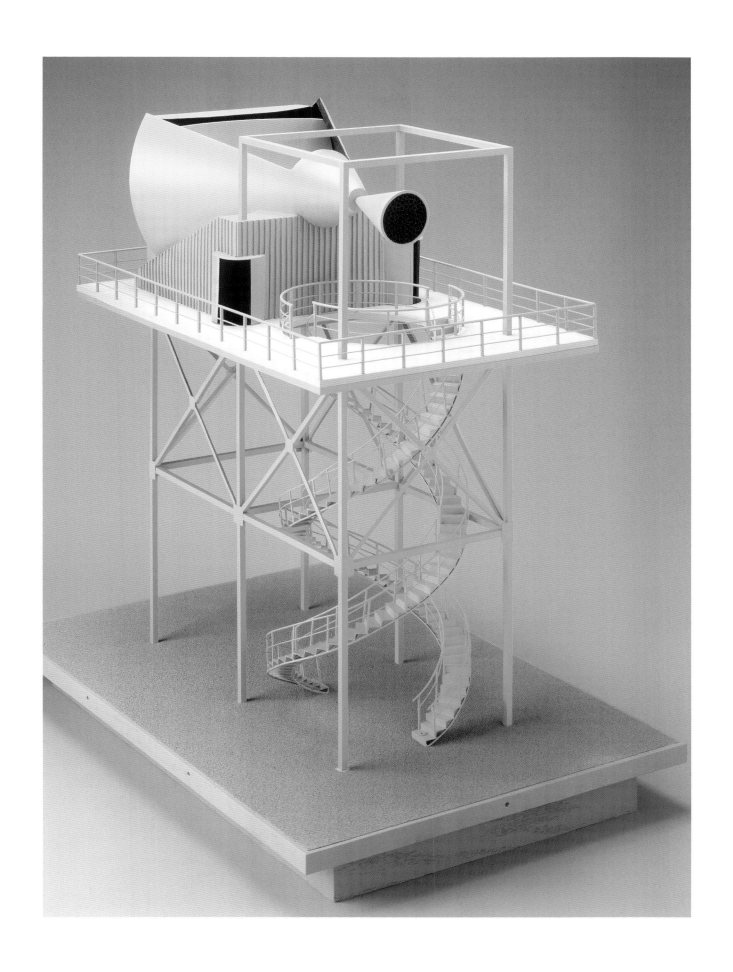

Reading Machine for Parsifal. One Signature, 1992

Details of *Rome Ruins*, 1978
Ten color pinhole photographs
35 x 28 cm (14 x 11 in,) each; edition of 3
Collection of the Vancouver Art Gallery

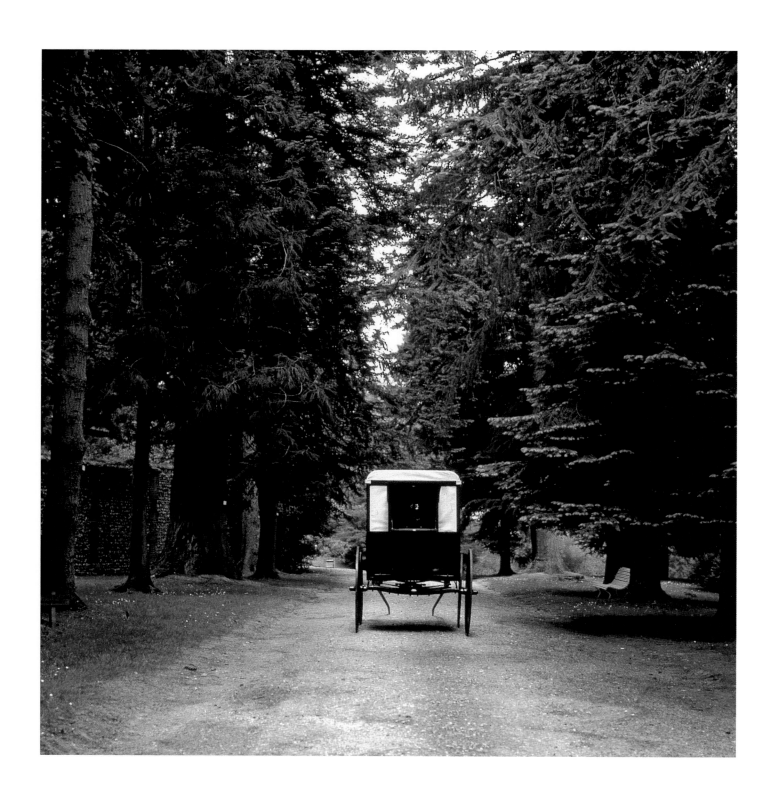

Camera Obscura Mobile, 1989
Installation, The Harcourt Arboretum,
FRAC Haute-Normandie, Sotteville-lès-Rouen,
France, 1996

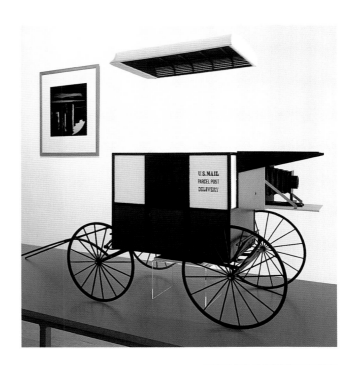

Detail of model from *Camera Obscura Mobile*, 1989
Installation, Lisson Gallery, London, 1996

Detail of photograph from *Camera Obscura Mobile*, 1989

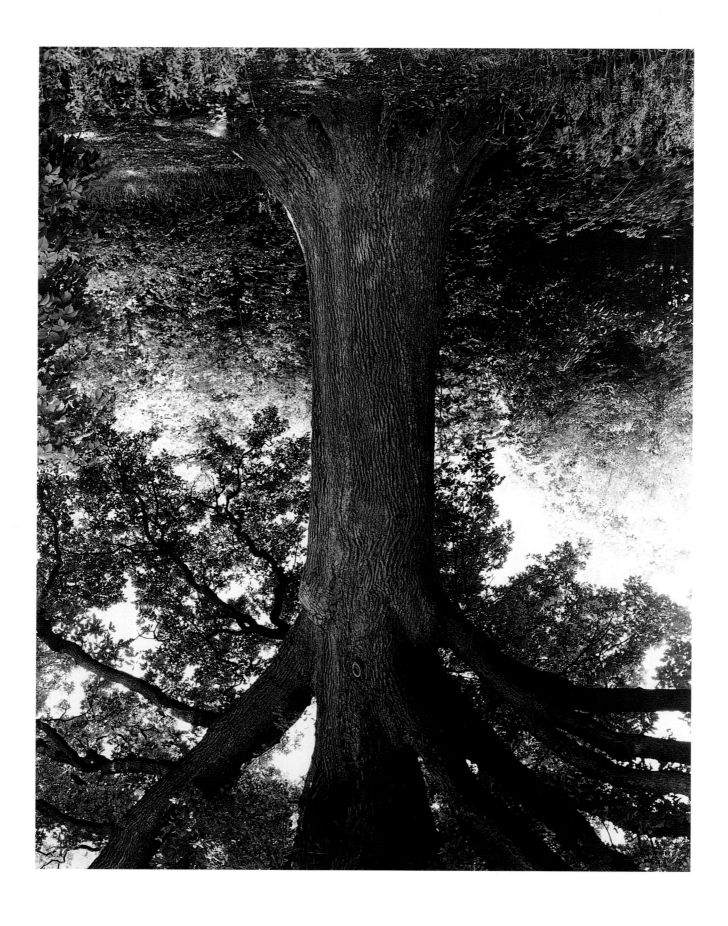

Details of *Flanders Trees*, 1989

Details of *Flanders Trees*, 1989

A Can of Worms
by
Lynne Cooke

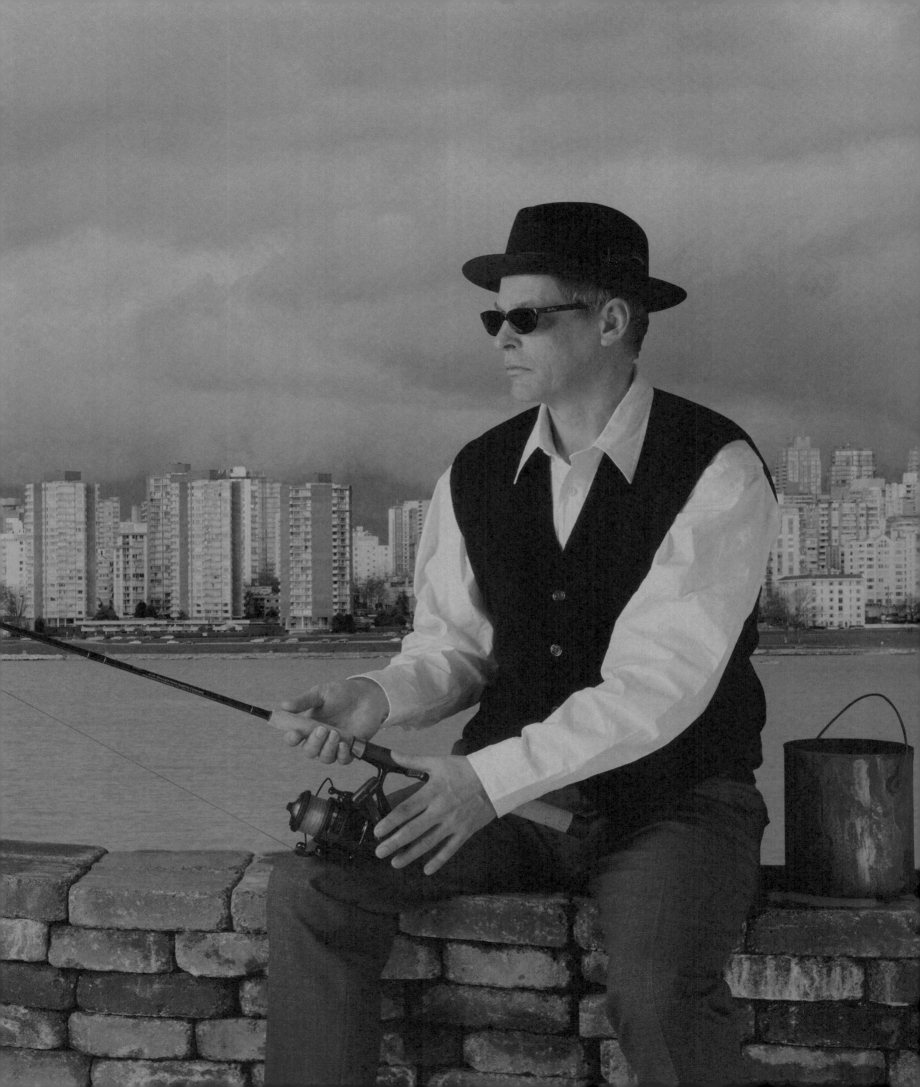

If my dreams appear witty, this is not the fault of my individuality, but of the peculiar psychological conditions under which the dream is fabricated…The dream becomes witty because the shortest and most direct way to the expression of its thoughts is barred for it….
—Sigmund Freud[1]

The indefinite process of supplementarity has always already infiltrated *presence, always already inscribed there the space of repetition and the splitting of the self.*
—Jacques Derrida[2]

Tripping on that idea, I was reminded…My point is, the trip is the thing.
—Rodney Graham[3]

A rusty can sits on a stone ledge set against a neutral black backdrop. *Can of Worms* (2000), Rodney Graham's sole still life, is presented as a light box, yet it has the sensuous mundane simplicity of a seventeenth-century Spanish still-life painting by Francisco de Zurbarán or Juan Sánchez Cotán, or a bunch of asparagus by Edouard Manet. However, with characteristically sly wit, Graham deviates subtly from the simple pared-down *nature morte*, introducing a trail of references and allusions that coil restlessly around each other. Equally telling is the role he accords the title, which functions here less as a caption than as a supplement, identifying the contents of the can which would otherwise be unknowable, thereby rendering the visual subservient to textual exegesis. The exceedingly long electric cord powering the light box, carefully looped, trails over the floor to a nearby socket, illuminating the image in such a way that the can comes to resemble a lamp within the somber pictorial space. The sumptuous glowing surface, a dematerialized projection with a dream-like presence, is infused with an atmosphere markedly different from the flat external light on which paintings and photographs are dependent. Unlike most artworks that employ this medium—in which the cord, considered purely utilitarian, is concealed—here Graham asserts its facticity as a foil to the illuminated object, for which it is both the literal and metaphorical source. Dangling from the lower frame of the artwork, the cord melds the luminous illusion, which it animates, to the actual space in which it is contained. Metaphorically, too, it connects to the can in that its tidy coils contrast suggestively with the squirming organic tangle imagined trapped within the vessel from which it appears to emanate.[4] A hallmark of Graham's art, here as elsewhere, the loop is never just a loop. The insidious wit underpinning this fictional/factual, literal/metaphorical elision imbues the hallucinatory image with the distilled, compact character of a visual pun. As with such encrypted figures, any attempt to unravel its condensed layerings threatens to destroy the gentle humor, causing the unitary visual/verbal image to mimic itself, duplicating and splitting into a veritable can of worms.

ADDENDA

I.

"Artists tend to be not very well rounded people," Graham argued in a recent interview. And he added, to substantiate this claim, "They bring everything into their work instead of having things outside of it that they might do for leisure or relaxation."[5] Several times, while honing the skills required to realize a particular work, Graham by his own account was almost waylaid into other career paths, whether that of analyst, novelist, or singer-songwriter.[6] Conversely, the pursuit of a certain work has dovetailed with potential leisure activities, as when making a new series of photographs of trees became the occasion to take a break in the country for a few weeks.[7]

Gracious, loquacious, Graham has responded to questions from interviewers concerning the inspiration or genesis of his works with unusually forthright and fulsome accounts. In addition, he has frequently offered

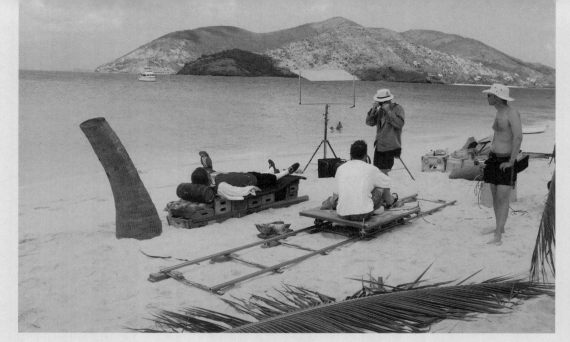

Production still from *Vexation Island*, 1997

addenda, liner notes, glosses, and marginalia, as well as catalogue essays, that allude not only to the motivations underpinning individual works or series of works but to their content. From this miasma of frank, lucid, insightful explanations springs a veritable surfeit of starting points for the analysis of any particular work in his heterogeneous oeuvre. For Graham's panoply of written and spoken texts, together with his rapidly growing repertoire of songs—themselves yet another form of commentary—interweave reference and association so that many works feel as overdetermined as the principal motifs in a memorable dream.

 In an exemplary interpretation, the paradigm for which is Sigmund Freud's explication of his "Dream of the Botanical Monograph" (which Graham has taken as the subject for several of his works), the analyst returns again and again to the key motifs, mining them slightly differently on each occasion, concentrating on certain resonant figures while ignoring others in what must remain an incomplete narrative, a reading that can never exhaust its subject but ultimately will prove a kind of mise-en-abîme. Sometimes overtly, many of Graham's supplements refer to Freud, Freudian analysis, or Freudian models of the psyche, for the founding father of psychoanalysis occupies a central place in his imaginary. Although bearing the straightforward, frank, and friendly tone of a conversational exchange, these articulate apologia may be read as a kind of auto-analysis, albeit one that is more circumstantial, allusive, and anecdotal than rigorously psychoanalytical. While they function to reinforce the

effect of authenticity and authority in his most literary of works, such disclosures conversely serve to undermine the presence and strength of the unitary image in those of his works based in a visual lexicon of citation and reinscription.

II.

Notations, glosses, appendices, and marginalia proliferate throughout Marcel Duchamp's oeuvre and those of many of his heirs. Given that Graham's early work is determined by discursive modalities rather than by stylistic, formalistic, and medium- or genre-based concerns, it is best read through a Conceptual pedigree, even though today he believes that "Conceptual art is dead."[8] While his recent work remains founded on the discursive, its vocabulary and syntax are now filtered through performative idioms, as seen in *Halcion Sleep* (1994), which marked a crucial turning point in his career. A video projection featuring the drugged artist as protagonist/performer, it was followed in 1997 by *Vexation Island*, a Hollywood-style featurette and the first of a trio of "short costume pieces" in which Graham assumed a starring role. In these and related works in film, video, and photography, visual languages take priority over their textual and aural counterparts. And in place of the erudite, even arcane modernist sources—ranging from Richard Wagner to Georg Büchner, Edgar Allan Poe to Freud—that formerly fueled his literary ventures, his recent works are marked by a melding of popular tropes based in vaudeville, buffoonery, and comic jests, with

others mined from more explicitly high-art prototypes. Weaving a spoken text with samplings of his own compositions and those of others inspired by the rock band Nirvana, *Aberdeen* (2000) proved another milestone in his oeuvre. By drawing on his catholic interest in diverse fields of music, ranging from heavy metal to easy-listening, he has infused subsequent works with a more informal colloquial tone. Although as a singer-songwriter he wants his songs to have "an emotional resonance that is based in a collective familiarity," Graham nevertheless acknowledges that as artworks these hybrid compositions must continue to function within the discourse of contemporary art rather than that of music.[9]

III.

More immediately relevant to his practice than the father figure of Conceptual art is one of Duchamp's most seminal offspring, Robert Smithson. Graham's fascination with Smithson's practice has been variously reflected in both his art and manifold ancillary activities.[10] Celebrating "the wild allusiveness and careening hilarity of [his] essays," Graham characterizes his mentor's thinking in terms that also illuminate his own. In an essay tellingly titled "Smithson's Brain," Graham seeks to describe his forebear's state of mind, his "affliction," by borrowing a concept coined by Jonathan Swift, "labyrinthine vertigo." Immediately, however, he reconsiders, offering in place of the notion of a centerless circle, spiral, or labyrinth, a motif he deems more pertinent: the meander—"a circuitous journey, and a leisurely one, or at least one guided ultimately by the imperatives of the site-seer's pleasure." "And," he gleefully adds, with characteristic appreciation of its totally fortuitous likeness, "the adjective *meandrine* means full of windings, especially of a rather beautiful genus of corals with a surface bearing an amusing resemblance to a fossilized human brain."[11]

Several protagonists in Graham's own works seem partial to a meander, or ramble: the cowboy in *How I Became a Ramblin' Man* (1999), both protagonists in *City Self/Country Self* (2000), even the cyclist in *The Phonokinetoscope* (2002). However, all are ultimately entwined in a relentless circuit, a remorselessly endless loop whose impact is akin to that decentering Swiftian

state: labyrinthine vertigo. Having finished his song, the cowboy in *Ramblin' Man* remounts his horse and rides into the sunset, but every shot documenting his retreat mirrors one tracing his arrival, so that his departure is finally sutured seamlessly into his initial appearance across the distant prairie, transforming what initially seemed an idyllic reverie in sepia-toned Cinemascope into a melancholy predicament fraught with an ironizing pathos. The rustic yokel and the city swell of *City Self/Country Self* amble along the lanes of a provincial town, each tracing a path that echoes that of his antagonist, like complementary trajectories on a Möbius strip. Their brief encounter pivots on a pratfall: the changing fortunes of the hat, embodying contending social ambitions that each figure can neither relinquish nor realize, mimics the predicament of the vanguard artist.[12] Even *The Phonokinetoscope*'s cyclist, skimming breezily through the bucolic park, eventually reverses his forward motion, though possibly without realizing that he is retracing his route. Facing into the future while riding backwards to the strains of a bittersweet paean to nostalgic phantasms of desire, he too ends where he began.

Graham's use of the loop in his three costume dramas—*Vexation Island, How I Became a Ramblin' Man*, and *City Self/Country Self*—has been considered critical to a self-reflexive cinematography, to a stringent deconstruction of not only the ontology of film but the discipline and history of the medium.[13] Yet in these works the loop acts not only structurally but syntactically: it introduces a psychological dimension, manifest as repetition compulsion. Trapped in a relentless replay, the mythic subject—castaway, cowboy, country bumpkin—is prey to a dizzying mutability.

When starring in roles based on archetypal filmic genres, the artist functions very differently than he does in his video-based projections *Halcion Sleep* and *The Phonokinetoscope*, where he quite self-consciously retains the position of auteur/director even though planning to hallucinate during the performance. *Halcion Sleep* centers on his drugged body, which is driven through Vancouver one night from a motel in the outskirts of the city to his downtown home, where he is deposited in his bed. A single take from a static camera of the

sleeping figure stretched out on the back seat of the vehicle, *Halcion Sleep* follows the model of low-budget videos shot in the 1960s and 70s, when artists were exploring what was then a new technology to record their performances. Many, like *Halcion Sleep*, were made specifically for the camera.

While more complex and more sophisticated in structure, *The Phonokinetoscope* does not deviate significantly from this model. Once again the subject is the artist in a transformed state of consciousness. And once again Graham makes no attempt to visualize his transfigured condition. Rather, his point of departure lies in the anecdote that in 1947, after taking LSD for the first time, the drug's inventor Albert Hofmann cycled from his laboratory to his home in Basel. In *The Phonokinetoscope* Graham's mental condition is intimated by his trick of blithely cycling while seated backwards along the gently winding paths of a picturesque urban park. These free-wheeling trips serve as veiled analogues for mental flights. As the haunting melody conjures a collective yearning couched in the familiar lineaments of a dream-like romance, Graham's knowing deployment of engaging whimsy teases out the intricate substructure of this nexus of sentimental cultural tropes. Before entering the space of the projection, the viewer must place the needle on a 33-rpm record to start the audio component. Since the stylus's position can vary on the track, the relation between lyric and image is open-ended. Moreover, since the duration of the recording is longer than the film, often both film and song will play in tandem but not in sync. Such splitting prompts the speculative mind to probe more freely than when sound and image are tightly in thrall, when, as in a music video, images are cut to the song.

Conversely the structural and syntactical looping, which interrupts the meandering journeys taken physically and mentally by his filmic protagonists, traps them in mechanistic models of repetitive activity, undermining the romance, wearying out the humor in the pratfall, and distancing the viewer from any emotional identification with these clichéd figures. By exhibiting the principal props, costumes, and even masks of his own face in a gallery adjacent to that in which the projection is shown, Graham prioritizes role-playing while he

simultaneously undermines viewers' tendencies toward empathetic identification. Announcement cards for his recent solo shows with pictures of Graham at work, researching or scouting, further reinforce a recognition that the artist is the producer of his own image. Informal rather than posed, these portraits celebrate the free-wheeling, shape-shifting star in ways relatively new in his practice: formerly, in most of his literary works, he inserted himself seamlessly into the work of a preexisting authority, infiltrating stealthily as if to merge with its author. As his ongoing play with identity and authorship hones in on a dialectic between spectacularized celebrity and self-alienation, he has staged performances to inaugurate his exhibitions, at which he sings tracks from the CDs released in conjunction with the shows. In *Loudhailer* (2003), his most mordant project to date, this theatricalizing ricochets uneasily across split-screen projections of a pathetically helpless Graham, marooned far offshore, alternately entreating and threatening would-be rescuers from the wave-swept pontoon of his tiny seaplane.

IV.

Delving further into his increasingly complex exploration of the subject position, Graham made two large-scale photographic works in which he again is featured, though in both cases the work's relation to conventions of portraiture is a problematic one. *Fishing on a Jetty* (2000) is, in the artist's words, "a not too scrupulous reconstruction of a shot" from a scene in *To Catch a Thief* (1955), a minor Alfred Hitchcock set piece in which Cary Grant plays the role of a retired cat burglar who disguises himself as a sport fisherman to avoid pursuers, who suspect he is a notorious copy-cat burglar.[14] Graham's disguise is mockingly, teasingly transparent. Not only does he barely conceal his features, but his demeanor and pose (with his back to the water and rod seemingly on the wrong side of the jetty) are risibly implausible. He begs to be caught, to be unmasked. Full of innuendo, this cavalier parody carries among its many allusions an arch reference to fellow Vancouver artist Jeff Wall, the hallmark of whose work involves casting anonymous figures in highly staged situations, themselves based either on specific art-historical prototypes or on more generic

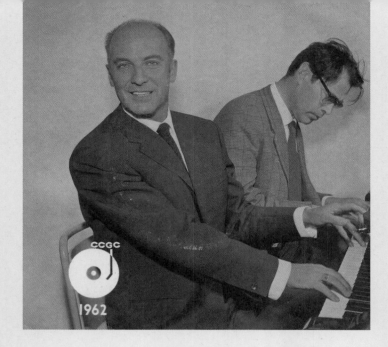

Cover of LP by Wim Sonneveld and
Godfried Bomans, 1962

typologies drawn from the same sources. For Wall, citation serves as a means of substantiation, the vital key to a troubling insertion in tradition and history. The sober earnestness in Wall's mise-en-scènes rarely gives way to lighter moments; at most the dour world of the disenfranchised and underprivileged veers toward the grotesque and ghoulish, far from Graham's hilarious and absurdly comic posturings. In contrast to Wall's subject, whose alterity is defined socio-politically by economic relations, Graham's is inscribed in cultural terms, in representations of artistic identity that are determined through self-fashioning and self-othering.

Graham again invoked his Canadian colleague in the next work he made in this genre, *Fantasia for Four Hands* (2002).[15] Prompted by the gift of a recording by the Dutch comic duo of Wim Sonneveld and Godfried Bomans, "who seemed to be performing a routine of jokes about classical music in a genre close to that of Victor Borge," Graham resolved to create "a double self-portrait in the manner of Jeff Wall" modeled on the cover of the record sleeve. In what reads like a vertiginous free-falling stream of association, Graham explained: "Then it occurred to me to add novelty to the work by doubling it again in the manner of [Arthur] Ferrante and [Louis] Teicher (i.e., with two pianos facing one another)." Further musing on the large Masonic ring he wears in homage to Borge (who was not a Mason) led him instead to Yves Klein, a Rosicrucian; this in turn suggested the possibility of making the cover of the acoustic panel adjacent to the instrument "a shade of ultramarine as close

as I could get to International Klein Blue." Terminating this trail of associative connection, Graham came to the resolution that: "It was my intention to create a kind of frozen cinematic effect in the back and forth flickering of attention that is caused by two pictures representing slightly different scenes…"[16] His account breaks off here with an ellipsis, as if halted in mid-thought, or as if checked by a sudden reservation or by the recognition that adding more would only lead to yet further explication, further references…

Adopting, as usual, an apparently straightforward tone and directly personal address, Graham begins this text with reference to the gift, which stimulated the train of thought, but clearly it is not the beginning. He was already thinking about Wall's work. He was already playing with variants on Deutsche Grammophon record covers, as seen in *Getting It Together in the Country* (2000), where he "amateurishly" adopts the standard pose of a troubadour seated at the foot of a sprawling tree, his guitar on his knee. Integral to many of his accounts of the genesis of individual works are references to early memories or childhood events that ground the undertaking in a kind of psychic excavation. In this instance, the link is provided by Borge, whom, Graham confesses, "I greatly admired as a child, whom I count as an early inspiration for my own music jokes—particularly *Parsifal*—and who once played the 'Minutenwalzer' in under a minute while sitting on a powderkeg with a one minute fuse." "What a genius," he enthuses.[17] On a number of occasions Graham has recalled that "his first

and definitive aesthetic experience" occurred when, as a four year old, he watched such Hollywood classics as *The Red Shoes* (1948) and *Scaramouche* (1952) that his father, acting as a sometime projectionist, screened in the lumber camp in British Columbia, where he was then manager.[18]

Fantasia for Four Hands is at once a seductively self-mocking spoof on the iconic celebrity performer and the only work Graham has directly identified as a self-portrait. Tellingly, he appears not once, not even twice, but doubled and redoubled. The left-hand panel of the diptych, in which Graham and his other self are seen facing right, is paired on the right by a second image in which they now face in reverse. The internal relations between each pair are constant, in that the foregrounded figure looks dolefully at the camera, literally and metaphorically "playing to the audience," while his companion, head bent, concentrates intently on the keyboard. So similar are the two photographs that at first glance they seem to be a single image in reverse. Closer examination reveals that the same set-up was shot seconds later, then flipped to provide the companion image. That is, there was only ever one piano and one camera position. In order to create the duo the photographic negative was manipulated. Graham's antic image flagrantly contradicts another staple of much contemporary staged photography, namely that computer manipulation is in service to documentary effect, to verisimilitude. Virtually life size, this monumental full-color portrait represents the artist as a flamboyant virtuoso, a showman par excellence. By contrast (to which this bravura gesture pays irreverent homage) Wall's *Double Self-Portrait* (1979), made many years earlier, represents the artist standing, arms folded, casually dressed, manifestly inactive, in a bland interior setting shorn of any identifying or personalizing details. Demonstrably low-key, this inscrutable portrayal becomes a studied refusal to vouchsafe anything of its subject beyond a record of a physical likeness.

Significantly, Graham calls his work not "piano duet," but "fantasia." Originating in the Renaissance, by the eighteenth century the fantasia became a vehicle for free improvisation and the expression of a heightened subjectivity. Often realized in the form of a piano duet, it reached a pinnacle with Franz Schubert, becoming a revered staple of bourgeois *Hausmusik* through much of the nineteenth century. With the advent of recorded music and broadcasting in the twentieth century, the piano duet lost its former stature and esteem, becoming the province of specialized players, many of whom depended on a mass audience interested in spectacle. The career of Ferrante and Teicher is both exemplary of this and exceptional. For in addition to their wide popularity as entertainers known for their easy-listening music, they attracted a second, specialized audience for their pioneering compositions in a similar vein to John Cage's works for prepared piano. Borge's fame as an extraordinarily talented musical humorist long overshadowed recognition of his skills as a performer and conductor of the classical repertoire. For much of his career he employed his gifts as a classical performer in a hilarious debunking of the decorum and formality—the rituals—surrounding this revered art form. Graham's delight in these virtuosos who bridge apparently contradictory fields or who collapse what are conventionally considered opposing disciplines parallels his high regard for such errant talents as Samuel Beckett and Buster Keaton. The invocation of Klein within this pantheon is entirely appropriate. A showman par excellence as well as a modernist pioneer, Klein created a manifesto-like work based on a leap into the void. A photograph documenting his bold projection into space (from the upper floor of a suburban residence) is much revered, even though the recent appearance of a variant, which contains a cyclist in what had formerly been a deserted street, has now exposed it as a skilled montage, a fake.

The melding of buffoonery with high art is a recurrent feature in Graham's oeuvre and a hallmark of those recent works that feature him in a leading role. Graham's maverick practice is overtly apostate, devoid of dogmatic or theoretical pronouncements on the state of art and its potential for social or political change. A chameleon who might have become an analyst, novelist, or singer-songwriter, he increasingly exploits these roles and related others in a study of identity that filters the comic staples of popular art with more exalted tropes into a dizzying delusory system that spirals around an empty center.

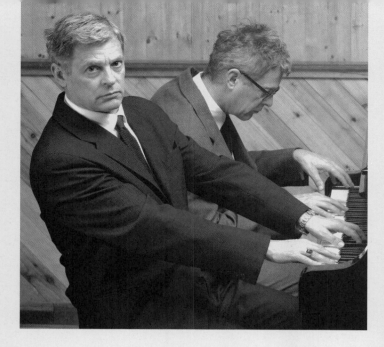

Detail of *Fantasia for Four Hands*, 2002

V.

David Joselit's contention that "the best art of the last decade has explored the conditions of identity *as property* in the fullest material and psychological sense" is widely shared.[19] The malleability and mobility of the subject as author constantly transmogrifies as Graham quixotically engages version after version of the artist hero. Interchanging cultural stereotypes, escaping into altered states, he undermines the sanctity of a given identity, eroding and corrupting it into vertiginously shifting, newly recombinant wholes that elude possession in any unitary sense. Addressing the plethora of contemporary approaches to this issue, which he subsumes under the rubric of an "ethnographic turn," Hal Foster cautions of the danger of a self-othering that flips over into a narcissistic self-refurbishing. "Reflexivity can disturb automatic assumptions about subject positions," he writes, "but it can also promote a masquerade of this disturbance: a vogue for traumatic confessional in theory that is sometimes sensibility criticism come again."[20]

Psychoanalysis has been taken as the lingua franca of much recent artistic practice and critical discourse alike. Its tropes and structural models, ranging from a repetition complex to the mirror stage, are piously embraced as politically efficacious tools for a relativizing and re-centering of the subject: rarely are they parodied or enervated. Graham's apostate investigations are singular in their trenchant eschewal of what have become routine deconstructivist methodologies in favor of an artful lampooning both of self-othering and of that self-fashioning-cum-sensibility-criticism mired in supposedly candid avowals of inspiration, influence, and intention.

In his text-based works of the late 1980s Graham probed the notion of authorship in general and artistic genius in particular through rogue stratagems that, as Matthew Teitelbaum has demonstrated, devolve into absurd celebrations of mastery over the father figure while offering new interpretive freedoms to the reader. Nevertheless, other works—such as the facsimile book *Die Gattung Cyclamen (Installation for Münster)* (1987), based on Freud's "Dream of the Botanical Monograph" —betray a leavening humility in its wry tribute to patriarchal authority, recognition that it remains the basis through which "we…define our place in the world."[21]

In her acute study of Graham's multifarious forays into literary interpolation, indebted above all to Raymond Roussel, Marie-Ange Brayer brilliantly analyzes Graham's strategy of anastomosing two heterogeneous registers—one textual, one visual—situating a proper name (i.e., Freud, Judd) at their juncture.[22] Thus Graham's specular play, which ricochets from name to name, ultimately dismantles all genealogy, she argues, thereby "undermining the legal foundation of the text, anchored in the author as guarantor of the productivity of meaning."[23] Graham's destabilizing methodology of augmenting the name of referents as a vehicle for dissembling meaning consequently becomes a tautological process that results in names losing "what is proper to them, viz. their legal 'property': identity."[24] By contrast, in his recent visual works, direct reference to such talismanic modernists as

Herman Melville, Wagner, Poe, and Büchner is forsaken in favor of generic or stereotypical figures—country yokel, castaway, cowboy, concert performer, celebrated actor. Their generic identities are supplemented by allusion to individuals of such diversity and range that the composite subject becomes explosively unruly. Under this barrage of citation and allusions, the plethora of connections spins into the fantastical. Reflecting on one such chain of dizzying association, Graham observes laconically: "I was struck by the connection and the work came out of the fortuitous conjunction of text and image." As so often with his textual addenda, this is an explanation that is no explanation.[25] Just as reference spirals out into a vertiginous mise-en-abîme rather than into closure, so any attempt to locate origins in a point of genesis will lead to an archeological excavation, with recollection uncovering screen memories that, in turn, veil more deeply repressed experiences, ad infinitum.

A far cry from the kinds of rigorously theoretical deconstructive methodologies of the 1980s, Graham's deceptively disarming, transparent, open-ended methodology engages in beguiling sleights of hand and feints deftly designed to mask the intensive labor, the arduously acquired skills, the rogue erudition, and the infinite visual and verbal textual interlacing that generates and, in turn, is in service to its subject. In the mirror optics informing *Fantasia for Four Hands*, reflection mutates into refraction, so that far from drawing on the visual metaphor of Jacques Lacan's "Mirror Stage" signifying the constitution of the subject, the imperfect doubling here serves as a fracture line between the subject and its manifold representations. In reversing, splitting, and duplicating, it refutes any unitary identity. The visual exegesis, like the textual supplement, comes to resemble an optical device for which, as Brayer notes, "proper names are a mere 'reality effect' in the midst of dreams."[26] Her gaze caught in a restless, flickering oscillation between the twin images, her mind plummeting through this labyrinthine mise-en-abîme, the viewer might be tempted to put the lid back on what is the most beguiling of Graham's many cans of worms.[27]

1: Sigmund Freud, *The Interpretation of Dreams*, trans. A.A. Brill (New York: The Modern Library, 1994), 191 n. 6.

2: Jacques Derrida, *Of Grammatology*, trans. Gayatri Chakravorty Spivak (Baltimore: The Johns Hopkins University Press 1998), 193.

3: Rodney Graham, note on *The Phonokinetoscope*, in *Rodney Graham* (London: Whitechapel Art Gallery, 2002), 109.

4: This connection is made more explicit in a montaged reproduction. See ibid., 96.

5: "A Little Thought: Rodney Graham and Matthew Higgs in Conversation," in ibid., 78–79.

6: "I spent a year and a half doing nothing but researching Freud. I basically gave up making art. I thought I'd become a psychoanalyst instead." Ibid., 79. The result was a series of works devoted to a footnote from Sigmund's Freud's *The Interpretation of Dreams* (1899), including *Schema: Complications of Payment* (1996), part of which takes the form of a video projection of a lecture in which Graham assumes the role of an authoritative academic who spins a web of almost serious scholarly speculation in a manner reminiscent of Robert Smithson's 1972 Utah lecture on *Hotel Palenque* (1969). In 1999 he titled a CD of folksy pop songs *I'm a Noise Man*, and in his notes to his LP *Getting It Together in the Country* he compares—tongue in cheek—his newfound commitment to songwriting to his earlier research into Freudian marginalia: "I find myself once again having turned my back on my true vocation." Artist's note on *Listening Lounge II*, in *Getting It Together in the Country* (Munich: Kunstverein; Münster: Westfälischer Kunstverein; Berlin: Künstlerprogramm/DAAD; and Cologne: Oktagon Verlag, 2000), 12. In his interview with Higgs, he wistfully speculates that if he pursues the role of singer-songwriter too assiduously, it will jeopardize his stature and, ultimately, his status as a visual artist. *Rodney Graham* (2002), 82–83.

7: "It's such a relaxing activity, unlike my other art, which I find more stressful." Graham, in Barry Schwabsky, "Inverted Trees and the Dream of a Book: An Interview With Rodney Graham," *Art on Paper 5*, no. 1 (September–October 2000): 67.

8: Graham, in Steven Stern, "River Deep, Mountain High," *Frieze*, no. 71 (November–December 2002): 67.

9: Graham states that he wants his songs to have the kind of collective familiarity that verges on déja vu. "A Little Thought," 82.

10: In the interview with Schwabsky, in which he discusses the impetus behind his large-scale tree photographs, Graham states: "I was thinking of the Smithsons, too, where he turned the tree upside down, the stump pieces." "Inverted Trees and the Dream of a Book," 67. Not only *Schema: Complications of Payment* but *Aberdeen*, too, is indebted to Smithson's notorious lecture: "the idea was to go there [Aberdeen, Washington, Kurt Cobain's hometown] and make a slide documentation piece that would be accompanied by a lecture, not unlike Robert Smithson's *Hotel Palenque*." "A Little Thought," 79.

11: "Smithson's Brain," in *Robert Smithson: Operations on Nature,* exh. cat. (Toronto: Art Gallery of Ontario, 1994), n.p.

12: For a fuller account, see my "Rodney Graham: A Tale of a Hat," *Parkett*, no. 64 (May 2002): 96–102.

13: Alexander Alberro argues that "Graham's film and video projects problematize the cinematic apparatus, dismantling its operation into a number of interrelated components and activating the viewer in the production of meaning." Alberro, "Demystifying the Image: The Film and Video Work of Rodney Graham," in *Rodney Graham: Cinema Music Video* (Vienna: Kunsthalle; and Brussels: Yves Gevaert Verlag, 1999), 74. Graham offered a point of departure for a reading addressing the identity of the artist as subject when he joked, "These works [the short costume pieces] are conceived more as Hollywood style star vehicles and less as auteur films—I never direct them, and in fact it gives me pleasure to relinquish this role. It's an actor's/executive producer's life for me." Graham, unpublished artist's notes on *City Self/Country Self*.

14: Graham, artist's note on *Fishing on a Jetty*, in *Rodney Graham* (2002), 105.

15: A spin-off from *Fishing on a Jetty, Can of Worms* exceptionally takes the form of a light box, a medium that Wall has made his own.

16: Unpublished artist's notes on *Fantasia for Four Hands*.

17: Ibid.

18: See, for example, Graham, "Siting Vexation Island," in *Island Thought: Canada XLVII Biennale di Venezia*, exh. cat. (Toronto: Art Gallery of York University; and Brussels: Yves Gevaert, 1997), 9–10.

19: David Joselit, "An Allegory of Criticism," *October*, no. 103 (winter 2003): 12.

20: Hal Foster, "The Artist as Ethnographer," in *The Return of the Real: The Avant-Garde at the End of the Century* (Cambridge, Massachusetts: The MIT Press, 1996), 180.

21: Matthew Teitelbaum, "Returning to the Present or Writing a Place in the World: Rodney Graham," in *Rodney Graham: Works from 1976 to 1994*, exh. cat. (Toronto: Art Gallery of York University; Brussels: Yves Gevaert; and Chicago: The Renaissance Society at the University of Chicago, 1994), 40.

22: Marie-Ange Brayer, "Rodney Graham, An Optical Involution: The Name Augmented," in *Rodney Graham* (1994), 51–63.

23: Ibid., 53.

24: Ibid.

25: Unpublished notes. This, like the other account cited above, conflates the appearance of explanation with its substance, reveling in the role of serendipitous connections and affinities that are taken to be portentously meaningful, in contradistinction to the Surrealists' penchant for the weird, the uncanny, and the bizarrely fortuitous.

26: Brayer, "Rodney Graham, An Optical Involution," 57.

27: Although Graham likens this to sequential film frames, as found in the earlier work *Adjacent Film Frames 3184–3185* (1984–91), here the fact the image is reversed or mirrored sets up an oscillation between the two panels that instead of producing an effect of advancing temporality as occurs with adjacent film frames, does the opposite. It establishes a kind of looping akin to that which is found in a lenticular device.

How Long, Baby, How Long…?
by
Diedrich Diederichsen

A common heuristic method is to look for an object that is similar to another in one respect but entirely different in most other ways in order to discover something new about the two objects. Traditionally artists have not employed highly elaborated heuristics because they presumed that their practice was not scientific in nature (although, as every dandy knows, it is possible to perform excellent experiments with one's own intuition); however, the attitude toward heuristics and experimentation changed with the paradigm shift that brought us Conceptual art. This shift was not a single turning point, one that took place only or predominantly in the 1960s, but a series of turning points—that is, a true historical development (but that is another subject).

Conceptual artists in the broadest sense, then, are interested in music because while it too is an art, it is the most distant of all art forms—invisible, temporal rather than spatial, usually collaborative rather than solipsistic. Moreover, music is often fleeting, dependent on the moment, and less immediately available than the visual arts, literature, or other tangible media. Technical reproducibility, especially digital, has resulted in the increased availability of all arts, both as material and object. This has led to a de-emphasis on the specific characteristics of individual art forms. Within Conceptualism, however—whether it be semiological, sociological, historical, or aesthetic—generic distinctions continue to be decisive, especially where they are technical in nature, because they touch upon the antagonism between two notions: the irreducibility of a given art form and the idea that art is, above all, socially determined or even autonomous. Irreducibility was a guiding paradigm of American modernism, and the idea of total convergence within contemporary postmodern culture also relies on a certain media-based or technological disposition.

Time and again in his work, Rodney Graham takes the current condition of convergence as his point of departure and then causes the postmodern continua—by definition unencumbered by history—to become tangled up with more traditional media and genres. In this way Graham reaches precisely that stratum of artistic production in which the precondition for art is not medium; rather, his work is organized around logical or formal principles like time, space, order, etc.

One fundamental characteristic of music is repetition, whether it be the repetition of a bar or phrase within a single musical composition or the repetition of the entire composition as one listens to it over and over. Invisibility is a second fundamental characteristic. Because it cannot be seen, music must rely on auxiliary objects, incidental constructions, and symptoms.[1] Graham's work concerns itself with both the production and reception of music. The logic of coincidence links his work with its thematic constellations. While Graham is evidently interested in internal processes, this interest is not limited to music. It was he after all who also conceived the idea of filming himself under the influence of LSD in *The Phonokinetoscope* (2002). His experiences on the drug are opulent internal visualizations that, for the viewer, are reduced to the experience of watching Graham ride through a park on a bicycle.

The third characteristic of music is its ability to encode socially significant developments that lie outside the dominant discourse within the cultural mainstream. Through music we become informed about all kinds of outsiders to society—Hungarian Gypsies, Welsh coalminers, African-American migrant workers—as their music is traced by those interested in it for ethnological or political reasons and then absorbed by the mainstream through the appropriation of musical forms such as czardas or the blues. (However, increased mainstream awareness of these groups through music does not necessarily afford them any particular socio-political gains.) In this way music functions as both a subcultural code and as a medium for preserving history.

These three aspects of music represent constants, as it were, that are independent of music's various manifes-

tations. However, when they are brought into relationship with the visual arts, as is the case in Graham's work, they are subject to other systems that both contaminate and enhance them. It has been pointed out on numerous occasions that the circle or wheel and, similarly, the dual tropes of repetition and looping are the basic structuring principles on which Graham's work is based.[2] This has also been elaborated by the artist himself, who talks about these principles in relation to another one of his preferred methodologies: exposing the concrete and contingent aspects of representation.

Both repetition and looping are evident in Graham's photographic series of upside-down trees, which are reminiscent of an illustration in Ferdinand de Saussure's *Course in General Linguistics* (1916), the sacred text of semiotics. In his text, Saussure always uses the word "tree" to stand as the signifier, the linguistic portion of the sign, while a graphic representation of a tree stands for the signified—that to which the signifier, whether it takes the form of letters or sounds, refers in the outside world. (In semiotics, this relationship is commonly expressed as a formulation with signifier over signified, separated by a division bar.) The Saussurian graphic of a tree became famous, reappearing within the writings of Jacques Lacan and many others. However, its ubiquity was not due to its illustrative value, but the relation that it illustrated—one that Graham alludes to in his photographs. His trees seem to suggest an awareness of their own existence as contingent abstractions, shadows of the concrete. They are positioned upside down not only because they relate to the camera obscura (one of Graham's themes), but also, one imagines, because as placeholders for the signified they occupy the underside of the semiotic division bar.

But I digress. What I really want to do is to explain how Graham responds to the widely held view that he is an artist of circularity and repetition by creating an almost accidental connection between the signified abstraction (the circle, or loop) and the concrete form that is suffused with everyday life, such as the bicycle, whose name denotes "two circles" or, more precisely, "double circle." Thus *Weather Vane* (2002), an image featuring Graham sitting backwards on the handlebars of a bicycle perched on a weather vane, may be read as a reorganization of the semiotic hierarchy of signifier over signified. Consistent with the methods of a Conceptual artist, Graham confronts us with the fact that abstract notions are bound up with concrete forms and dependent on particular local, historical, and social dialectics and ideologies.

For the purpose of discussion we can take the subject of repetition as the starting point for our little tour of Graham's musical output. It must be said that in his practice repetition by no means exists merely for its own sake—as a formal device uniquely manifested in music. Repetition is present in antagonistic relationship to its opposite: development, the idea that something changes over time rather than simply being replayed ad nauseam.

In *Parsifal (1882–38,969,364,735)* (1990), one of Graham's most ambitious and humorous projects, the artist uses a loop structure to generate an open-ended and virtually limitless version of Richard Wagner's *Parsifal* (1877–82) that, if performed in its entirety, would last almost thirty-nine billion years. This version of *Parsifal* is based on composer Engelbert Humperdinck's so-called supplemental music, which Humperdinck wrote to accompany an unusually time-consuming set change that Wagner had not anticipated. Based on Wagner's melodic lines, Humperdinck's musical supplement is a thirty-three-bar loop to be played as many times as necessary for the set change to occur. In Graham's version every instrument plays a predetermined number of repetitions and then starts over again from the beginning; the number of repetitions, however, changes with each instrument and is determined by an increasing set of primary numbers. In theory, when all parts coincide again, the opera may resume and the next act of *Parsifal* may be performed—that is, nearly thirty-nine billion years from now.

Whenever Graham performs *Parsifal*, it is as if his composition has been underway since the 1882 historic debut of Humperdinck's supplement within the original. In other words, he presents the exact segment that would be played at this point in the score had it begun at that time; it is as if the piece has been playing continuously since 1882 and Graham simply decides to turn up the volume for the precise duration of any number of arbitrarily scheduled performances. Conceived in this

Performance of *Parsifal (1882–38,969,364,735)*,
8:18:13 to 10:19:23 pm, 28 June 2000,
Nationalgalerie im Hamburger Bahnhof, Berlin,
in collaboration with Freunde Guter Musik Berlin
E.V. for the series "Music Works by Visual Artists"

way, *Parsifal* exists as a legitimate but largely unheard piece of music—one that shares its immateriality with all other music—and constitutes the longest musical composition of all time. John Cage's longest composition, the performance of which has just begun in Germany, is only projected to last until the year 2640.

There are two possible ways to approach repetition in music. The first is the repeated presentation of that which the audience or composer finds to be beautiful, a kind of second-helping for gourmands. Strict theoreticians committed to music as an indivisible whole would condemn this practice as fetishistic listening, but it could also be read as an appealing figure of regression, a kind of infantile subversion of the work's obligation to grow and develop and of the advocacy of its beautiful moments and passages. This view is advanced by Michael Glasmeier, who has written on Graham's fondness for loops and repetition. Notably, Glasmeier begins his study with a motto from Karl Philipp Moritz, an eighteenth-century German writer who opposed the Protestant notion that too much beauty arouses disgust by arguing that, in beauty, a trail begins that one only learns to travel upon by encountering it repeatedly.[3]

By contrast, the second type of repetition does not seek to repeat what was already beautiful, but uses repetition to constitute the very musical meaning that makes beauty possible. The bourgeois critique of repetition—an aspect of musical thought dating from the eighteenth century to Theodor Adorno—is the target of a rich jazz and pop music tradition. In practical terms,

repetition of a beat in jazz and pop, most radically in early techno and pulse-oriented Minimal music, does not constitute repetition in the strictest sense of the term, even when it is driven by a computer-controlled sequencer. A series of identical beats intended as a sequence is not complete until a predetermined number of beats have been repeated, and only then can the sequence itself be repeated. Until that point, the repeated, identical beats also have immanent meaning as individual elements.

These two seemingly contradictory types of repetition are woven together in Graham's Wagner-without-end. Because any synchronous relationships among the parts are very quickly left behind, the individual elements acquire an immanent musical meaning. However, this meaning is only achieved by repeating a self-contained compositional sequence: in the same way that a loop generates an infinity, a repetition of type one generates a repetition of type two.

Similarly, in *More Music for the Love Scene, Zabriskie Point* (2000), a lyric from the song "Lot of Knocks" poses the question "How fuckin' long can a song go on?"[4] On the basis of Graham's supplement to the soundtrack for Michelangelo Antonioni's film *Zabriskie Point* (1970), it is possible to discover more about the difference between, as well as the convergence of, repetition and endlessness. In the film's famous love scene, a seemingly infinite number of couples (in fact there are approximately six) make love in the California desert. Graham learned that Jerry Garcia, who recorded the music for this scene alone with a guitar, did so in real time while the completed film was running, and finished

Study for *Reading Machine for Lenz*, 1992
Ink on paper
27 x 29.7 cm (10 1/2 x 11 1/2 in.)
Archives Yves Gevaert, Brussels

the score in four takes.[5] Until his death in 1995, Garcia was the lead singer and guitarist for the Grateful Dead, a band that epitomizes endless concerts and endless improvisations. The duration of the Grateful Dead's live performances, together with Terry Riley's, hold a number of records that were probably unbroken until the advent of rave and techno. In *Zabriskie Point* we hear the shortest version of the Dead's improvisatory classic "Dark Star." This music, which is structured very little by the drama-turgical statements and caesuras of the film, is marked by the absence of forward progress. This absence, however, is not the result of repetition but of its conceptual opposite: a wholly unimpeded freedom of development, that notion of collective improvisation in which every step derives—or at least should derive—from the participants' interaction: that is, from the social interaction within artistic practice and not from preestablished rules.

We encounter this same conjunction of freedom and the absence of progress—somewhat broadly interpreted—in an essay by Jeff Wall (Graham's former bandmate in the UJ3RK5) on Graham's work *Reading Machine for Lenz* (1998), which in turn refers to Georg Büchner's literary fragment *Lenz* (1838).[6] Büchner's *Lenz* in turn represents a semi-fictional text by a nineteenth-century author about another author, the eighteenth-century writer Jakob Michael Reinhold Lenz, who wrote some of the most important dramas of the German Sturm und Drang, including *Die Soldaten* (The Soldiers, 1776) and *Der Hofmeister* (The Tutor, 1774). In 1983 Graham built a reading machine that allows one to read Büchner's

work as a loop. In doing so he made use of a repetition that is built into the text. In the English translation the phrase "through the forest" appears twice. The reading machine is constructed in such a way that, after the second "through the forest," the reader is diverted back to the first (this was made possible in part by the fact that Graham had the text printed so that both occurrences appear at the bottom of the page), and hence driven around in a circle.

Lenz's restless wanderings up and down through the mountains and his refuge at Pastor Oberlin's house thus become caught in an endless loop. A French version of *Reading Machine* thirteen years later proceeds in the same way. Just like the English phrase "through the forest," the expression "au long des forêts" occurs twice in the French translation of Büchner's *Lenz*. Ironically, this procedure would not have worked with the original German text, because the passage reads "den Wald hinauf" (up through the forest) the first time and "den Wald hinab" (down through the forest) the second. Thus in the German version, the forest does not stand on a level plane (but Lenz's restless movements seem to go on endlessly regardless). The relationship of Graham's looped *Lenz* to Büchner's original approximates Graham's *Zabriskie Point* loop to the Grateful Dead's "Dark Star." Both are versions of non-arrival, of time's inherent resistance to conclusion.

By contrast, the images and objects of the visual arts are always already finished—indeed even with respect to "process-based" works. Resisting conclusion would seem

to be, then, the exclusive purview of music. However, this tendancy has also been a principal project of literary modernity from Büchner to Samuel Beckett. By placing the loop and repetition at the forefront of my reflections, I, too, have used the loop—as both technical and abstract device, hence it is doubly objectified—as a fundamental reference point of Graham's work (like those I mentioned earlier).

It seems to me, however, that when we consider Graham's *Reading Machine* on the one hand and his meandering guitar music for the love scene from *Zabriskie Point* on the other, the philosophical phenomenon of a subject that has different ways of failing to find itself is much more important: whether it be a subject that goes round in circles or one that engages in an open-ended journey up and down, or whether it experiences endlessness as freedom (like the improvisations of the Grateful Dead) or as the denial of salvation or conclusion (like the unhappy and bewildered poet Lenz in the work of Büchner). For this reason, my reading would ideally not begin with loops and double circles and go backwards. Instead it would begin with Lenz's failed liberation, which suggests an atheism that has not yet managed to come into the world, and go forward toward the art and thinking of today, both the pessimistic versions and those that theorize liberation, including their respective (usually implicit) philosophies of history.

In his essay on Graham's *Reading Machine for Lenz*, Wall refers to Georg Wilhelm Friedrich Hegel's distinction in the *Science of Logic* (1812–16) between a "bad infinity"—which Wall regards as surviving in Sigmund Freud's "repetition compulsion," Friedrich Nietzsche's "eternal recurrence," and Karl Marx's notion of "surplus value"—and a "true infinity," which in the Hegelian philosophy of history stands for the concrete substance of finite and infinite beings. Infinity is not an empty formal principle, but one related to a specific historical content, a concrete finite being. According to this view, bad infinity would be a loop-like repetition compulsion, while true infinity would be the unfinished state of liberation, which can be conceived in concrete terms and whose content is determinate but whose historical preconditions are not yet at hand. Graham's work *City Self/Country Self* (2000) shows us how amusing bad

infinity can be through the use of a loop that presents a form of class opposition as a timeless antagonism unable to grow and develop into a master-slave dialectic—that is, into full class struggle.

Graham is not simply a Hegelian, however. He is also a great authority on Freud and a great applier of Freud's theories (see, for example, his 1996 work on monetary transactions in the Freud household, *Schema: Complications of Payment*). Thus he confronts Freud with precisely the kind of concrete historical dimension found in Hegel's dialectic of true infinity. In part but not exclusively from a Freudian perspective, Graham is interested not only in the historical conditions of social liberation, but also (and especially) in the individual time of personal liberation, in the birth of the subject and its failure to be born—from a psychoanalytic and a political perspective. He seeks the moment when, to speak optimistically, the subject exits the loops and connects them like two wheels to a bicycle frame in order to move. *In a direction.*

Thus the question of "how fuckin' long" a song can last acquires just as much significance in light of Büchner's *Lenz* as it does in light of the kinds of problems that would have confronted a musician in 1983. As we've seen with the Grateful Dead and Pink Floyd (who also appear on the soundtrack for *Zabriskie Point*), in the late 1960s and early 70s the song had become, in principle, indefinitely long. A musician in 1983 (give or take a few years) would have witnessed how music was then drastically compressed by the punk movement and its allies, who cut the average song back to two-and-a-half minutes.

In Büchner's text, although there are many temporal indicators, they do not yield a continuum. Specific dates are mentioned, phrases like "next day" and "in the morning" stand before new journeys and developments, and evening and night cover the restless spirit. But all of these temporal signposts reside in a vacuum. This is especially clear in the work's first sentence, which merely refers to the day that Lenz wandered into the mountains as "the 20th," while both the English and the French translations purport that the day in question is the twentieth of January. Thus, there is a conscious sense in *Lenz* that the poor wandering poet can only be brought closer to his liberation by that objective external time that stands

opposed to individual time, by a standard format (even if it is only that of the day trip, which was common in his time), just as the compressed songs of the punk movement, which resulted in the pop song being trimmed back to its traditional format, temporarily negated what was perhaps the bad infinity of free improvisation. In its turn, the cyclical recurrence of negations and negations of negation in pop music provides fuel (in my view incorrectly, but that is another subject) for the cultural pessimism of critics who refuse to see the development of the popular arts as development at all, who suspect that this too is only a bad infinity.

As a form, however, the song represents the symbolic possibility of conclusion both in time and with time, and it connects that possibility with real history, in the course of which the song's form arose and evolved. (Graham speaks of this as his special interest.[7]) In this way the song is open on both sides: it brings individual time into relationship with a form, and it brings this form into relationship with historical formats and memory formations. If a song happens to tip over into an endless improvisation or a loop, that is something different than the form that has always harbored a tendency toward the loop. The song is not a historical accident; its form is a collective production. In the nineteenth century, the song emerged as a product of the rural population, especially itinerant farm workers; and in the twentieth and twenty-first centuries it has been a product of youth and countercultures, as well as mainstream cultural industries.

Graham's ten-inch record *Getting It Together in the Country* (especially the A-side) and his mini-CD *What Is Happy, Baby?*[8] (both 2000) are both decisively marked by songs with acoustic guitar accompaniment. But Graham is also interested in the absolute antithesis of that type of song form: those highly artificial genres within 1960s garage punk, 70s disco pop, and above all early 80s new-wave music that often had a futurist agenda. He discovers specific historical forms in precisely these genres. The transition between the artist-as-musician who meditates to the strains of an acoustic guitar (even if he grins laconically as he does so) and the nervous, new-wave persona that plays with sound citations may perhaps be found in the two cover songs on *Getting It Together* and *What Is*

Happy, respectively Traffic's "Feelin' Alright," a hippie sing-along anthem; and the Beatles's "Blue Jay Way," a drug-soaked hymn by George Harrison to the experience of losing one's bearings in Laurel Canyon. In these cover versions, which add new ambiguities to already ambiguous songs, it becomes clear how, for Graham, pop songs—with their ostensible aesthetic of immediacy—actually drag around the undeclared baggage of cultural mediation. This becomes a declared and explicit subject in some of his other musical works.

Like many visual artists of his generation, Graham started out in a band.[9] The UJ3RK5 sounded like a typical post-punk group, the kind that in those years (1978–80) might have been carried by the British Rough Trade label.[10] Lyrics predominate in their songs, and their fast, hectic drums never get "groovy," but often in their nervousness they place a higher priority on the tautological doubling of the singer's emphasis than on building an independent rhythm of their own. Songs produced by bands like these represent a number of hard-fought negations. By negating the playfulness and aimlessness of hippie culture on the one hand and its commercial and bombastic variants on the other, punk had discovered a form that, in a certain sense, reconstructed the song as an authoritative form. An old, traditional form had suddenly become the goal of a movement that in every other respect consisted of fractures and leaps out of history. The futurism of punk and new wave, which the UJ3RK5 also embodied, could only function by means of a purposeful and targeted reference to the past. Only by way of a break with the continuous lengthenings of hippie musical culture and its naïve relationship to seamless and continuous growth could there be history—a past and a future—once again. A song title like "Eisenhower & the Hippies" is only too characteristic, not only of the UJ3RK5 but of the entire philosophy of the new wave of the early 1980s.

In some of his more recent musical projects, Graham emphasizes the limits of historical formats. In his recordings of old and especially new pieces on *The Bed-Bug, Love Buzz, And Other Short Songs in the Popular Idiom* (2000),[11] one is especially struck by the fidelity and precision with which he hones in on a number of now-obsolete conventions that were each fashionable in their

Cover of self-titled EP by the UJ3RK5, 1980

day. The fact that in the ephemeral reality of everyday life there lurks a very special form of eccentricity is one of the essential findings of the album. By definition pop music is specific to its temporal moment, and Graham and his collaborators work to re-create the eccentricities of early 1980s Euro-disco pop and the sophisticated variants of 70s American adult pop (as typified by early Steely Dan), as well as the brilliantly clumsy stumbling of new-wave music—Graham's enduring love—at the turn of the 80s.

Graham has this quotidian and familiar aspect in mind when he says, "The idea that any one of my works, or songs, might remind you of something you've seen or heard elsewhere is basically the highest compliment you could pay me."[12] Against this familiarity and historical signposting, however, there always stands a truly cold and cosmic gesture toward the purely material aspect of the work, even if it is usually a lightly ironic one: for instance, when Graham describes the songs on his *Getting It Together* as "Some Works with Sound Waves" or when he creates a composition intended to outlast the earth and the solar system, namely his *Parsifal*. And precisely such figures as Garcia and John Fahey, to whom Graham alludes in his *Zabriskie Point* work, have at one and the same time taken a special interest in the history of American song formats and their character as the products of historical development (Garcia played banjo in a jug band and Fahey studied American folk and blues) and also worked with extremely unbounded formats. Graham's recourse to the acoustic guitar must therefore also be seen against this backdrop.

Our discussion of folk formats versus other, more open-ended formats would not be complete, however, if we did not confront the issue of time. The former is based on a notion of time in which meaning is derived from the historical processes informing the creation of that format, whereas the latter is marked by individual time, the subject of the endless, meandering solo. On the one hand, individual time is shaped by an internal process that cannot be objectively represented by the concrete objects of music, such as scores and recordings—music's symptoms, as it were. On the other hand, the historical time of an established musical format can be deduced from the historical conditions that brought about its production.

In *How I Became a Ramblin' Man* (1999)[13] a number of these questions are woven together. Graham, with an acoustic guitar, moves about on horseback. For all intents and purposes, he is already a "ramblin' man." This ramblin' man is, of course, a topos of American folklore, appearing in countless blues songs; he perfectly parallels the itinerant young Lenz. On the poster for the German film adaptation of *Lenz* (1972) by George Moorse, who later directed several episodes of the socio-democratic soap opera *Lindenstraße* (Linden Street, 1985), the title appears beneath the famous first two lines of Allen Ginsberg's poem "Howl": "I saw the best minds of my generation destroyed by/ madness, starving hysterical naked." The rebellious, romantic identification of the roaming bourgeois son who has run away by choice with the individual who is homeless by necessity is also a topos of the cultural history of liberation of the last 250 years.

From Lenz to the beatniks, bourgeois sons have often identified with itinerant laborers at precisely the moment when they leave their sheltered childhood in the parental home for the first time.

Between these two versions of the ramblin' man, however, Graham interposes a process of "becoming." A wandering journeyman of one kind or another is something one must become, whether because of inner repetition compulsions (or attempts to break free of them) or because of the social motivations that cling to bicycles, song formats, or guitar strings. The title *How I Became a Ramblin' Man* stands in contrast to "I was born a ramblin' man" (1973), a lyric from the song "Ramblin' Man" by the Allman Brothers Band, an influential 1970s Southern rock group. One is not born a ramblin' man, Graham implies. That position can only be maintained by the blues-rock of a band like the Allman Brothers, in which the blues have been dehistoricized and decontextualized—appropriated, naturalized, and finally asserted as white Southern rock.

But how does one lay hold of the internal dimension of the process of becoming a ramblin' man with a horse, a guitar, and a tradition? How does the visual artist show the invisible and unobservable internal time of the soul and music? I have already suggested that merely observing a musician performing constitutes the visual manifestation of an internal musical movement. It is overlaid, however, by the successfully externalized, structured time of the mastered internal musical material. At various moments in the film *Zabriskie Point* we see hallucinations and external projections of internal mental images, which are most often associated with a particular music. This metonymic strategy has evolved into a cinematic convention for representing internal, mental processes: in order to show the internal execution of music, I as the director show something else that, I suggest, is executed internally—visual associations, hallucinations, dream images, etc.—and I play music at the same time.

The difference between *Zabriskie Point* and other contemporaneous cinematic narratives of introspection is the success the film had with its images of ostensibly musically induced internal associations and the relationship created between internal and political images. This "making public" of the internal process of cognition, and the purposeful manipulation, control, and above all deconditioning of that process under the aegis of the political represents an essential aspect of the psychedelic movement—especially its political wing, as expressed in the writings of Ginsberg and Robert Smithson.

Another artist, Hans Peter Feldmann, whose work has been rediscovered in Germany, recently related that, over a period of time, he consistently photographed the radio/tape deck in his car when he especially liked the music that was playing. As a photographer, one relies on the visual index even when reality is offering something invisible, like music. Graham, by contrast, simply increases the interiority, unobservability, invisibility, and intensity of that which eludes observation. What is more, he heightens the anticipated deviation of internal, individual time with respect to every measurable, objective temporality. How does he do that?

In the film portion of *The Phonokinetoscope*, Graham takes LSD in front of the camera and rambles—this time on a bicycle—through the Tiergarten in Berlin. He has a thermos with him, and he spends a lot of time contemplating details of nature, as one tends to do on LSD. The decisive aspect of the film, of course, is the fact that its lead actor is under the influence of a hallucinogenic drug. However, that fact is invisible. We can only take it on faith, supported by the facial expressions, states of concentration, physical attitudes, and, ultimately, the music. The film's installation includes a record player and a vinyl record containing one of Graham's own somewhat clichéd songs, a loving reconstruction of 1970s psychedelic rock. Graham captures the beauty of the music, which, unlike the psychedelic rock of the 60s, is not usually regarded as beautiful but rather strange, overambitious, and clumsy—qualities Graham captures as well.

Rather than try to find visual metaphors for the sensations that occur on LSD, Graham contains them in his head without revealing them to the viewer. One might argue that he does the opposite of Antonioni, for example, who shows a house exploding from different perspectives, one after another—its treatment suggesting the fulfillment of one character's wishes. The temporal disorientation that Graham is presumably experiencing is not even

hinted at. Time, for the artist on LSD, is not structured in a comprehensible order, nor does it follow a logic that can be communicated; it is individual time. Like some of his other cinematic projects, Graham seeks to show something invisible. This is reinforced by the fact that, as an artist working in film, he does not assume the role of director, but instead becomes the producer and lead actor. The director, he points out, differs from film to film.

In this way Graham abandons the auteur theory, which has historically represented the convergence of art and film, in favor of an older model of production used in prewar Hollywood movies. In his capacity as actor, he actually induces the required hallucinations, instead of manufacturing them through acting technique. This is only logical, as hallucinations are unique to the person experiencing them. He functions the same way in *Halcion Sleep* (1994), albeit under the influence of a different drug. As is the case with certain Method actors, Graham is not *representing* the effect of the drugs, he *is* the effect of the drugs.

The artist Mathew Hale, who assisted Graham during the filming of *The Phonokinetoscope*, has noted various historical and contemporary connections between Graham and psychedelic rock music.[14] He compares Graham to Syd Barrett, the legendary founder of Pink Floyd who embarked on a solo career after one and a half albums and vanished soon thereafter apparently due to serious mental disturbances caused by psychedelic drugs. Throughout *The Phonokinetoscope*, Graham pays homage to Barrett. Besides the film, the installation also includes a record player whose tone arm the viewer may set to play a composition that borrows a lyric from "Bike," one of Barrett's best-known songs with Pink Floyd. "You're the kind of girl that fits in with my world" is both the refrain and title of Graham's pastiche.

Though Hale does not mention this, Barrett can be seen as the Lenz of recent pop music in that he is both a real artist and a mythologized figure. (However, the mythicization of Barrett has taken place during his lifetime, whereas Lenz was mythicized posthumously by Büchner.) Graham makes use of these two figures in the knowledge that such legends make a comfortable intertextual net. One can draw from them at will without taking them too literally. However, neither Barrett nor Lenz had legends to fall back on the way Graham does. Both young men constructed their legends from scratch, as it were, and ended up failing tragically.

Graham's work seems to suggest that it is possible to exit such a doomed Oedipal cycle by way of the eternally youthful, up-to-the-minute language of pop music. (Perhaps this is what Graham is talking about in the song "Music for the Very Old" on his 2003 release, *Rock Is Hard.*[15]) For Adorno, jazz was a "Perennial Fashion" and therefore related to eternal recurrence. Graham reverses this proposition when—precisely by means of the aggressively temporal and transitory nature of the musical formats he has adopted—he leaves the eternal now in which Fahey and Garcia lived and looks back. And he does so, for once, in temporal categories that can actually be lived, beyond eternity and eternal repetition. That is precisely how fuckin' long a song can go on.

Translated from German by James Gussen

1: When music is ontologically immaterial—as in several philosophies of music—a recording or a sheet of music are merely symptoms of a process that actually happens elsewhere, on another level, in another ontologically different order.

2: For example, by Anthony Spira, "A Cycle-logical Journey," in *Rodney Graham*, exh. cat. (London: Whitechapel Art Gallery, 2002), 93–101; and by Michael Glasmeier, *Loop — Zur Geschichte und Theorie der Endlosschleife am Beispiel Rodney Graham* (Cologne, Germany: Salon Verlag, 2002).

3: Glasmeier, *Loop*. The complete text of the motto from Moritz reads: "The repetition of the beautiful does not cause surfeit or disgust, but increases its charm for the person who has begun to discern the trace that is present in it, and who pursues that trace every time it presents itself to him."

4: "Lot of Knocks," in *More Music for the Love Scene, Zabriskie Point*, in Graham, *Getting It Together in the Country — Some Works With Sound Waves, Some Works With Light Waves, and Some Other Experimental Works*, 10-inch record and catalogue (Munich, Germany: Kunstverein; Münster, Germany: Westfälischer Kunstverein; Berlin: Künstlerprogramm/DAAD; and Cologne, Germany: Oktagon Verlag, 2000).

5: Presumably Graham gleaned this information from the same expanded, double-CD edition of the soundtrack (with additional recordings and notes) that I possess. *Zabriskie Point Original Soundtrack Plus an Entire Disc of Newly Discovered and Unreleased Material From Pink Floyd and Jerry Garcia*, Rhino Movie Music compact disc set R2 72 462, 1997.

6: Jeff Wall, *Dans la fôret: Deux ébauches d'étude sur l'oeuvre de Rodney Graham* (Brussels: Emile Van Balberghe Librairie, 1996).

7: See Graham and Matthew Higgs, "A Little Thought," in *Rodney Graham*, 75–83.

8: Produced by Lisson Gallery, London, 2001.

9: For example, among many others: Mike Kelley, John Miller, Tony Oursler, Stephen Prina, Albert Oehlen, Markus Oehlen, Jean-Michel Basquiat, and, with Graham, Jeff Wall.

10: The UJ3RK5 released one four-track EP titled *UJ3RK5* on Polydor Records in 1980.

11: Produced by Dia Center for the Arts, New York, and Graham, 2000.

12: Graham, in Higgs, "A Little Thought," 82.

13: The lyrics and score of the song for the projected film installation are reproduced in the liner notes to *Getting It Together in the Country*, 14–15.

14: Mathew Hale, "And I Am Wondering Who Could Be Writing This Song," *Parkett*, no. 64 (May 2002): 116–24.

15: "One more round of this and I'm bound to lose control / Life is so unfair, then you fall into a very dark hole / Seems I slipped / When I lost my tourniquet grip / And no one ever said things will change / It will always always be the same. / It's high time my very last cent was well and truly spent: / Income versus outcome that's my predicament. / At long, long last, after all these years / The shocking truth can be told: / This is music for the very very old." From "Music for the Very Old," on Graham's self-produced *Rock Is Hard*, 2003.

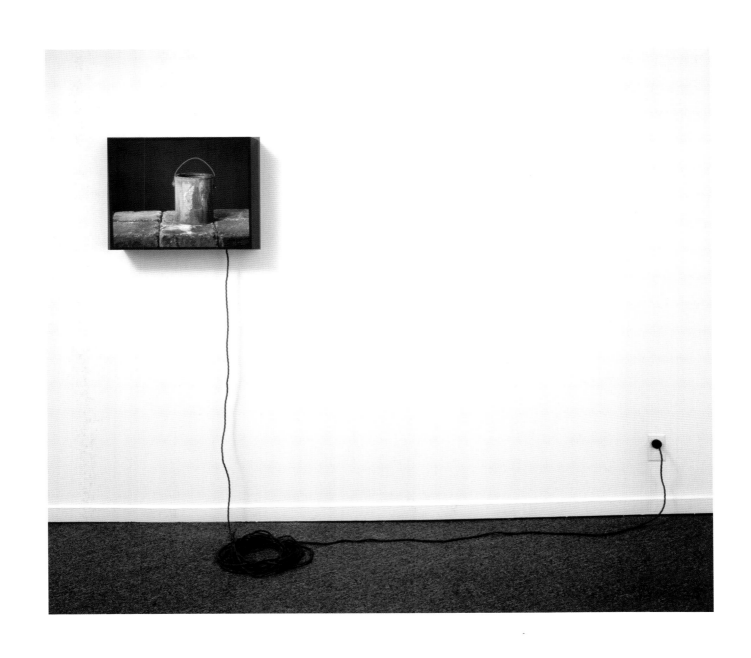

Can of Worms, 2000
Color transparency mounted and sealed between two-ply
Plexiglas in aluminum light box with walnut surround
and aged silk electrical cord
Light box: 56.4 x 46.9 x 10.1 cm (23 x 18 1/2 x 4 3/4 in.);
edition of 10

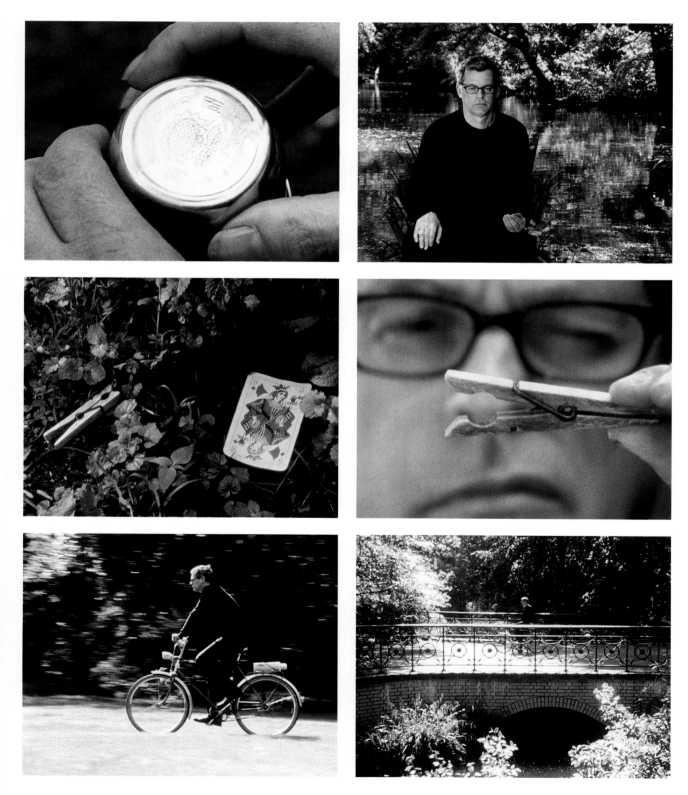

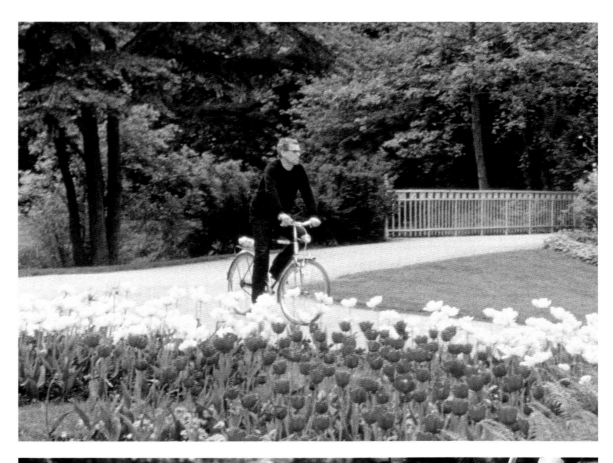

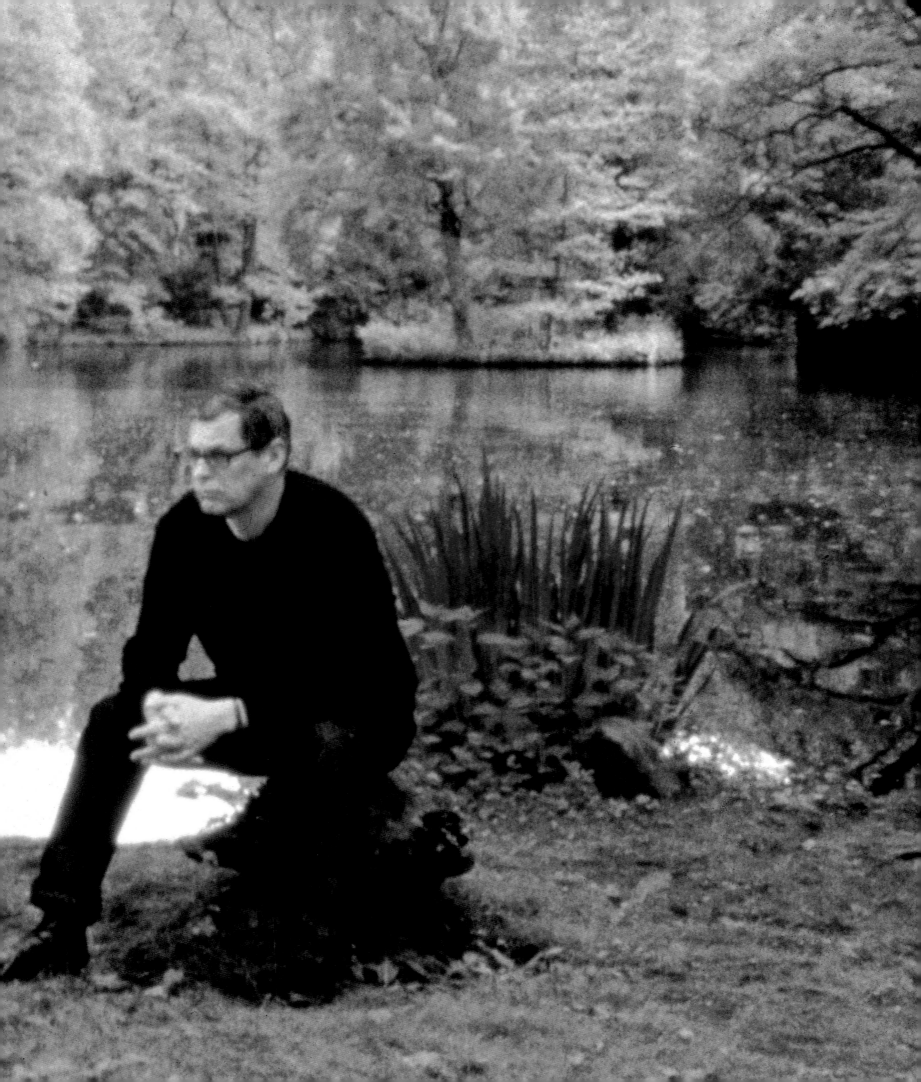

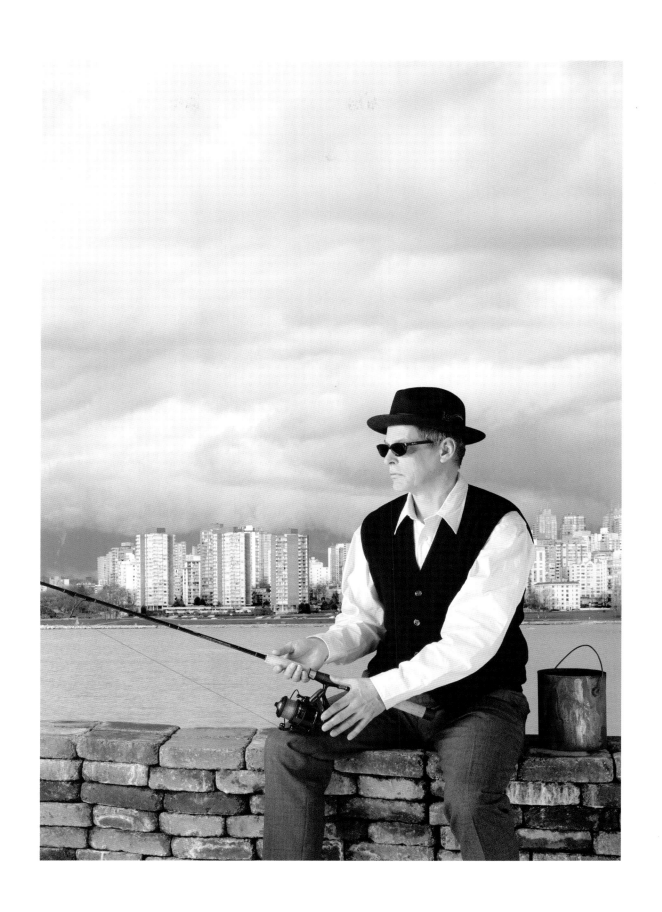

Fishing on a Jetty, 2000

Masks from *City Self/Country Self*, 2000

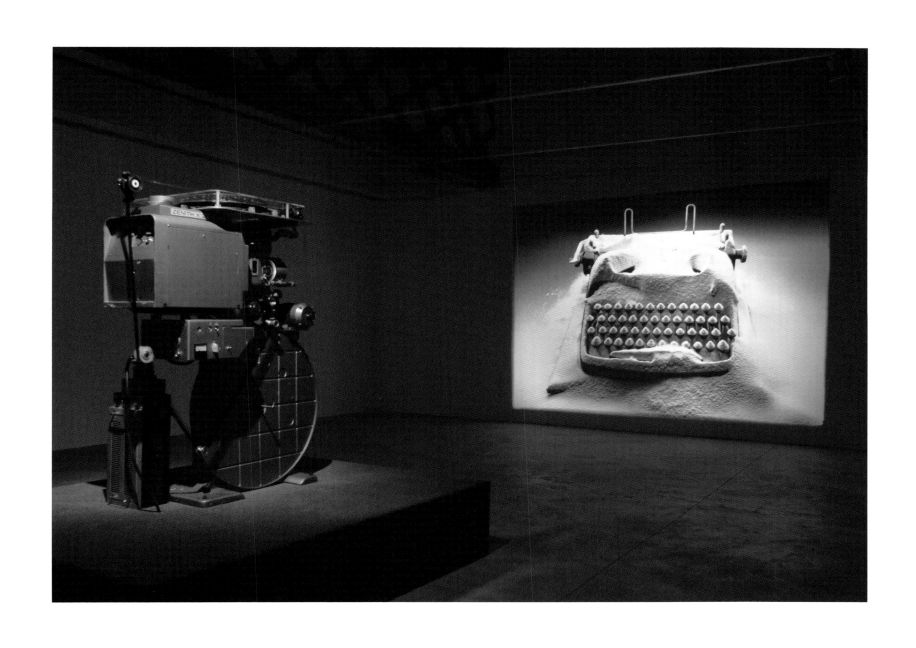

Rheinmetall/Victoria 8, 2003
Installation, Donald Young Gallery,
Chicago, 2003

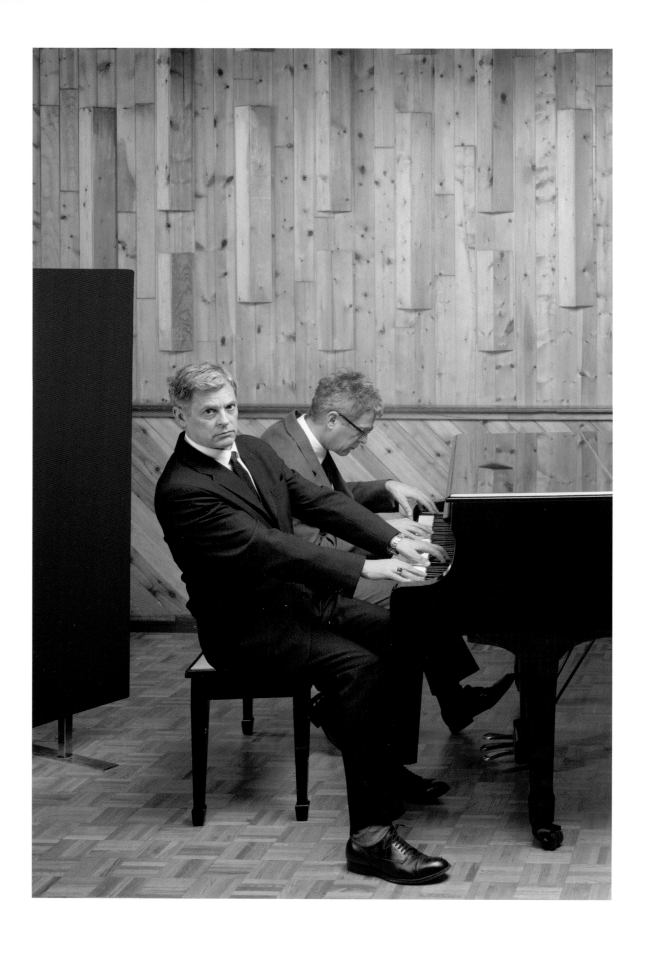

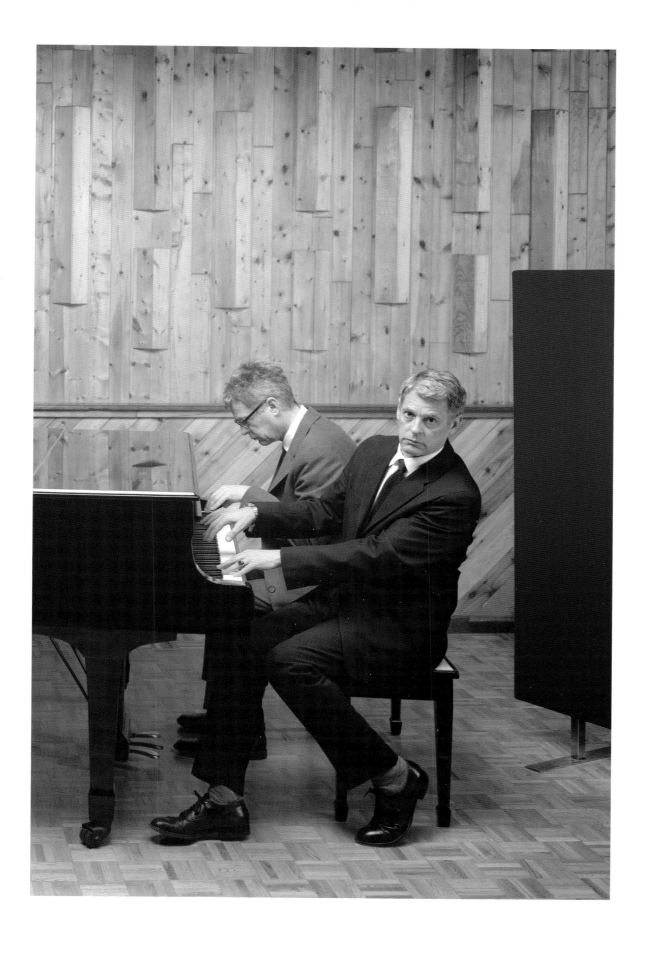

Fantasia for Four Hands, 2002

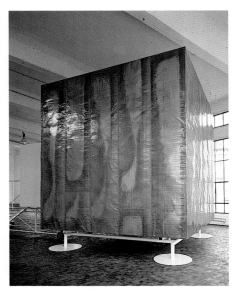

The King's Part, 1999
Anechoic chamber, painted metal staircase, and sound equipment
550 x 1050 x 400 cm (216 1/2 x 413 x 157 1/2 in.)
Collection Sammlung Hauser & Wirth, St. Gallen, Switzerland
Installation, Sammlung Hauser & Wirth, 2001

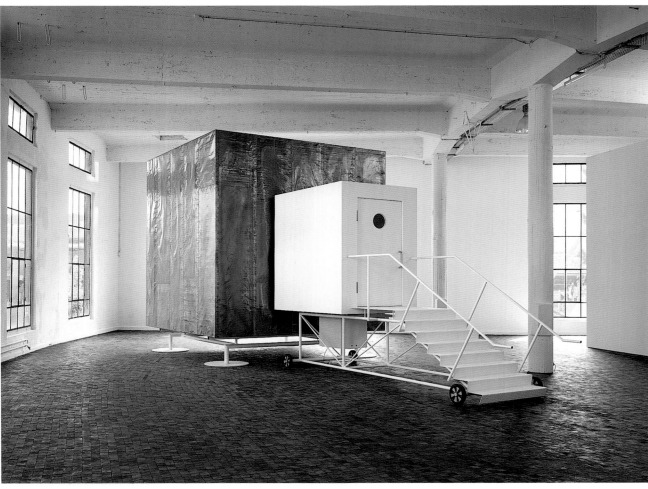

Production still from *How I Became a Ramblin' Man*, 1999

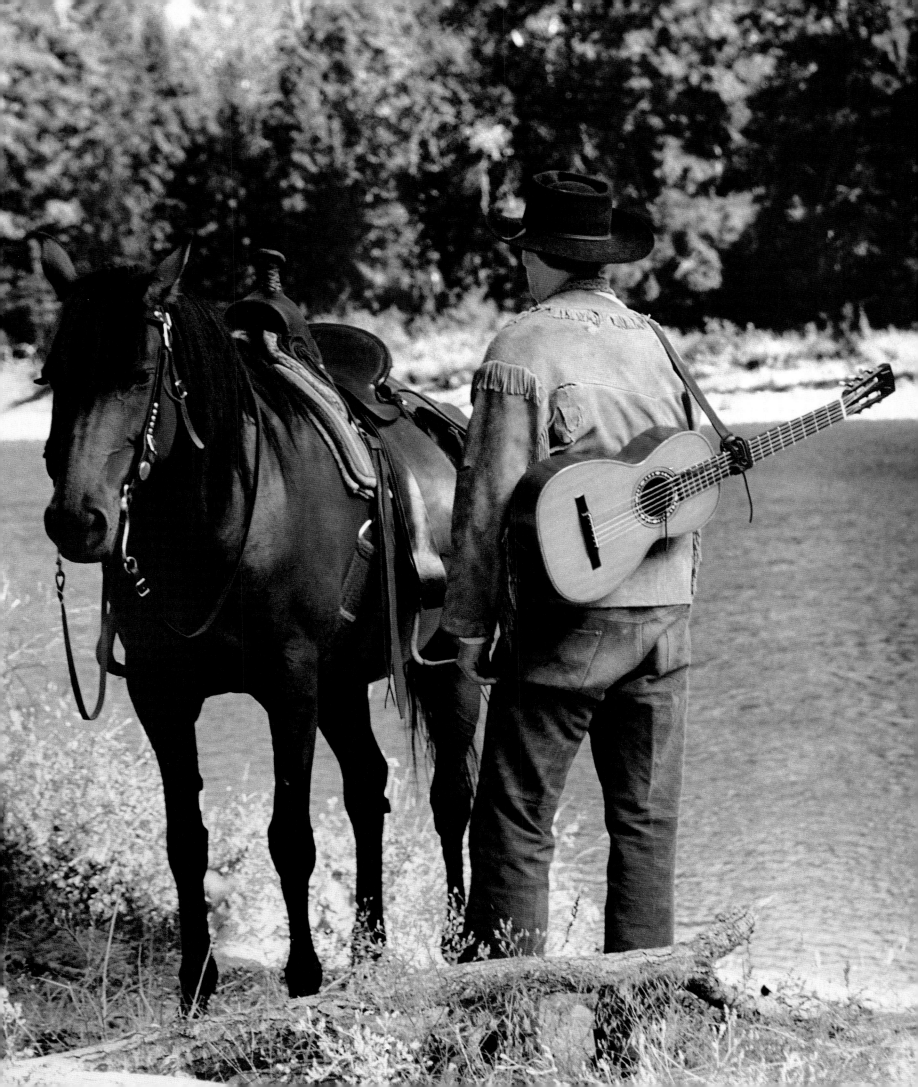

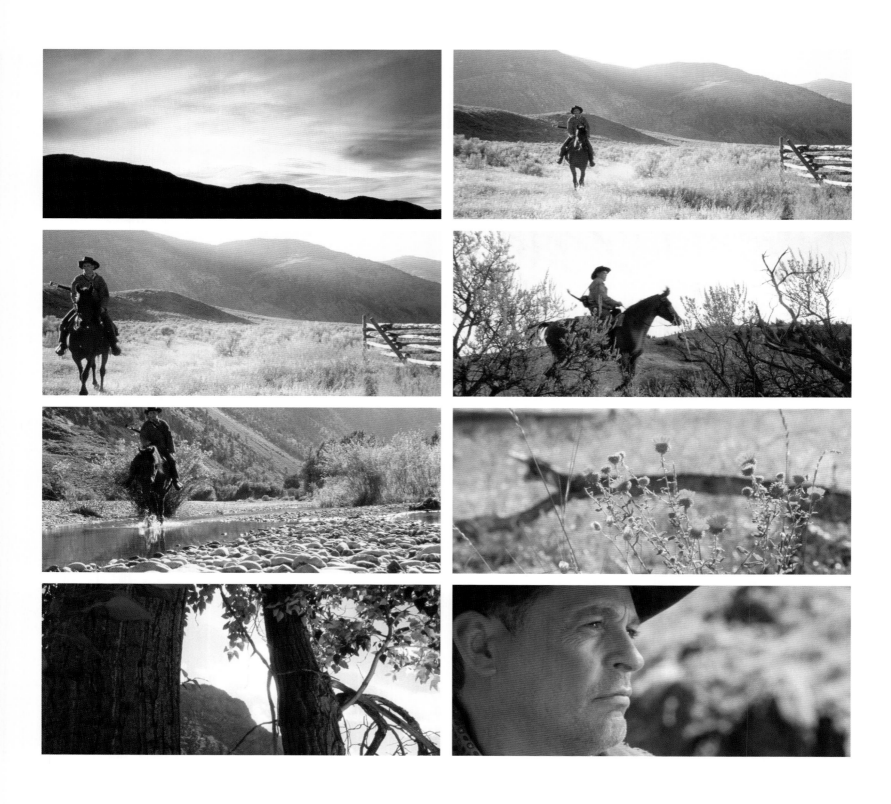

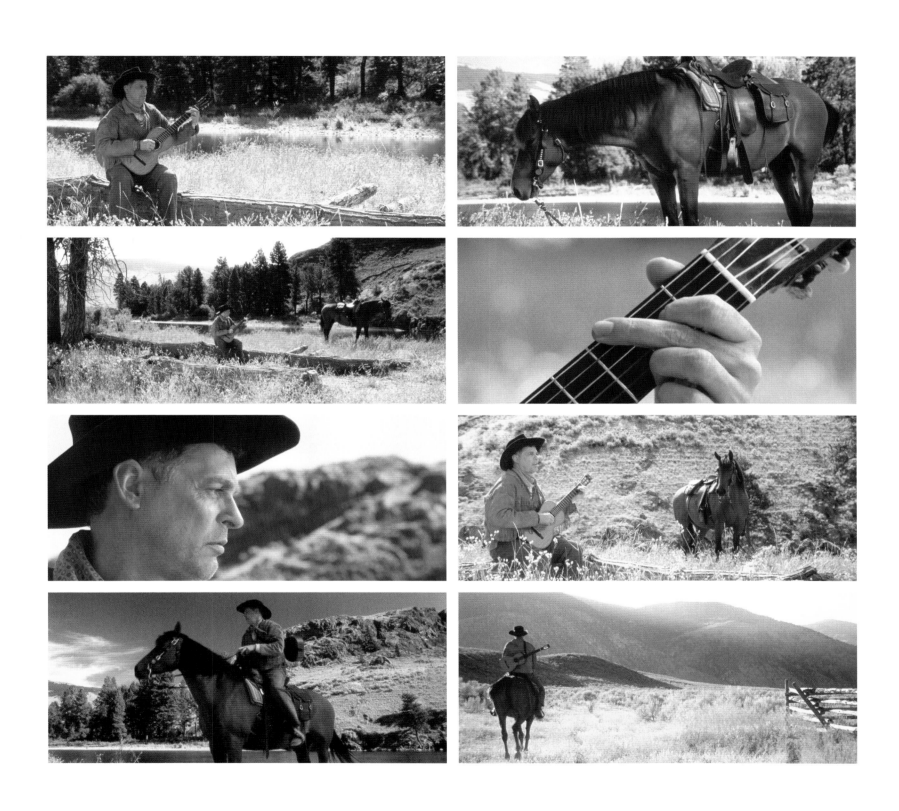

Stills from *How I Became a Ramblin' Man*, 1999

Anomalies of the Phenomenal:
A "Close" Reading of
Rodney Graham's Joke Works
by
Shepherd Steiner

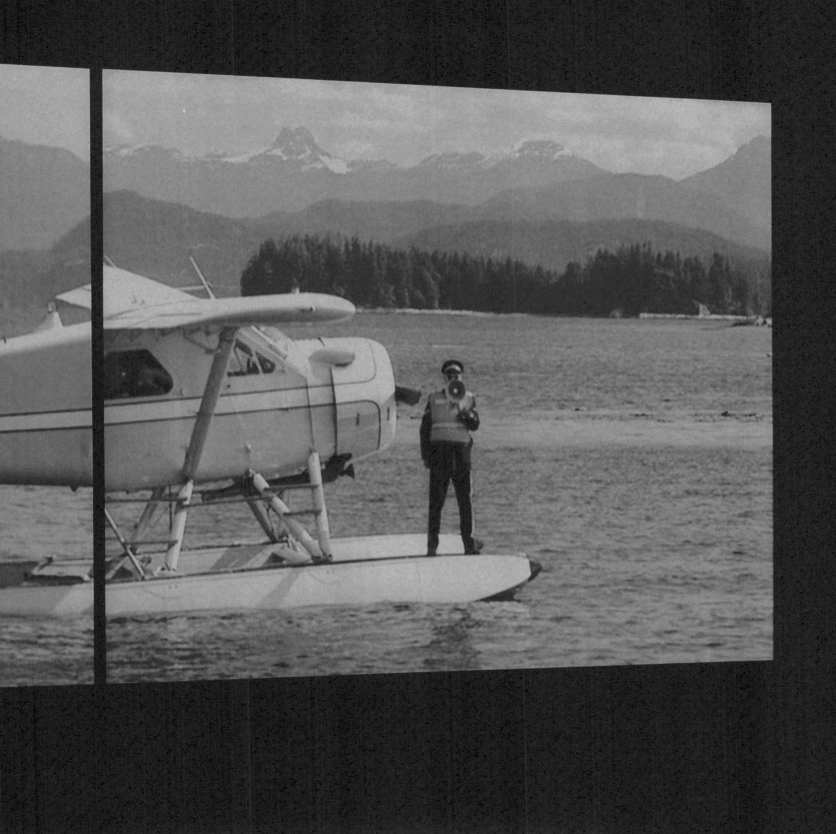

It's hard not to like the work of Rodney Graham. One becomes as friendly and intimate with it, as quickly and easily, as another finds it critical and detached. Production values are high. Sublimation is palpable. Elevated topics, detailing (of costumes, say), finish, and formal and linguistic concerns (whether specific to the bookwork, the perfect pop song, or the harmonic motion of the looping video) are all paramount. All of Graham's works are dashed off in exquisite and effortless style. There can be little doubt that one is in the presence of a chaste and unsullied aesthetic. But, as I said, one also finds human interest here, and all-too-human worries. Under the thinnest of veils one finds Graham singing of his hopes and sorrows; recounting his fantasies and dreams; revealing his obsessions, dependencies, youthful enthusiasms, and curiously high-minded intellectual pursuits. It's all so personable and relaxed it is easy to forget that one is in the presence of art. Graham's works have the appearance of second nature about them. They are so accomplished that they seem made without a hint of pretension, an ounce of unnecessary thought, or even a moment of labor lost. Such are the pleasures of the work: few will not find something to their liking here. For myself, the pleasures of both critical detachment as well as close and intimate company are precipitated more than anything through the joke: a joke whose nature is in the main autobiographical is transferred to the work through a kind of ventriloquism, comes off with a manifest ease and charming delivery, and has the perfectly desired effect of the humorous icebreaker, allowing conversation to flow and dialogue to begin in earnest.

 I laugh at Graham's work. More to the point, I laugh at Graham's work through the optic of what seems the very materiality of his own experience. The humor is varied. I laugh at Graham's mystified self, deep in the clutches of illusion and dream in his video performance *Halcion Sleep* (1994); and I laugh at this self-portrait along with Graham's awakened or enlightened self, an authorial presence that seems to observe the whole performance from the driver's seat. At times, say in the slide presentation *Aberdeen* (2000), the humor is slack, spread out across the work as a whole as if conception itself was the idea of an adoring fan while execution was left to a technician of the documentary school. In *What Is Happy, Baby?* (2000), Graham's third album of popular music, I can't help thinking that the convention of the love song and the venerable tradition of the concept album (I'm thinking, here, of the Beach Boys album *Pet Sounds* [1966]) is turned into a platform for thinking "the disenchantment of the world" and something like Stendhal's "promesse du bonheur."[1] At other moments, say in the costume pictures *Vexation Island* (1997) and *City Self/Country Self* (2000), the humor is pointed, self-deprecating visual slapstick that is hard to miss[2] and hard not to see through the eyes of a seasoned producer, who knows exactly how to build and focus narrative tension for a laugh. At other moments still, the humor is educated, refined, and, as with the previous works mentioned, nothing if not self-reflexive.

PREFACE TO READING

Take *Reading Machine for Lenz* (1993), an elegant work that seems to stage the whole question of close reading. Three typeset pages—the first fixed in place and the latter two encased back-to-back in a revolving plate—contain a section of Georg Büchner's novella *Lenz* (1838). When one moves in close enough to read this looping supplement, one feels as confused and implicated in the wild emotions of its protagonist as much as oddly detached from the whole affair. One is simultaneously in the grip of Büchner's version of Young Werther yet somehow distanced from it all, as if one were occupying Graham's own critical perspective on its author, his character Lenz, and the Sturm und Drang movement itself. Framed by the reading machine,

Lenz, 1983
Clothbound book with slipcase
22.7 x 15 x 3.5 in. (9 x 6 x 1 in.); edition of 10

one's perspective of the text is refracted though the eyes of something like the fastidious scientific objectivity of a nineteenth-century philologist, but in as much seems blinded to the hypnotic trap of the former's empiricism and epistemological certainty. The apparatus turns, and given that it is no longer the fashion to wear white gloves, one gently pushes on a diminutive felt pad: this to ensure that one's fingerprint is not left on the metal in rotating the frame from verso to recto and so on into infinity. It is intended that one read, and read closely, after all.

Expectations are high: concentrating is difficult; one scans, looks ahead, at best reads for what Graham describes in his "Artist's Notes" as the "two occurrences of the phrase *through the forest* in mutually compatible grammatical contexts."[3] It feels ever so slightly like a test of endurance, but the moment comes and passes effortlessly by—as if nothing has happened at all. And so one continues: once again ascending to the "snowy summits" and descending back down to the fictive valley, the happy company of Pastor Oberlin, the night, and Lenz's madness once more. Clearly a precursor of Graham's looping film works, this is the thick of an endless repetition that has since become one of the hallmarks of this artist's work. Whether turning Graham's reading machine is done in fear that something was missed—that some crucial detail to the plot, which would ally one, once and for all, with the illusive intentions of its author, was skimmed—or in hopes that in going back over the same terrain one will recognize the whole episode as affected and possessed of an overly romantic sensibility, is uncertain.

I take the key point of *Reading Machine for Lenz* to hinge on this uncertainty itself. Positioning the viewer in the uncertain region between the rhetorical registers occupied by Graham the post-Conceptual artist and his assumed persona as bedeviled Romantic narrator is the work's humor: humor in the most refined sense, at its most subtle and in the high tradition of Søren Kierkegaard, Friedrich von Schlegel, Stendahl, E. T. A. Hoffmann, and Charles Baudelaire. But be under no illusion of interpretative correctness here, this is slippery stuff, and more often than not the voices shift about, lay over other expectations, other sensations, other types of parody (there is the problem of the translation by Carl Richard Mueller, for instance), other ways of conjuring meaning from the work—a multitude of possible anomalies that are able to stand for the phenomenal question of reading.[4] For example, if one is drawn into the narrative and identifies with the fictional voice of Büchner, one does so to look for the furtive textual suture that will reveal Graham's hand, intentions, labor, and intellectual effort. Such signs of practice are not forthcoming. And so one goes over the passage again and again in an effort to pry apart stylistic parody from the original. Certainly "through the forest" is there, plain as day, but it turns out to be such a non-event—such a perfect mirror of having done absolutely nothing—that Graham's careful reworking and resculpting of the supplement is virtually displaced, hidden, blurred: completely confounded by the difficulty (pleasures) of turning to read.

An earlier version of the work, *Lenz* (1983), offers an interesting comparison. For what was once a cultivated

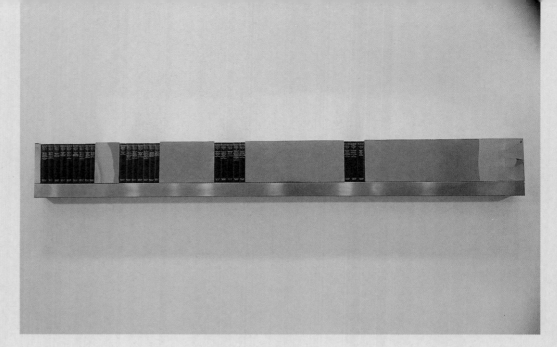

Standard Edition, 1988
Stainless steel, brass, and books (Sigmund Freud's
*Standard Edition of the Complete Psychological
Works*)
30.7 x 15 x 261 cm (12 x 6 x 103 in.); edition of 3

fetishism for the occupational minutiae of the Republic
of Letters and the "para-textual" apparatus of books has
disappeared,[5] or at least been reconfigured in the later
work. If *Reading Machine for Lenz* is a good example of
the importance this artist places on concealing the effort
involved in stylistic parody, his bookwork from ten years
before, *Lenz*, admits slightly more. This 336-page cloth-
bound book with slipcase makes clear that the supplement
hinges on very precise questions of typesetting, the folding
of folio sheets, the arrangement of a signature, and the
interleaving of other signatures. Of course, Graham's
specialized knowledge of bookmaking all comes off as if it
were at his fingertips, as if learned from long experience,
but again this is part and parcel of the Graham effect.
For if and when labor is revealed, it is typically rendered
transparent through the "mimicry of performance"[6]:
in this case a performance as distinguished bookmaker
or bibliophile, à la Yves Gevaert perhaps; in the case
of *Reading Machine for Parsifal. One Signature* (1992),
a "mimicry of performance" that hinges on a different set
of variables, word plays, genres, languages, etc. Mimicry
aside, Graham's Reading Machines should also alert us to
the very personal nature of Graham's use of irony, one that
is rooted in the grand tradition and shares some affinities
with other artistic practices in Vancouver, but that finally
stems from his peculiar tastes and how these insinuate
themselves into the idiosyncrasies of the practice.

This said, it should be emphasized that "practice"
is itself somewhat of a dirty word in the context of
Graham's oeuvre. (Within the genealogy of the *Lenz* works,

the teasing out or further opening up of an extant ironic
distance and the veiling of effort therein is a trace of this.)
Facility with language (and across a fairly dazzling
spectrum of languages) sublimates and elevates, gives
each work the appearance of natural beauty, a kind of
seamless thinking or enlightened self-knowledge that
springs directly from the body or imagination, much as
a flower from seed or root.

Certainly there is evidence to the contrary. The
insistence on autobiography; the recurrence of the joke;
a concern with repetition (in the Kierkegaardian sense:
see *Five Interior Design Proposals for the Grimm Brothers'
Studies in Berlin* [1992]); the presence of both visual
and earmarked thematics like blinding and seeing stars,
phonicity, melomania (an excessive attraction to music),
and listening (say, *The King's Part* [1999]), all carry the
vague suggestion of an intentional practice about them.
But they can go either way: they might be symptoms![7]
On firmer ground is the way in which Graham takes on
new projects in diverse media: he gets better at things,
and he is quite happy to show himself doing so. He
practices his guitar, openly admits to the difficulties of
writing lyrics, and over the course of time gains facility
with songwriting, finds his voice, earns a certain presence
on stage. If his facial expressions are slightly put on in
Vexation Island, his gestures are absolutely transparent
four years later in *The Phonokinetoscope* (2002). *Perhaps*
the signs of intention, but one has to admit that this could
be part of the artistic persona as well: that of a quintes-
sential dilettante eager to learn a new craft for the sake

Study for *Freud Supplement (170a–170d)*, 1989
Pencil on paper
38 x 25 cm (15 x 10 in.)
Archives Yves Gevaert, Brussels

of experience. But then, you say, what about the very intentional crafting of the corpus as a whole? It is such a perfectly closed and self-referential system that each work seems to orbit in perfect harmony with the others. In fact, each work is underwritten by the entire corpus to such an extent that reading any one unique work seems to mean reading it off or against the body of work as a whole. New work assumes significance without upsetting the balance, finds completion in extant works from the oeuvre, and it all revolves around the signature, face, touch, or presence of Graham. To which I respond in turn: autobiography, the close connection between art and life.

These qualifications aside—all of which turn out to be either/or events—allow me to focus on the question of Graham's constant authorial presence, as well as the existence of a rather more facile narrative effect. In looking at this body of work, I am constantly letting Graham's critical eye vigilantly guide my entrance to each of his works while I let the little mimic in him do its act.

Again, allow me to state it once more in order to focus my argument: all signs of intention are blunted, blurred, or contraindicated in one way or another by a pervasive sense of autobiographical effortlessness and ease. Look at *Jokes/Case Histories* (1988). It seems as if a copy of Sigmund Freud's *Jokes and Their Relation to the Unconscious* (1905) has been casually slipped into a Donald Judd sculpture that just happened to be at the right place, at the right time—waiting as it were to double as a handy shelving unit. Of course, there is an implicit acceptance that nothing of the sort has happened.[8] As in the case of the impressive

steel housing of *Standard Edition* (1988)—another Judd parody built to exacting specifications, indeed purposely built to shelve *The Standard Edition of the Complete Psychological Works of Sigmund Freud* (1953)—along with Graham's own *Freud Supplement (170a–170d)* (1988)—an object study on monomania that took Graham away from his art for two years[9]—the Freud is in careful, scrupulously detailed, point-for-point dialogue with the Judd. Even if the personalization of Judd's cold objectivity through the juxtaposition of Freud's *Jokes* or, conversely, the objectification of one of Freud's most autobiographical works through Judd is made to order, it still comes off as a harmless accident of nature. In making sense of this work, I just cannot get rid of a lingering image of the artist's studio: overflowing with books, the only shelf space left free for yet another edition of the *oeuvre Freudienne*, one of a number of Juddian pieces that simply lie about.

I come away from Graham's work time and again with the feeling that the art flows directly from a life lived, even if I know full well it is not the case or the complete story. I believe that film works as different as *How I Became a Ramblin' Man* (1999) and *The Phonokinetoscope* are both anecdotes taken from experience: that each is a unique, idiosyncratic joke that stems from a real episode in Graham's life. I believe that the perfect repetition of each—something that has by now assumed the status of a signature style—is nothing out of the ordinary for this complete and quintessential man of reason and nature. With respect to the accidental cut to cloudy sky that rounds off *Ramblin' Man*, the looser montage-like storyline of the

never-ending trip in *The Phonokinetoscope* that is put to a similar purpose, or the textual suture of *Reading Machine for Lenz*, I am reminded of Northrop Frye's definition of literary creation: "an activity whose only intention is to abolish intention." [10]

Of course, the organic connection between mind and body is a carefully crafted illusion that has its purpose —at least as important a purpose as stylistic virtuosity. In tandem, these two poles of Graham's works galvanize both an interpersonal response and a connoisseur's delectation with language; two types of "close" responses in which the tension between Graham's personas can be shown, if handled delicately, to go on to break. For the high-minded among us and within us, it is worth remembering that the close reading of the analytic gaze need not fall cleanly on the side of cold empiricism every time: the genuine concern of someone close who cares is at least as relevant, is always bleeding into its other, is invariably underwriting the former. What we are dealing with is a palimpsest-like structure in which the appearance of critical detachment consistently lays over top a warm feeling of camaraderie, friendship, and community. In fact, over the course of thirty odd years, Graham has staked out the limits of a practice that blends an odd mixture of autobiographical fact with the technical mastery of a positively dazzling variety of genres and languages, through and within which he is able to plumb the truth claims of each. In Graham's work, the truth of the medium (whether photography, film, video, sculpture, painting, text, or music) goes head to head with the "sincerity" of an autobiographical voice.

Given the potential for a rather lethal interpretative stalemate here, one that could amount to a cessation of critical dialogue between the work and the viewer, we would be wise to broaden our notion of what close reading in the face of Graham's work actually is, or entails. The work of Paul de Man is helpful: under the umbrella of "autobiography," one of two master tropes for this literary theorist, we can describe each type of close reading one encounters in Graham's work as a "figure of reading"[11] in which the dynamics of narrative are mistakenly identified with the contractually binding truths that either a delectation with language or an empathic projection with

persona entails. In Graham's work humor and irony turn on a fulcrum constructed here. And the here and now of here—the here and now of how narrative impels one to interpret or paraphrase Graham's mimetic behavior, or conversely the way in which the presence of the same work implores one to respond to Graham's use of language —is the joke. The joke, then, is both an obstacle to deep thinking and a moment wherein the analogical relationship between art and life can potentially be cracked open, or at least inched open in order to glimpse the trace of practice.

Take *How I Became a Ramblin' Man*, the second in Graham's trilogy of costume pictures, but for all intents and purposes a country-music video with a dim echo of the pacing and narrative hypertext of Michael Jackson's *Thriller* video (1983). Music seems merely an excuse to tell the story of an old cowboy who comes and goes and comes back again. Admittedly, I laugh for different reasons. If one does not have the patience for this ten-minute-long video, then knowing it is Graham playing Hank Williams is probably enough. Those with itchy feet can turn away satisfied in the knowledge of having got the joke: the artist has once again slipped chameleon-like into another role. However, if one sits through it all, the joke grows, doubles, mounts up to a height of twenty hands— and from this high horse who wouldn't chuckle at the abrupt cut to sky? It covers, the joke covers, a world of indiscretions and a multitude of sins. Given the pokey pace of the whole, this fast cut is as much a caricature of fine editing as it is deployed as a knowing device that allows for a negative moment of imaginative return, for the loop to begin again and ramble off into infinity.

So I find myself chuckling at the sudden break in tone that marks *Ramblin' Man*'s cloudy edit, laughing at *Vexation Island*'s bump to the head, smiling to myself at the textual knitting point of *Reading Machine for Lenz*, because I have the feeling I am laughing along with Graham, laughing at himself. In sum, I laugh at Graham's work because there is the sense that he, too, at one time or another had skipped "through the forest" unaware, and that he himself thought this cause for laughter. Ultimately, I laugh at Graham's work because imitation proper (mimesis) always manages to worm its way into simple narrative (diegesis).[12] In as much, a close reading of

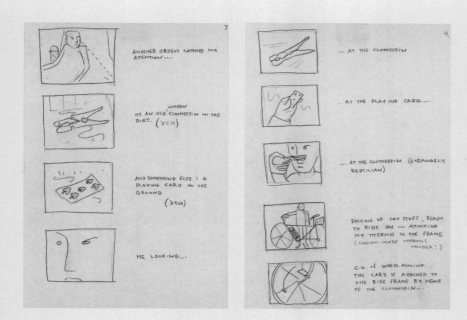

Studies for *The Phonokinetoscope*, 2002
Pencil on paper
21 x 28 cm (8 1/4 x 11 5/8 in.) each
Collection of the artist

Graham's joke works is a performative reading, repeating, or retelling of his jokes.

PERFORMING READING

Take *The Phonokinetoscope*. Narrative flows like a daydream. A series of perfectly parceled associative sequences seems to drift by as if untouched by human hands. How to describe it? Absentmindedness isn't exactly correct, but close. (I am thinking of the way the five-minute, 16-mm film loop always manages to fit perfectly with the fifteen-minute song on the vinyl record accompanying it, *whatever* the timing between the two.) No, it feels more like this patient's dreams and unconscious life are at or near the surface. Comparison is revealing. The sheer effortlessness of this work makes an early film like *Two Generators* (1984) seem a rather deliberate and dryly intentional exercise. In fact, in place of the sharpness or *willful thinking* of *Two Generators*—where illumination mechanically corresponds to cinematic projection—*The Phonokinetoscope* is shot through with the pointlessness of *wishful thinking*. (I leave out the bewilderment and singling out of the spectator that an actual projection of this raises for the viewer's own interpretative ["read" psychoanalytic] tact for now.) Soothingly paratactic is how I would describe it. I write myself into this narrative as a dream unfolding. I fixate on a string of loosely connected images. It's summer…there are flowers…Graham sits beside the bike…he takes the tab…it looks as if he has been told to put his hands in his lap…he concentrates on the clothespin…he reaches for the playing card…the music is wild…a capital F floats by…

he stares death long and hard in the face…ever so briefly, he rides his bicycle as if against time, facing backward, like the angel of history.

The spectacle of marginal details paraded out while Graham sits on the bank of the idyllic pond alone is especially salient. Even if touched or graced with the consistency of "salmon mayonnaise"[13]—Freud's joking analogy for the processes of dream displacement[14] and condensation[15]—there is a kind of narrative drive here. At first I thought it deeply simple-minded, in the sense that the meaning of this series of numinous objects is there for the taking, laid open to the world, if only we hadn't woken up. Now it strikes me as somewhat self-evident. There is a very clear logic at work here, or at least there is the semblance of causal thinking. The thing is that what little connectedness and narrative progression there is between the objects on show is loaded up with contingency; or, at least, the appearance of contingency. For if Graham is the protagonist in this fantasy, one also senses his presence pulling the strings of the puppet we see. Thus, I take the proximity between the playing card and clothespin as naïvely transparent. No doubt we all secretly realize that the objects have been carefully placed by a "smart Graham" (somewhere behind the camera directing the shots) in order to produce the desired effect of slight surprise, the grinding of gears (well, raising of an eyebrow), and finally, hallucinogenic epiphany in the "dumb Graham."[16]

This said, if the powers of reasoning on display are laughable and trippy, it seems that all of this is under

the stage direction of a kind of reason that is nothing if not quirky and idiosyncratic. I imagine watching the rushes with the person whom we have dubbed the smart Graham and agreeing with him that before us is a completely earnest and objective account of the invention of cinema. That is what is at stake! Of course, I also imagine turning away in order to mutter under my breath that this guy is a little kooky and a touch theatrical. Just listen to the melancholic lyrics: "Fuckin' awful day…/I'm the "i" they failed to dot/From the land that time forgot/I just lost my train of thought." Whoops!

Whether the music lays another rhetorical riff over this internal and objectified dialogue between the two Grahams I am describing is difficult to assess, as is the difference between Rodney Graham the person, or the practicing artist, and the two personas present in the work. Certainly the plenitude of the Syd Barrett–type power chord and the swelling wall of sound is palpable and heightens the overall effect. If the soundtrack runs out, one does have to consciously put the needle to the record once more. Further, the disjointedness and forgetfulness of the lyrics seem to synch up with the "just sitting there… me looking…me riding" of the storyboard.[17] Both seem intentionally simplified, as if a controlling intelligence has dumbed things down for the benefit of the unsophisticated. So one does find a duplicate structure. But again, given the personas, one wonders where the trace of true intention lies. The "just sitting there…me looking" is too easy, too obviously self-conscious not to raise suspicion.

If I recall correctly, the whole idea of sitting under a tree was to be an homage to the opening scene of Heinrich von Kleist's *Prinz Friedrich von Homburg* (1821), in which the image of another quitter heralds and announces the action. What of this? Has "me looking" replaced the complexities of close reading that we observed in *Reading Machine for Lenz*? Perhaps the garbling of the proper name and location (the vocalization of P. F. v. Homburg along with E. T. A. Hoffmann into L.S.D. Hofmann or Albert Hofmann through the blurring of a chorus of voices and suggestions) crystallized the idea of an acid trip? But then substituting "a few tabs of Hofmann" for "The Tales of Hoffmann" hardly comes off as the "elocutionary disappearance"[18] of the artist or the traces of rigorous or serious practice, even if it does seem ripe for interpretation through the optic of dream displacement and condensation.

I said: "That's a great shot of the F on the fender."
He said: "Oh, I know, it was the director's idea!"

Not bad for a ready repartee. But one cannot be sure if it is one.[19] Indeed, it must be admitted that Graham's work seems to thrive on a kind of social exchange or interpersonal give-and-take that lends Freud's notion of the "day's residue"[20]—what Freud claims the dream draws upon as its resource—a far more palpable, idea-oriented substantiality. I recall Graham telling an audience that the idea of *Vexation Island* came from a friend who wanted to make a pirate movie. This made a tremendous impact on me at the time, and prompted rather startled laughter from us all. Why Graham would be so willing to give the appearance of relinquishing authorial control, or be so open as to discuss such issues in speaking of the work, is baffling.

Baffling, that is, if one is unaware of the importance placed on an effortless style. Baffling, if one does not recognize the centrality of the fiction that the art flows directly from the life. "Art must give pleasure," as Robert Linsley puts it, "and nobody takes pleasure in conspicuous displays of effort."[21] The throwaway remarks, the generosities intending upon the provenance of ideas, the informal style of conversation generated around the work itself, the veritable catalogue of distractions and associations that make up the "Artist's Notes,"[22] are all a part of the mythical spin that inevitably accompanies the phenomenalization of this work. In making sense of Graham's assumedly self-conscious and, in turn effortless, dreamlike, and autobiographical practice, it inevitably comes off as a joke. In the case of *The Phonokinetoscope*, a joke in one of its potentially embarrassing, "yeah cool," definitely funny, perhaps generational guises: For what if he really did or does do acid, and so on? He is from Vancouver, and one would hate to laugh just because he's from the West Coast and different. What of the status of the joke in a close reading of Graham's work? And for that matter what of the insinuation of humor in Graham's self-conscious and sublimated art?

Study for *Freud Supplement (170a–170d)*, 1989
Ink on gouache
22 x 49 cm (8 1/2 x 19 in.)
Archives Yves Gevaert, Brussels

A BERLIN FRIEND

One hardly need refer to the correspondence between
Freud and his "Berlin friend," [23] Wilhelm Fliess, to
suggest that even close friends laugh at other friends'
dreams. Nevertheless, Fliess's famous reply to Freud, after
having read the proofs of *The Interpretation of Dreams*
(1899)—that the book was "too full of jokes" [24]—is
telling. So, too, Freud's own terse response that stands as
a reminder of both the "far-reaching…agreement" Freud
would posit between the "joke-work" and the "dream-
work," as well as the conflicting presence of various forms
of analogy which he would maintain only the trained
psychoanalyst could unpack.[25] The exchange between
Fliess and Freud flags an insurmountable interpretative
block that prohibits one from ever unraveling the chain
of signification in *The Phonokinetoscope*. Graham's critique
of Freud's structuralism is acute. As with his ready
repartee above, his interest in the joke revolves around
the dialectical resources it draws out from or materializes
in the viewer. From as early on as the *Freud Supplement
(170a–170d)*, Graham posits a nondialectizable remainder
that constantly escapes Freud's conceptualizing grasp.
What we are singling out here is the way the joke keeps
the "dream-work" far safer than Freud's transparent thera-
peutic would ever allow. All the careful analysis and good
intentions in the world cannot out-negotiate metaphor.
The effortless joke places the real labor of Graham's
"dream-work" on the far side of an asymmetrical chiasmus,
the likes of which Freud's "one-sidedness," "single-
minded[ness]," "monomania," unilateral glaucoma,

"monocularity" (I'm quoting from the *Freud Supplement*)
was forever "'turning a blind eye.'" [26]

This said, in interpreting *The Phonokinetoscope*,
or indeed any of Graham's works, the close reader is
continually cast in the role of Freud's "Berlin friend" who
can never quite get over laughing at all of the jokes. This
"image of interpretation" [27] or "figure of reading"—when
one is made to play Fliess to Graham's Freud—is one
we want to hold on to, in fact, lay over the literal reading
the autobiographical image puts forth in this body of
work. And this does not mean taking a figural reading for
granted either! Interpreting this work only through the
eyes of the fictional persona of the knowing artist is to
ignore what is actually transpiring in front of one's face,
or indeed under one's critical skin—where diegesis always
crawls with the likes of mimesis. If the repercussions
of this phraseology are somewhat occulted, consider
Graham's bookmark for *Dr. No* (1991). It fits seamlessly
between pages fifty-six and fifty-seven of the Pan Books
edition of the Ian Fleming classic. Few will not experience
the dread of Graham's recounting of James Bond's
encounter with the centipede firsthand, even if they look
down at it from the detached and humorous perspective
of secondhand knowledge. The fears or desires that
accompany one's entry to the book, that help one find
one's place in the book, that all wait there dormant in
the bookmark, are carried back out into the world, linger
long after the book is laid down, and inevitably creep
and bleed into even the most instrumental account of the
work. Overarching conceptualizations aside, one is always

undergoing (enduring, suffering through) something or other in reading Graham's works. In other words, notwithstanding the danger we have just negotiated, for the critic there are certain advantages to keeping in touch with one's provincial and uneducated roots. Allowing the referential aspect of language to grip one, heart and soul, is at least as important as putting up the appearance of being a reflective and well-schooled academician able to make hard and fast distinctions between art and life.

In any case, by virtue of this palimpsest-like double vision of Graham's joke-work, one glimpses a very different story than that of natural cycling, organic circularity, stylistic effortlessness, or the metaphysical unity between surface and depth. Seeing the joke of both a literal and figural reading puts the real intention of Graham's work into focus: in the case of *The Phonokinetoscope*, a one-sided, single-minded, monomaniacal focus. For this film loop and its "whatever" soundtrack works very hard at disassociation. In spite of the copious amount of free association one comes across in the body of work generally and in the artist's notes on the *The Phonokinetoscope* in particular, Graham's attempts to recapture plenitude amount to little more than the positing of a schizophrenic-type viewing condition. The other side of the coin being: the attempts to recapture a plenitude of self-knowledge for Graham the knowing artist through stylistic analysis falls equally short of the mark. At the very center of Graham's aesthetic is a deeply felt sense that literal and figural meaning are both of the order of mere appearance.

Think of it this way: If one is constantly stumbling over the jokes, one can never quite get into the dream. And this makes for a very strange predicament indeed. The reader is positioned somewhere between Graham as hapless, fantastical protagonist and Graham as know-it-all artist. What Friedrich Schlegel defined as irony, "a permanent parabasis," here unfolds in terms of what Paul de Man describes as the "distinction" one "learn[s] to make between the persona of the author and the persona of the fictional narrator." [28] Continuities of consciousness are decisive here, but so too is the absolute distance of a "voiced otherness." [29]

One hears this voiced otherness at numerous moments in Graham's corpus. I take one of the more interesting to be a live improvisational performance in Antwerp, Belgium, with Graham sitting on a stool, noodling away on his guitar—à la Jerry Garcia—to the love scene of Michelangelo Antonioni's *Zabriskie Point* (1970). At a moment such as this, the seamless merging between art and life is dramatically intensified and put under acute pressure through a careful staging of the personal in historical terms—in this case through avant-garde reference, the figure of the troubadour, and something like a deadhead's symbolic fantasy of becoming one with the music.

Voiced otherness, something manifest within and beyond the all too common side effect of the hallucinogenic experience, is crucial to isolating Graham's practice. In *The Phonokinetoscope* it is neither the curious allegorical look of Graham on acid (i.e., the look of someone who might not appear really together from one's straight perspective) nor is it the intensely symbolic identification one might feel with Graham on acid (i.e., the rush of ideas that aligns one's own movement of thought with Graham's experience of being one with the universe). Voiced otherness is the negative or passing moment in this dialectic that gives each its place in the world. Coming face-to-face with Graham's joke-works means getting the joke of both the literal and figural interpretations and then listening for and responding to this dim call of something other.

Allow me to briefly derive a notion of practice from this uncomfortable feeling of being and not being oneself. Look closely at the pastoral setting in which the playing card and clothespin of *The Phonokinetoscope* are nestled. It is the most demonstrable trace of practice I have to show. And by practice, I do not mean to flag the appearance of the hapless necessity with which Graham's on-screen persona ultimately unifies the two otherwise disconnected objects. Nor do I flag the awareness of contingency with which Graham's fictional, or behind-the-scenes persona, cues us to the fact that the objects are simply two juxtaposed props. Practice in this work, in Graham's work as a whole, is neither grounded in the assumed unity of the two objects nor in their critical separation. No, practice is the facility with which Graham, the artist, is able to play off a literal and a figurative reading in the same scene; put each in proximity to the other and

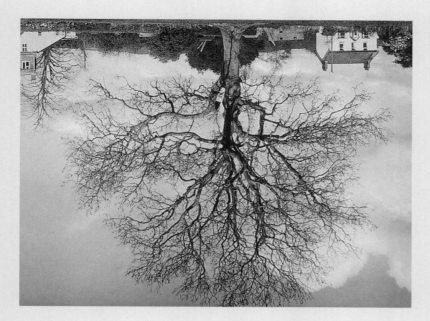

Welsh Oaks (#2), 1998
Monochrome color print
91.5 x 122 cm (89 x 72 in.); edition of 2

outdistance a transparent dialectic in the process and in terms of whichever point of view one happens to pick up on and run with. If close reading is attuned to language (and in Graham's case closeness also has a seductively autobiographical purchase), practice would be the facility of placing one thing in the proximity of the other, and doing so in such a way that the tropological system or "whirligig (*tourniquet*)" around which the work turns allows the artist to disappear in the process.[30]

The task of criticism can be little other than to identify this whirligig, sit on it, and spin. In as much my claim is that the joke is not simply a projection on the part of the viewer, but part and parcel of an intentional rhetoric that goes to the crux of Graham's apparently effortless practice. I would say it is the moment at which the joke-work opens up a negative space of intention; the uncertain future the work predicts and then confronts; an *ellipsis*, or clinamatically[31] squashed loop or circle, where the original idea (always personal, always circumscribed to a life lived) finds its completion and reception (always alien, always thrown and mediated by the busy, changing hive of language and convention) in a strong viewer (actually weak) who bends Graham's weak practice (actually strong) to his/her own purpose.

AU DELÀ PRINCIPES DE LA BLAGUE

Take *Fishing on a Jetty* (2000). In its carefree and fiddling insistence on being all about a subject matter revolving around assumed personas or aliases and their associative dimensions for the artistic personality, it highlights the problem of meaning in Graham's work as a whole.

The first time I saw this work I burst into laughter, and I should admit that it was in the pointed or strikingly singular way described by Baudelaire—as a "collision of…two infinities"—that I happened to laugh at all.[32] One reads the work instantly as a joke. I imagine most people laugh at Graham's upside-down *Flanders Trees* (1989) for a similar reason. All of Graham's photographic works have the feel of one-liners about them.[33] But I am not simply pointing to the fact that the works glory in their upside-downness or the very circumscribed set of issues around the camera obscura from which one trajectory of the photography seems to emerge. I am talking about narrative effect, a question of occupying or assimilating the fictional gaze. I am referring to the way *Fishing on a Jetty* relies on a very high level of public discourse on contemporary photography, and more importantly bends or turns these expectations concerning the language of photo-Conceptual art (indeed any critical attitude) toward an alignment with the assumed perspective of Graham the person, or practicing artist.

Thus, in *Fishing on a Jetty* Anthony Spira has recognized that "The mannered style and pose of the subject offers a parody of narrative photography in general and fellow Vancouverite Jeff Wall's carefully composed tableaux in particular."[34] This was the punch line for me too. It's difficult to describe precisely, but what one senses at the exact moment of getting the joke is the uncomfortable feeling of hearing Graham's knowing voice in one's head. As with so many of these works, Graham's authorial identity makes its presence known in a far more unnerving way than simply meets the eye, or than stylistic analysis

is able to plumb by virtue of critical paraphrase. In other words, this work does not resemble anything, but it does sound like a paternal voice admonishing a little mimic for doing something. This authorial voice should be recognized as a fictional persona; an instancing of a figurative language that has little or no attachment on the certainties of meaning in the world. Throwing one's voice at the work, and believing it is the work itself speaking or telling the joke, is the crux of the matter. In this case, it is all too easy to fall into the trap of performatively acting out the role of Graham's self-conscious authorial presence and assuming this to be the proper meaning. Mimicry as paraphrase, the paradigm of critical objectivity, comes at the cost of understanding because of the tremendous grip the language of photography presently exerts on our critical attitudes vis-à-vis close reading. But also, because Graham's work sets up the conditions of viewing in which meaning made, any meaning made at all, is self-fulfilling or conveniently the perfect double for what one believes to be true.

So while I think this work depends on a similar structure of personification, I do not think it is related to that voice one hears in, say, *Flanders Trees* or *Welsh Oaks* (1998). When it comes to language and the specifics of language, voiced otherness is always in the singular. A moot point perhaps, but important to consider if one has any stake in the close reading of unique works of art, and Graham's works are nothing if not unique. Aesthetic pleasure depends on little else than the freedom between reference and play that a close reading of the individual work offers up.[35]

That the joke is subject to the anomalies of the phenomenal question of reading should be clear enough. That this is closely connected to Graham's careful use of language, as well as a vouched-for authorial intention that is invariably written off as so much malarkey, is given by now. So, too, the insight that the veneer of the joke—the autobiographical slant it has, the dialectical resources it summons through the hermeneutic questions and answers it begs—unsettles or troubles the phenomenality ("image-likeness" or "intuitableness")[36] that any one single viewer has the appearance of conjuring up from deep within the works themselves. Here, in hand then, one has the tools necessary for beholding and unfolding "the aesthetic…

[T. J. Clark is speaking for me here, paraphrasing de Man] …that moment (this is the claim) at which the materiality of the sign is grasped again, and grandly played with, but precisely *as* 'phenomenal substance,' as part of a world of stuffs and perceptions."[37]

Rather than concluding with a historical account of Graham's joke-works, permit me the indelicacy of summing up Graham's interest in the joke with a few broad brushstrokes. Generally speaking, I see Graham's work in terms of a shift from the inside joke or slimly allegorical riddle (of the bookworks say) to the outwardly visible, broadly symbolic joke or sight gag of the film, music, and performance works. However, knowing what we do of phenomenality, this history is rendered negligible. In fact, we can isolate Graham's interest in the joke to an otherness that has escaped the laugh from the very beginning. One is always let in on Graham's jokes, and it is upon being let in on the joke that a true outside looms up. What has elsewhere been described as that which underwrites the system of substitutive reversals or exchanges between an inside and an outside and which remains supplemental to the linguistic play of this back and forth, is the beyond of the theory of the joke.[38] Graham has always pointed to this beyond. After all, who can miss the buffoonery of tracing Graham's footsteps "through the forest" in *Reading Machine for Lenz*? And is this any less a question of performance than gathering round Graham at an opening and listening to the contemporary troubadour in action? Neither is this to claim that a veritable web of sophisticated references does not underwrite the live performances, merely that one is all but deaf to the underwriting of metaphor by metonymy (and vice versa metonymy by metaphor) in the face of Graham's noisy (in whichever case, more thoroughly transparent or symbolic) antics. In spite of the buffoonery of it all, I am always catching myself listening with cocked ear, half expecting to hear the wisdom of a well-traveled minstrel. In all we are facing a very conscientious practice that has slowly and methodically cultivated and raised up the possibility of an outside to the hegemonic system of the joke's worldly inside, for an elite as well as popular audience.

One way of simplifying this question in terms of a single significant thematic running through the work

as a whole would be to raise the relative status of both inside and outside jokes in terms of the punch line—a Benjaminian move[39]—laying over these the question of positive and negative reception respectively. In this sense, the punch line is forwarded as a negative entrance that literally has one seeing stars at every turn. Whether it is the magical sparkles of *Coruscating Cinnamon Granules* (1996), the imagined stars of *Vexation Island*, any one of the works revolving around the optical experiments of Joseph Plateau, the look-at-me look of the stars on the spine of the *Freud Supplement*, the startlingly short take of Graham showing off by riding his bike backward in *The Phonokinetoscope*, or the vain glory of the film work itself as star vehicle, fixating on the star is the thing.

That this point (the star) ultimately opens up to the question of practice, possibility, hope, the looking forward to a bright future, or new languages as yet unexplored, is what a close reading Graham's joke-work (dis)covers. Needless to say, this is a discovering that comes at the price of covering one's tracks; especially since the trope of autobiography is involved; even more so, if one realizes that all of Graham's antics spring from nothing more than a healthy fascination with language and the generous pleasures had in teasing out the ironies implicit to each of the dazzling array of languages one finds in this corpus of work.[40]

CONTRACTUAL DISCLAIMER

We cannot confirm any of this. All one has to go on is the virtuosity of surface, the appearance of an absolutely effortless style, the facade of a series of jokes that seem to flow directly from a life lived: in sum, the signature, face, touch, and presence of Rodney Graham. All this talk of hope, possibility; the long hours and painful rigors of a very careful, conscious, labored, intensely serious practice is mere speculation: one grounded on the assumption that the dynamics of narrative are the dynamics of reading, in turn the dynamics of practice. And the present author "warrants" that this "Work," and I as the "sole Author of the Work," "contains no matter which is libelous, or in violation of anyone's right of privacy." (See my contract: point 3, "Warranties." Dated 08/01/03. Signed, Shep Steiner.)

1: Theodor W. Adorno, *Aesthetic Theory*, trans. Robert Hullot-Kentor, Theory and History of Literature series, vol. 88 (Minneapolis: University of Minnesota Press, 1997), 311.

2: Graham describes the "narrative impetus" of the work as deriving from "the injury laugh endemic to film comedy since Louis Lumiere's *L'Arroseur arrosé (The Hoser Hosed)* of 1895." Graham, "Artist's Notes," in *Exhibition Guide* (London: Lisson Gallery, 2001), n.p.

3: Graham, "Appendix I: Artist's Notes," in *Rodney Graham: Works from 1976 to 1994*, exh. cat. (Toronto: Art Gallery of York University; Brussels: Yves Gevaert; and Chicago: The Renaissance Society at the University of Chicago, 1994), 81.

4: Paul de Man, "Hypogram and Inscription," in *The Resistance to Theory*, Theory and History of Literature series, vol. 33 (Minneapolis: University of Minnesota Press, 1997), 33–34.

5: Gérard Genette, *Paratexts: Thresholds of Interpretation*, trans. Jane E. Lewin, Literature, Culture, Theory, vol. 20 (Cambridge, England: University of Cambridge Press, 1997).

6: De Man, foreword to Carol Jacobs, *The Dissimulating Harmony: The Image of Interpretation in Nietzsche, Rilke, Artaud, and Benjamin* (Baltimore: Johns Hopkins University Press, 1978), ix.

7: My skepticism with finding true artistic intention here is not unfounded. Graham's increasing presence in his art—first as signature in the early book works, as young hopeful in *Recital* (1992), as star and executive producer in his trilogy of costume pictures, as well as lead singer in his band—should be enough to point interpretation in the direction of conventional autobiography. That he takes sedatives in *Halcion Sleep* (1994); melancholy bends notes and vocal harmonies in his music; something like lethargy slumps one back to the supine position required for engaging the equally unusual *Casino Royale (Sculpture de voyage)* (1990); he in part works through his own debt crisis in *Schema: Complications of Payment* (1996), sings of getting "ripped on everything that comes [his] way…mixing Tylenol and Tanqueray"; possibly resorts to acid in order to forget himself in *The Phonokinetoscope*: all have the appearance of illness behavior. The careless may be tempted to pronounce: "He's depressed. Self-absorption is one of the signs. When it's spread across a corpus of work like a series of anecdotes from a life lived, it's a call for help!" However, given there is a kind of self-analysis going on in each work, that all of these personal issues have the look of something just past, already over about them, or that they seem objectified by a kind of authorial eye, I call it even: either/or.

8: See Marie-Ange Brayer's excellent reading of these works in her "Rodney Graham, An Optical Involution: The Name Augmented," in *Rodney Graham* (1994), 51–52.

9: Being led away from his vocation is a leitmotiv in Graham's work. It is rooted in an early obsession with Sigmund Freud and the founding years of psychoanalysis—specifically, the circumstances that would distract or divert Freud from writing *The Interpretation of Dreams* (1899). Being led astray is figured as an "idle glance" in Graham's *Die Gattung Cyclamen (Installation for Münster)* (1987). In *Freud Supplement (170a–170d)*, it is manifest as a circuitous addition of "new associative material to Freud's analysis of his own so-called Botanical Monograph Dream of March 1898." See Graham, "Artist's Notes" and "*Freud Supplement (170a–170d)*" in *Rodney Graham* (1994), 94–95 and 125–130.
 Graham works through this material again in *Schema: Complications of Payment*. And as he reveals in his artist's note on *I'm a Noise Man* (1999), this "'allotrion,' or 'other path'" is connected to his camera obscura works and his ambition to "make a music video for a song that was to be written and sung by [him]." In a characteristic note, Graham describes how his research into Freud led him away from his art for a two-year period. See artist's note on *I'm a Noise Man*, in *Rodney Graham: Cinema Music Video* (Vienna: Kunsthalle; and Brussels: Yves Gevaert Verlag, 1999), end sheet.

10: Northrop Frye, *Anatomy of Criticism: Four Essays* (Princeton, New Jersey: Princeton University Press, 1957), 89. Quoted in de Man, "Form and Intent in the American New Criticism," in *Blindness and Insight: Essays in the Rhetoric of Contemporary Criticism*, Theory and History of Literature, vol. 7 (Minneapolis: University of Minnesota Press, 1983), 26.

11: De Man, "Autobiography As De-Facement," in *The Rhetoric of Romanticism* (New York: Columbia University Press, 1984), 70.

12: See Genette, "Frontiers of Narrative" (1966), in *Figures of Literary Discourse*, trans. Alan Sheridan (Oxford, England: Basil Blackwell, 1982), 127–44.

13: Freud, *Jokes and Their Relation to the Unconscious*, trans. James Strachey (London: Routledge and Kegan Paul, 1960), 51.

14: It is in connection to the example of "salmon mayonnaise" that Freud first introduces the concept of "displacement," saying "its essence lies in the diversion of the train of thought, the displacement of the psychical emphasis on to a topic other than the opening one." Ibid., 51.

15: On condensation, Freud writes: "In the course of the dream-work the material of the dream-thoughts is subjected to a quite extraordinary compression or *condensation*." Ibid., 163.

16: De Man describes irony as a dialogue between the "*eiron* [smart guy] and *alazon* [dumb guy], as they appear in Greek or Hellenic comedy." De Man, "The Concept of Irony," in *Aesthetic Ideology*, ed. Andrzej Warminski, Theory and History of Literature, vol. 65 (Minneapolis: University of Minnesota Press, 1996), 165.

17: See Graham's storyboard for *The Phonokinetoscope*, reproduced in *Rodney Graham*, exh. cat. (London: Whitechapel Art Gallery, 2002), 108–09.

18: Stéphane Mallarmé, "Variations sur un sujet," in *Oeuvres complètes*, ed. Henri Mondor and G. Jean-Aubry (Paris: Gallimard, 1945), 366. Quoted in Michael Fried, "Morris Louis" (1970), in *Art and Objecthood: Essays and Reviews* (Chicago: The University of Chicago Press, 1998), 126–27.

19: And I had the pleasure of accompanying Graham on his location scouting for the work in Berlin in the spring of 2001. We rode bicycles together through the Tiergarten. We stumbled upon a *Denkmal* or two, we found the Rousseau-Insel, and I should also say that my girlfriend gave him the bike for letting her stay at his house once.

20: Freud, *Jokes and Their Relation to the Unconscious*, 160–61.

21: Robert Linsley, in conversation with the author, March 2003.

22: The only thing any of these "artist's notes" are clear about is the idiosyncratic nature of the metonymic associations involved. Given their humorous content, it is easy to forget how well they serve the work proper, how effortlessly they focus "phenomenality" and present the works as autobiographical and associative material. As a veritable catalogue of surface distractions underwritten by the signature of Rodney Graham, they stage the presence of the work in terms of the joke.

23: In a note appended to the *Freud Supplement*, Graham acknowledges the importance of a letter from Freud to "Wilhelm Fliess (the 'Berlin friend' of the [Botanical Monograph Dream]) dated January 16, 1898." Graham, "*Freud Supplement (170a–170d),*" 126.

24: James Strachey, editor's preface to Freud, *Jokes and Their Relation to the Unconscious*, 3.

25: Ibid., 89, 173.

26: Graham, "*Freud Supplement (170a–170d),*" 127–30.

27: See Jacobs, *The Dissimulating Harmony*.

28: Friedrich Schlegel's Fragment 688 appears in footnote 62 of de Man's "The Rhetoric of Temporality," in *Blindness and Insight*, 218.

29: De Man, "Dialogue and Dialogism," in *The Resistance to Theory*, 108.

30: Genette's resonant term for Marcel Proust's *Recherche* was "an endless discussion between a reading of the novel as fiction and a reading of the same novel as autobiography." Genette, *Figures III* (Paris: Editions du Seuil, 1972). Quoted in de Man, "Autobiography As De-Facement," 69–70.

31: For references to clinamen, see Harold Bloom, *The Anxiety of Influence: A Theory of Poetry* (New York: Oxford University Press, 1973); and Graham's note on *Camera Obscura Mobile* (1996), where he writes: "Flows can be regulated but the unpredictable always occurs: the *clinamen*." *Rodney Graham* (2002), 28.

32: Charles Baudelaire, "On the Essence of Laughter, and, in General, on the Comic in the Plastic Arts," in *The Painter of Modern Life and Other Essays*, trans. Jonathan Mayne (London: Phaidon, 1964), 154.

33: In an excellent essay on Graham's work, Steven Stern describes the technique of inversion in works such as the Oxfordshire Oaks series (1990) as "seeming one-liners." Stern, "River Deep Mountain High," *Frieze*, no. 71 (November–December 2002), 64.

34: Anthony Spira, "A Cycle-logical Journey," in *Rodney Graham* (2002), 95.

35: In the case of *Fishing on a Jetty,* there is the play on the proper name with its sexual innuendo, as well as the long list of humorous references that Graham provides in his artist's notes. I won't rehearse these here, but will single out Graham's reference to the shot being a "typical Hitchcock joke" in order to point one in the right direction. Graham, artist's note on *Fishing on a Jetty*, in ibid., 105.

36: Rodolphe Gasché writes: "A phenomenon is characterized by the fact that it is intuitable (*anschaulich*), imagelike (*bildhaft*)." Gasché, *The Wild Card of Reading: On Paul de Man* (Cambridge, Massachusetts: Harvard University Press, 1998), 53.

37: T. J. Clark, "Phenomenality and Materiality in Cézanne," in *Material Events: Paul de Man and the Afterlife of Theory*, ed. Tom Cohen, Barbara Cohen, J. Hillis Miller, Andrzej Warminski (Minneapolis: University of Minnesota Press, 2001), 100–01.

38: See Andrzej Warminski, prefatory postscript to *Readings in Interpretation: Hölderlin, Hegel, Heidegger,* Theory and History of Literature, vol. 26 (Minneapolis: University of Minnesota Press, 1987), xxvii–lxi.

39: Jacobs, "Afterword: 'I, the Juggler,' in *The Dissimulating Harmony*, 113–16.

40: I have greatly benefited from conversations about Graham's work with Robert Linsley, Florian Berktoldt, Nicholas Logsdail, and Yves Gevaert. I would especially like to thank Grant Arnold, Lisa Mark, Anthony Spira, Shannon Oksanen, and Rodney Graham himself for their criticism of an early version of this essay.

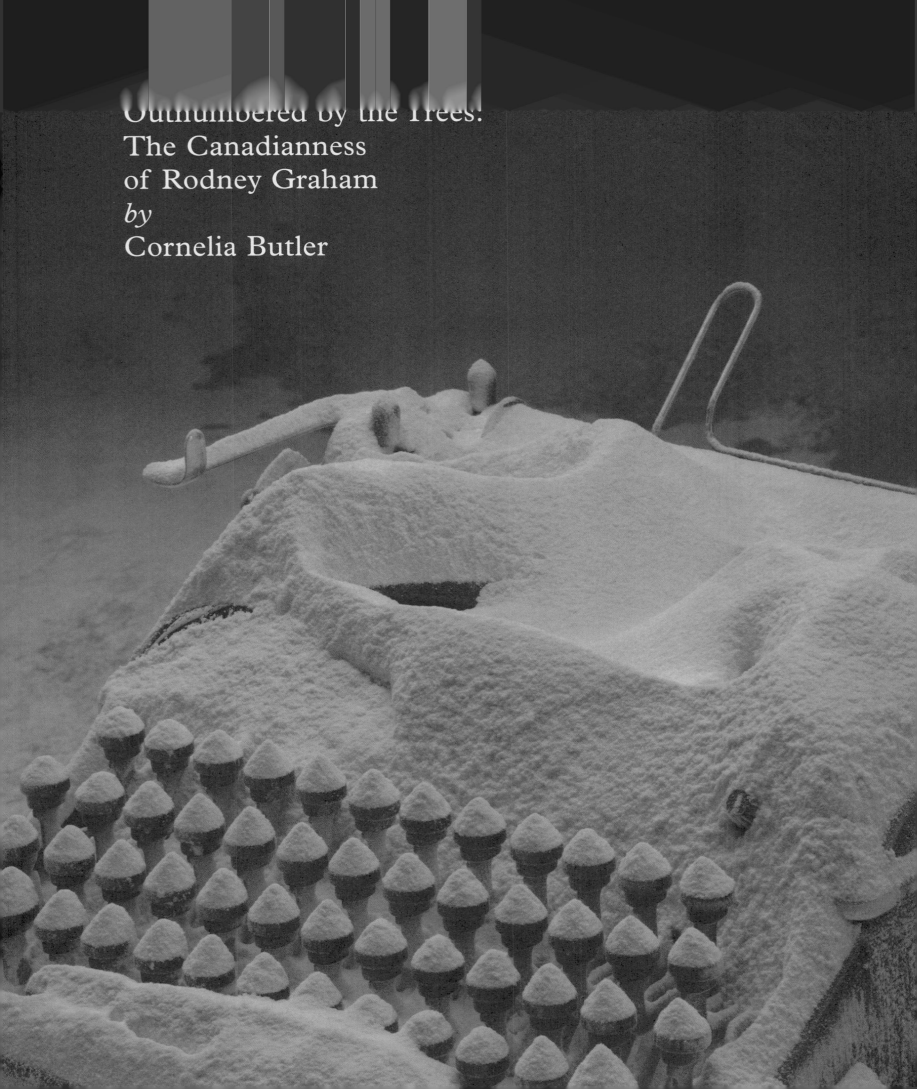

Outnumbered by the Trees:
The Canadianness
of Rodney Graham
by
Cornelia Butler

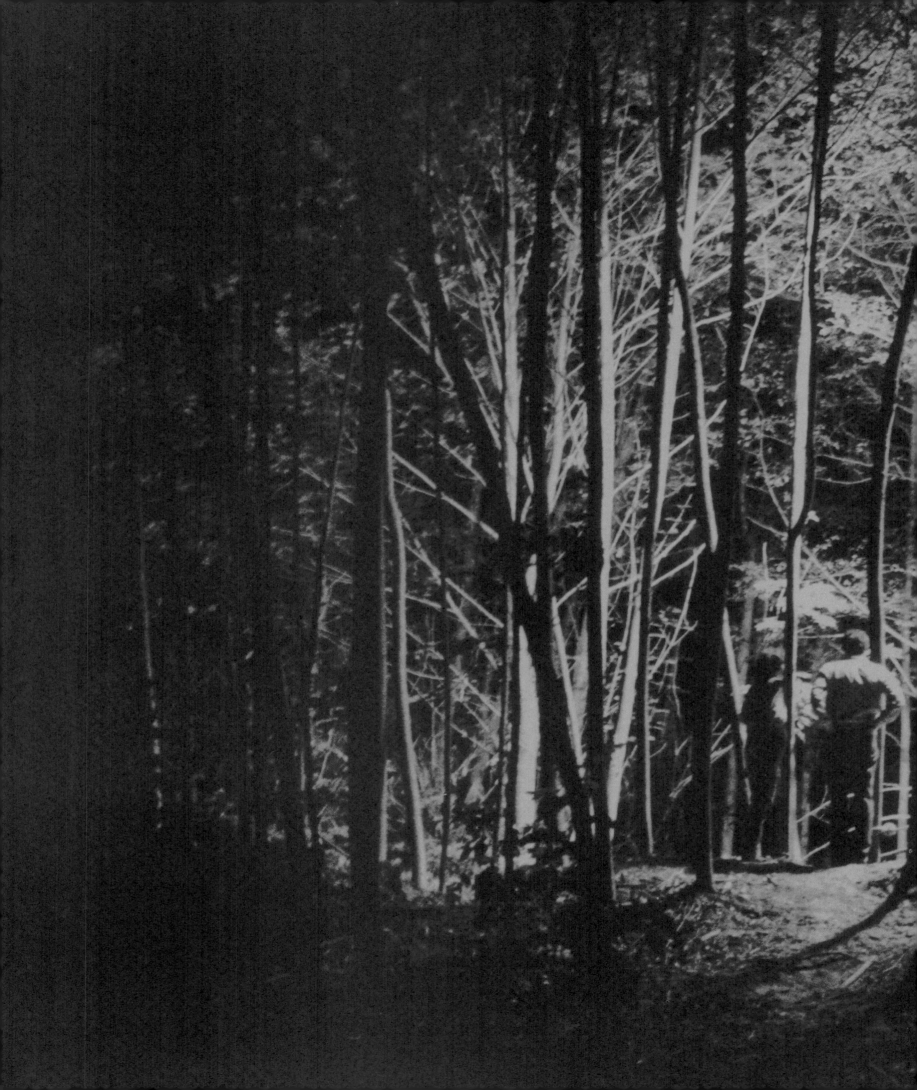

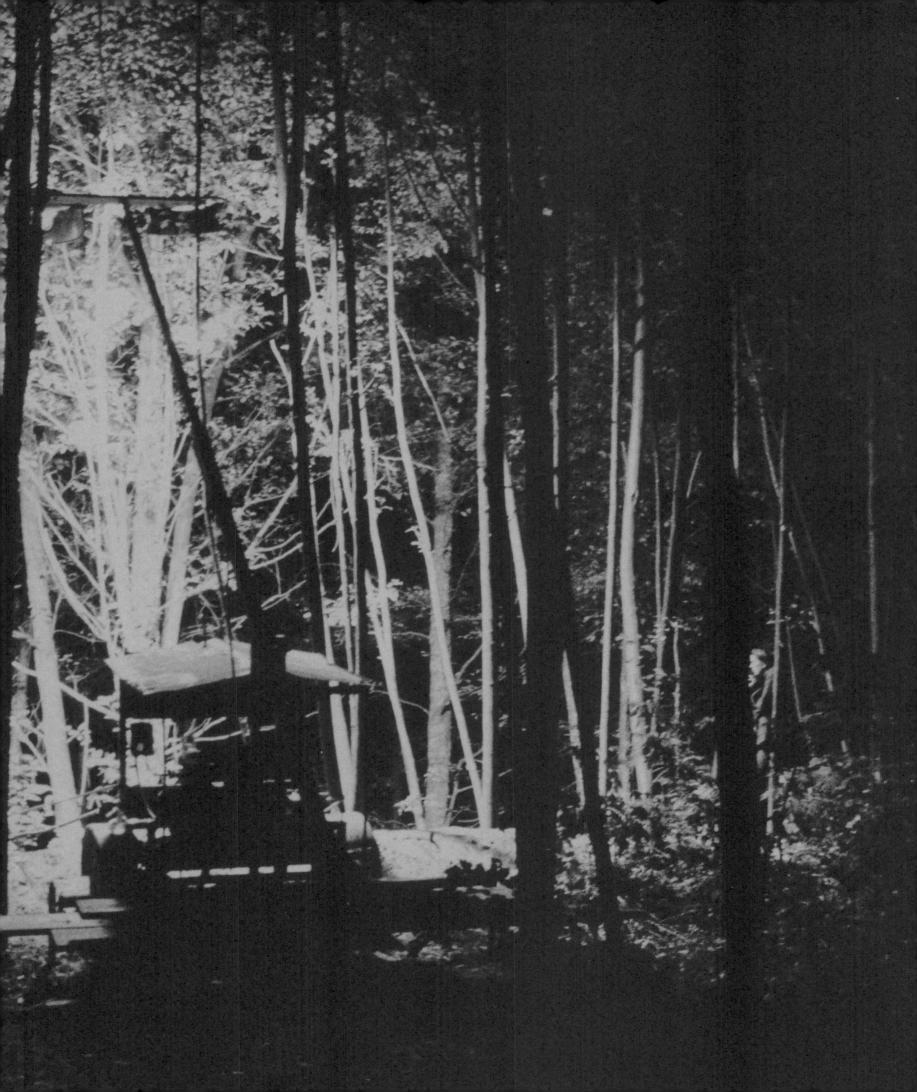

*Our central idea is one which generates, not the excitement
and sense of adventure or danger which The Frontier holds
out, not the smugness and/or sense of security, of everything
in its place, which The Island can offer, but an almost
intolerable anxiety.*
—Margaret Atwood [1]

*On a wider plane, it is a source of constant frustration to
attempt to be Canadian.*
—Harold Innis [2]

At various points in the literature and notes on his work,
Rodney Graham definitively locates his "earliest memory"
at two distinctly different points in his life. The more
mysterious and resonant memory dates to when the artist
was four years old and living with his family in a British
Columbia logging camp where his father was the manager
and sometime film projectionist. Graham remembers
seeing films at night, screened in the cookhouse in the
forest. One can imagine what films might have been
shown during the early 1950s in this masculine environ-
ment, this heart of darkness, full of men and towering
trees. Graham's other earliest memory is more familiar
to most of us: he recalls sleeping in the backseat of the
family car and the comfort and euphoria of those
moments of half consciousness.

Two very different versions of Graham's
relationship to landscape and patriarchy are found in the
conflation of these two memories and their mythologized
recounting by the artist. In the passage from the dark
verticality of the forest (standing both in defiance of and
dominated by the inevitable move of industry) to the
lulling horizontality of that somnolent journey, perhaps
being driven by dad in the family car, lies an emblematic
set of reversals. From anxiety to peaceful oblivion and
back, these vivid hallucinations provide one key to
Graham's complex, succinct, and often indulgently
beautiful work.

The most useful traverse of Graham's rambling
oeuvre is not chronological. Rather, like the perpetual
looping that underlies most of his books, sculptures, films,
videos, and photographs, his oeuvre engages an ongoing
network of related passions to which he returns again and
again. In his first retrospective publication, a raisonné-
style overview of works from 1976 to 1994, the compilers,
in fact, construct an almost unnavigable, "synthetic"
typology, stating:

> *It would have been simplest to adopt a general chronolog-
> ical classification. Such a classification, however, would
> have precluded a unified perspective of the work.... This,
> we hope, will shed light on the evolution over time of the
> exploration of concepts chosen. The inquisitive reader will
> doubtless easily locate works created at the same time but
> classified under different concepts.... [The] catalogue is
> therefore both fixed in time...and open-ended.* [3]

I would like to employ such a discursive device to track
the progression from what Graham calls his early "lighting
events," the illuminations in natural settings that occupied
him from the mid-1970s to the late 80s, to a deceptively
unassuming work like *Halcion Sleep* (1994), which Graham
posits as a return to his interest in performance—specifi-
cally with himself as actor and subject.

I'd like, for a moment, to consider Graham's
Canadianness—to, in a sense, perform a reversal of the
artist's own fortune, which has taken his work, its market,
and its reading out of a Canadian context and into an
international one—and to ask what, if any, bearing a
reading of his nationality might have on understanding
the early land-based work in particular. Graham himself
raises the specter of regional identity when he makes
mention of how Kurt Cobain loathed his hometown of
Aberdeen, Washington, the subject of Graham's slide
projection *Aberdeen* (2000): "Cobain hated Aberdeen
creatively, the way [Sigmund] Freud hated Vienna." [4]

Dan Graham
Detail of *Homes for America (slide projection)*, 1966–67
Twenty 35-mm slides and carousel projector
Dimensions variable
Collection of the artist

N.E. Thing Company
Detail of *1/4 Mile Landscape*, 1968
Hand-tinted silver prints, printed map, watercolor,
and graphite paper
Dimensions variable
Collection Art Gallery of Ontario, Toronto

Perhaps the way, one wonders, Graham might feel about Vancouver, which he often calls "this godforsaken town."

Here, Graham invokes two of his fascinations—Freud (psychoanalysis/Europe) and Cobain (rock/ music)—via a lingering preoccupation with locating the self in a place. The fact that Graham's curiosity about Cobain as an artist, and his own rekindled love of the guitar, led him to Aberdeen (a place less than a day's drive from Vancouver but which he renders exotic nonetheless) says something about Graham's ambivalence about his origins in a particular landscape. In an aptly low-tech maneuver, Graham documents the storefronts and depressed main streets of Aberdeen with the distanced eye of Dan Graham's seminal photo essay *Homes for America* (1966–67), which takes us through the suburbs of the American Northeast. Where Dan Graham stylistically has the clinical eye of a first-generation Conceptualist, Rodney Graham's typology is presented with a kind of agonized empathy underscored by the tragic life and death of Cobain himself. This tension surrounding one's place of origin, of an almost inevitable localism versus the driving need for intellectual escape, has prodded him with friendly yet vexing regularity throughout his career and culminates in the video work *City Self/Country Self* (2000), completed the same year as *Aberdeen*.

There are huge dangers in inscribing a regional, much less national, identity onto the work of any artist, and Canadian artists have repeatedly addressed this issue directly: a 1987 General Idea print titled *From Sea to Shining Sea*, featuring a world map with Canada missing, speaks to the notion of an absent, or at least misunderstood, national identity. But it seems interesting—maybe even a little perverse—to reconsider the regional history of Vancouver in relation to the convolution of Graham's early work. Through a reexamination of the Canadian west coast Conceptual tradition and broader notions of Canadian identity, one might come to understand the nature of attention in the work, as well as his obsession with Europe and Freud. In this way Graham is tied to an alternate reading of landscape—a motif that recurs consistently throughout discussions of Canadian identity.

Key to mapping the first half of Graham's career is a reconsideration of his early preoccupation with location. Probably the most important reference here to a practice constructed around issues of site and theories of communication is that of N.E. Thing Company (NETCO), the collaborative North Vancouver–based duo of Iain and Ingrid Baxter. Active from 1965 until 1978, NETCO, as they became known, worked against media-based categories for art-making, exploiting Marshall McLuhan's famous dictum "the medium is the message." They sought to invent new kinds of art-making activity, often transforming aesthetic information into pure data. Lucy R. Lippard, who spent time in Vancouver where she organized "955,000," one of her groundbreakingly expansive curatorial propositions, was struck by the centrality of landscape in the Baxters' production and read it as a response to isolation:

Vancouver is compelling to an American with an idealistic bent because it looks like fresh ground. The art is…still struggling to replace regionalism with something other

Jeff Wall
Landscape Manual, 1970
Ink on paper
26.5 x 21 cm (10 1/2 x 8 in.)
Collection of the Vancouver Art Gallery

than international numbness, but the mood, the attitudes, some of the work and the way the future is being considered are tantalizing…The points of departure (Robert Morris, [Ed] Ruscha, [Bruce] Nauman and, in Canada, Michael Snow and Les Levine) might be the same but Baxter's projects…are refreshingly original answers to esthetic isolation.[5]

Baxter taught Ian Wallace, who himself taught Jeff Wall and, for a brief time, Graham. And without overstating the nature of this lineage, it is worth mentioning one early NETCO work because of its obvious formal connections not only to the American sculptor and Conceptual artist Robert Smithson but to Graham's illumination projects in the landscape.

In 1966 as part of a conference called "The Medium Is The Message," N.E. Thing Co. created a performance piece titled *Beauty Through Destruction and Disintegration*.[6] The work was composed simply of ice allowed to melt, over time, in the landscape on the campus of the University of British Columbia in Vancouver. This kind of entropic intervention into a site is typical of the evolution of NETCO's practice and initiated a Conceptual tradition and context for American figures like Lippard and Smithson. The anti-technological impulse, a kind of fascination/repulsion binary not only in the ice piece but permeating all of NETCO's projects, is a key piece of the "Canadianism" I am arguing for in Graham's work.

Speaking retrospectively, Graham has cited Marcel Duchamp and Smithson as two primary influences

on his work and, indeed, on his self-formulation as an artist.[7] Again, Graham's almost Joseph Beuysian deployment of his formative memories is important here; where Beuys wrapped totemic objects in felt and fat, Graham envelops his memories in the awesome embrace of the primordial woods at night. Recalling Graham's two patriarchal night visions—the logging camp nestled in the forest and the meandering backseat sleep in the family car—one might connect the (vertical) forest with the Freud/Duchamp father figure, and the wandering consciousness of the (horizontal) car ride with the more open-ended, geographically based Conceptualism of an artist like Smithson. Clearly Graham, like other artists of his generation, felt liberated by the permission that Smithson's discursive projects engendered.

It is in Graham's stubborn resistance to join either camp—expressed through a formal commitment to location, process, and an elegant economy of means—that one finds the peculiar Conceptualism in his early work. It is here during the formative decade of 1975–85, when Graham was a student of Wallace and a close colleague of Wall, that Vancouver's Conceptual tradition matured. Artists such as Snow and Levine in eastern Canada and the Baxters in Vancouver initiated a tradition that profoundly impacted artists such as Wall, Wallace, and Graham, and a now-emerging generation of artists elaborating Vancouver's Conceptual tradition.[8]

Smithson was certainly aware of the activity in Vancouver, having worked there between 1969 and 1970. It is worth looking briefly at Smithson's Vancouver work

as it resonates with Graham's own early production. Graham's Polaroid experiments echo what Wall has called Smithson's "way of dissolving, or softening, the objectivistic and positivistic tone of Minimalism, of subjectivizing it by associating its reductive formal language with intricate, drifting, even delirious moods or states of mind."9 Describing the formal demeanor of Smithson's snapshots, photographs, and magazine layouts, Wall claims a literary intentionality over a Conceptualist one—the images function as travel log rather than art criticism. Wall's own *Landscape Manual* (1970) similarly traverses the urban landscape with a rambling mixture of literary, Conceptualist, and cinematic references that align him with Smithson's more narrative, subjective brand of Conceptualism. *Landscape Manual* was included in Lippard's "955,000," an exhibition that served as the culmination of the remarkably fruitful period during which Smithson worked in Vancouver. Smithson made a lasting impression on the artists there, one that continues to this day.

There is, I believe, a generalized misalignment of Graham's work with the 1980s and 90s work of Wall, Wallace, Ken Lum, Roy Arden, Arni Haraldsson, and other Vancouver-based artists whose photographic practices and representations of Vancouver defined a style that derived from the Frankfurt School, rigorously taking up nature and the city as subjects.10 It seems productive, for the moment, to cleave him from the so-called Vancouver School in order to navigate the personal symbology that emerges over the full evolution of his work. The history behind this critical association is based, in part, on the body of work that first launched Graham's career to international attention, the *Flanders Trees* (1989) and *Oxfordshire Oaks, Fall 1990* (1990) (or, the upside-down trees, as they have become known). Gorgeously photographed and richly produced, these monumental images of single, inverted trees represent a decade-long effort but are somewhat of an albatross for the artist, who has grown tired of their easy beauty and ready accessibility. But the statuesque, quietly subversive pictures emerged at around the same time that the Vancouver School was being exported and consumed by the international art community, becoming for many the entry to Graham's work.

The representation that seemed to take hold for an international audience ever in search of vestigial traces of modernisms in transition was that of Vancouver as a frontier city transformed by the new global economy and the perceived sense of loss, even nostalgia, in the emblematic representation of that transformation. The construction of British Columbia–as–wilderness hangs over contemporary practice, rooted in imagery from traditional nineteenth-century landscape painting. This notion still lingers amidst the accelerated reality of Vancouver's growth as an important economic center of the Pacific region. (Witness the rise of the film industry in Vancouver, which has been dubbed "Hollywood North.") Canadian artists such as Emily Carr and Jack Shadbolt glorified the rugged western Canadian mountains and shores and took up the representation of what they viewed as the dying civilization of First Nations people. In their renditions, behind every lone fir tree a statuesque, albeit romanticized totem pole appears. The art world's constant recounting of Vancouver's history and change in the last decade is a bit tedious for the artists who live there, but indeed happened concurrently with Graham's focus on the emblematic, solitary tree between 1979 and 1993. Indeed, the Vancouver School itself provides an oppressive legacy for a younger generation of artists whose work is distinctly non-photographic —ignoring the scenery and its representation and instead mining the region's unsung Conceptualist past and its postcolonial present. I am thinking here of artists such as Geoffrey Farmer, Brian Jungen, Myfanwy MacLeod, Damian Moppett, and Ron Terada. Toronto's Nestor Krüger and other young artists throughout Canada share a similar set of concerns.

By 1989 the tree had been present for more than ten years in Graham's work. It appears in two guises: as an isolated specimen and as a thicket of trees forming a backdrop or screen for the artist's lighting events. In 1979 Graham made the first of many works that incorporate the camera obscura. *Camera Obscura* comprises a site-specific, outdoor sculptural installation; documentary material; an architectural model of the project; and the single image of a tree. In 1976 he made *75 Polaroids*, a work he now considers seminal and the culmination of numerous "'experiments' involving the night-time

Myfanwy MacLeod
The Tiny Kingdom, 2001
Wood and mixed media
411.4 x 121.9 x 121.9 cm (162 x 48 x 48 in.)
Collection of the National Gallery of Canada

Nestor Krüger
two turntables, 2002
Digital video on DVD; dual screen projection with audio
3 x 4.8 x 10.9 m (10 x 16 x 36 ft.)
Courtesy of goodwater, Toronto

observation of nature undertaken with the aid of a Polaroid 180 camera." In stark opposition to Canada's great, hieratic landscape-painting tradition and the encumbered melancholy of the Vancouver School pictures, Graham made process-based light experiments at night. These distinctly subversive works emerge from the pitch-blackness of the city's edge.

75 Polaroids is made up of notational snaps, literally bits of trees grabbed by the camera as the flash guided the artist through a forest in British Columbia. With the camera as probe, Graham made an automatic document of his own stumbling and blindness. Literally confounded by the flash of light in complete blackness, he created images that mimic retinal afterimages in their fragility, while rendering a typological study of trees. Abstracted branches and trunks look simultaneously menacing and anthropomorphized. As if to underscore this extraction from nature, the pictures are installed in a discrete, black room in a continuous, frieze-like band. This important work anticipates Graham's subsequent, career-long investigations of light and the apparition of nature, including *Illuminated Ravine* (1979); *Two Generators* (1984); *Lucas a non lucendo* (1987), the lighting of a sacred wood in Rome; *Coruscating Cinnamon Granules* (1996), a film of the heating of cinnamon granules on Graham's stove coils; and *Edge of a Wood* (1999), the surveillance of a forest's edge by a helicopter at night. As Carolyn Christov-Bakargiev has recently written, "all of Graham's works can be seen as focusing on different elements of the same mechanism: on the camera-object

itself as a place you can physically enter; on the reversed image that is reflected inside; on the light appearing that allows vision to occur."[11]

Smithson's more obscure, extemporaneous magazine, video, and film works such as *Swamp* (1969), a 16-mm film made with Nancy Holt, immediately come to mind as a precursor for *75 Polaroids* and Graham's subsequent lighting events. *Swamp* is the little known but memorable documentation of Holt filming her way through a marsh, guided by the instructional voice of Smithson. Following his lead, blindly but not blind, she holds the camera and records the stalks and reeds as the pair cut an awkward path across the unlikely landscape of a New Jersey meadow. According to Smithson, "It's a film about deliberate obstructions or calculated aimlessness."[12] Like Graham's forest, the swamp of Holt and Smithson's work conjures up dank, ominous, B-grade sci-fi images of man consumed by nature.

It is also interesting to look at Smithson's nonsites and sculptural interventions in nature, which profoundly expanded ideas about the de-territorialization of art. Made during his time in Vancouver, *Glass Strata with Mulch and Soil* (1970) consisted of sheets of glass literally planted in rich earth and left to accumulate debris, entropically submitting to the external forces of the environment. Notions of transparency and reflection in this work clearly implicate photography and its history in relationship to land exploration. Akin to Graham's low-tech forays, Smithson's work of this time also bears a kind of enslaved aversion to technology. Smithson's proposal drawing

Towards the Development of a "Cinema Cavern" (1971) was made shortly after the artist arrived in Vancouver. Traveling north to explore the Britannia Copper Mines, he got the idea to produce and screen a truly "underground" film. He envisioned a film that comprised one long take as the camera backed out of the tunnel in which it was shown. Like Graham, Smithson was compelled by the idea of a movie theater as a vast, dark cave for viewing an illumination.

Another more cinematic work of Graham's that bears mentioning here is *Edge of a Wood*, the idea for which came to Graham in 1979 and later emerged as what is arguably one of his most beautiful and eloquent works to date, an abstract foil to his recent, more narrative films. Graham filmed the beam of a helicopter panning a forest's edge at night. In a darkened gallery space the viewer first hears the helicopter approach; the noise soon becomes deafening and relentless as one sees a harsh, penetrating light encounter the forest. This work stands out as one of the most physically impactful visual experiences of the late 1990s—a period that saw the rise of large-scale video projection as the medium of choice for a new generation of international artists, including Eija-Liisa Ahtila, Doug Aitken, and Steve McQueen. In particular, McQueen's film *Western Deep* (2002), which descends into South Africa's deepest gold mine and exposes the dehumanization and oppressive darkness there, resembles *Edge of a Wood* in its blend of violence and sensuality. In Graham's work, the forest stands majestic, yet seemingly imperiled by the exposure. A familiar subject is transformed into an intensely aesthetic and profoundly disturbing experience from which viewers emerge confounded about the precise nature of what exactly they've just witnessed.

Though Graham has never indicated any ecological or even political intention behind his work, Wall makes the case that Graham's solitary trees unavoidably invoke the contestation of the forest as both a sacred and commercial ground: certainly there is a violation that occurs here.[13] Scale is seemingly distorted by night vision, the now-familiar mode in which a green hue tinges everything visible and cloaks things beyond view in a thick, dimensionless black. The fact that the work came

to fruition twenty years later again points to Graham's reliance on the loop as a kind of endless track, prolific and always incomplete, from which works ebb and flow. In this case, Graham extracts a fully mature work utilizing technologies more advanced than in his early filmic experiments, which now seem refreshingly elementary in their manifestations. *Edge of a Wood* exists like an expulsion, a preverbal expression amid much more articulate and, in a way, sophisticated works like the three films Graham calls his "trilogy": *Vexation Island* (1997), *How I Became a Ramblin' Man* (1999), and *City Self/Country Self* (2000). Like the infinitely dark and claustrophobic mine shaft in McQueen's film, the image of the forest is non-textual—made mute in a way by the noisy force of the soundtrack. The forest or wood now takes on an almost socio-political resonance standing in for the postcolonial situation of Vancouver's economic growth, diminishing natural resources, and relationship to native peoples. Even the choice of the word "wood" instead of "forest" signals a kind of logging camp woodsiness, or a backing away from the more romantic classification.

The aggressive physicality of the confrontation between trees, light, and sound so vividly captured in *Edge of a Wood* must be akin to the on-site experience of *Illuminated Ravine*, a performance/installation in the landscape done the same year Graham shot the initial footage for *Edge of a Wood*. For this work guests were invited to witness the two-hour illumination of a ravine adjacent to a landscaped area surrounding Simon Fraser University on two consecutive nights. Light was cast by mercury-vapor lamps powered by a gas generator. According to Wall's description of the event, "The engine's racket and exhaust made the place seem like a worksite in the pioneering resource industries, while the flickering light produced a dream-like image of nature closed in upon itself under our distanced gaze."[14] Another of Graham's colleagues and a frequent writer about his work, Robert Linsley, eloquently describes a 1991 restaging:

> *an extraordinarily vivid industrial landscape. This*
> *violent intrusion into the night forest has many social*
> *as well as philosophical readings…but new possibilities*
> *opened up when some people began to explore more*

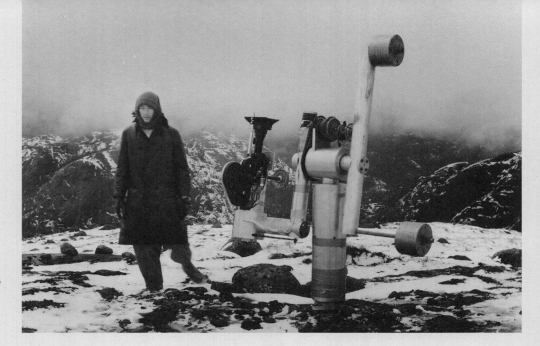

Michael Snow
Production still from *La Région Centrale*, 1970
Color film with sound
180 minutes
Courtesy of the artist

distant regions of the work, to treat it as an environ-
ment. The piece was discovered to be quite extensive as
the light spread unevenly through the trees, broke into
shadowed zones and dim clearings, and faded away....
In the lower regions of the piece, where the faintest trees
stood just beyond the most umbrous thickets, with white
teeth clenched and gleaming in the dim light, stood
revealed three Indian totem poles.[15]

Wall calls these events "nature theatre," as
opposed to Graham's less evocative term "lighting events,"
and provides the first close reading of them in terms
of the documentary tradition and their relationship to
industry and modernism. By calling these works and
the subsequent film *Two Generators* "lighting events,"
Graham aligns their production with process-based,
randomly induced events that occur in de-territorialized
patches of nature. He intuitively synthesizes the issues
of site and nonsite, entropy and intervention, investigated
so thoroughly in the works of NETCO.

There is also an important link here with experi-
mental filmmakers like Snow. He, too, turned his attention
to the inevitable Canadian subject of landscape in other
early film and photographic works, such as *Atlantic*
(1966–67), a multi-image meditation on the ocean; *La*
Région Centrale (1970), a film in which an automated
camera, mounted on a vehicle designed by the artist,
tracks the Canadian Shield landscape from dawn to dusk;
and *Plus Tard* (1977), in which Snow photographed
a series of landscapes painted by The Group of Seven,

a group of artists active during the early part of the
twentieth century whose work virtually defines the
Canadian landscape tradition. In one rather startling
production still from *La Région Centrale*, Snow—looking
like an arctic explorer flanking an oversized, antique
telescope—stands on top of a snowy peak with his
motion-control camera. (It is worth noting that in 1970
Snow exhibited this monumental apparatus as a discrete
sculpture at the National Gallery of Canada prior to
publicly showing the film itself—calling it *De La Région*
Centrale.[16] As is the case with Graham's camera-obscura
mobiles, which exist as models, sculptures, and function-
ing machines in the landscape, the apparatus of viewing
is itself the object of fascination.) In *La Région Centrale*
the classic view of the mountains is transformed into an
indecipherable, vertiginous patch of blurry ground. Like
the relentless zoom of *Wavelength* (1967), the camera's
moving pan across Snow's loft studio not only obliterates
our understanding of narrative, but exhausts the subject
altogether. Anticipating the specific choice of site in 1969,
Snow said, " I want to convey the impression of absolute
solitude, a kind of Farewell to the earth that I think we are
going through right now."[17] Though Snow and Graham
apparently have an ambivalent relationship to the nature
around them, they are intensely interested in its represen-
tation and annexation.

It is in this contentious and self-conscious
relationship to technology that I would like to frame
Graham's identity as a Canadian and link his production
to another lineage, suggesting a specifically Canadian

response to technologies of communication. Graham has often stated that the monumental and aggressive film *Two Generators* was created as a reaction against cinema, which he "neurotically hated at that time."[18] The complete title of this work is as follows: *Two Generators: A river illuminated by means of 2 self-sufficient industrial lighting systems for a duration fixed by the length of 1 roll of motion picture film.* (To insist on such an overtly Conceptualist title in the mid-1980s was itself an aggressive act.) Like *Wavelength*, *Two Generators* is technically primitive and has become apocryphally known as something it is not: the crude series of cuts that make up *Wavelength* are often remembered as a seamless zoom; and Graham's film, occasionally regarded as an interminable test of audience endurance, in fact simply unfolds according to the apparatus of its own making, its screening regulated by the conditions of projection. Instructions appearing on the label of the film canister state: "For Exhibition: to be screened in a commercial cinema. Project repeatedly over a 60–90 minute period. Projectionist note: Aspect ratio 1:1.85[.] Sound as loud as possible."[19]

As an almost environmental work of film, *Two Generators* relies on the artist's use of the film loop and enacts what might now be understood as Graham's low-grade vexation. In a fascinating text, Michael Dorland proposes the existence of the phenomenon within the national psyche:

> *vexation, like resentment, is an emotion or a form of expression that does not suddenly surface; rather, it is slow-burning and long-term. To say something is vexed… is to say that it has occurred again and again, that it is tormenting…. Like resentment…vexation is experienced repeatedly, repetitively, compulsively, and obsessionally.*[20]

While Graham's and Snow's projects, created nearly twenty years apart, critique different cinematic conventions (Graham's reacting against what he perceived as the oppressive nature of experimental film and Snow's in many ways initiating a post-structuralist relationship in opposition to narrative), there are many formal similarities between the double-projected image of the river and slow zoom of the studio. Both might be said to exist through the physical experience of endurance. While Graham's film is repetitive, compulsive, and obsessional, Snow's insistent disregard for a linear apprehension of narrative, even as the camera moves relentlessly forward in space, might also be understood as a kind of vexation. Whereas in *Two Generators* the deafening sound of the generators literally obliterates the sound of the rushing river, which is only revealed as the generators power down, in *Wavelength* silence, ambient noise, or accidental speech stands in for scripted dialogue. (In Graham's later films *The Phono-kinetoscope* [2002] and *Softcore (More Solo Guitar Music for the Sex Scene, Zabriskie Point)* [2001] music fulfills this function. In the photographic work *Fantasia for Four Hands* [2002] it is almost as if the absence of music has rendered the images still.) Similar to *Wavelength*, the abstract movement of the rushing river in *Two Generators* hypnotically fills our vision to the point of abstraction and, finally, obliteration. We are, in a sense, pinned to our chairs by the belligerence of the camera.

The notion of the perversion of technology (which follows from Snow's project as well,[21] and to which I alluded earlier in reference to Smithson's *Cinema Cavern*), of making a film that subjugates the audience through its own apparatus, exists as a kind of obverse to the pianist Glenn Gould's preference for technologically enhanced recordings over live performances. Indeed, in describing *Two Generators*, Alexander Alberro has said: "Knowingly or not, Graham's cinematographic practice thus participates in the current debate between sound theoreticians concerning what might be called 'original' sound and 'represented' or recorded sound."[22] Gould ceased performing in 1964 and retreated not only into the recording studio, but also into an abiding obsession with technologies of communication, producing numerous radio broadcasts and keeping in touch with the world almost exclusively by telephone. While the full scope of Gould's brilliance as a thinker and musician is perhaps less understood outside Canada, Graham has long been a fan, creating a work in 1994 titled *Who Am I?* based on a 1967 *High Fidelity* magazine article titled "The Search for Petula Clark," in which Gould argues for Clark's "diatonicism…to 'refute' the decadent chromaticism of the Beatles."[23] Graham created a sound piece in which

Clark's song "Who Am I?" is repeated seven times as he ambled from his studio down a hallway and onto a balcony overlooking downtown Vancouver. As Graham approached the balcony, the ambient noise from the street grew louder and blended with the song—finally overwhelming the music altogether as he crossed the threshold onto the balcony itself.

Graham's is an audio-homage to both Gould and Clark. McLuhan's evocative term "omniattentive," originally coined to characterize Gould's allergy to live performance in favor of a technologically constructed one that engenders hypersensitivity by means of isolation and control, can again be invoked here to get at Graham's creation of a down-market flâneur. Describing his intentions in the Clark sound piece, he says, "In turning my back on the pure interiority of my studio and steadfastly making my way to within the purview of the street of cinema theatres I hoped to attain, if not an oceanic feeling, at least some auditory sense of what Petula Clark's biggest Tony Hatch–penned hits (*Downtown* [1964], *I Know a Place* [1963], *Don't Sleep in the Subway* [1967]) have always afforded: a warm and beautifully bubbly version of the previously somewhat chilly crowd-bath advocated by male *flaneurs* such as Poe and Baudelaire."[24]

I am reminded here of another Gould text, "Glenn Gould Interviews Glenn Gould About Glenn Gould" (1974). It is a perfectly articulated mise-en-abîme: questions posed by an avid talker to a prolific thinker who preferred a completely artificial form of transmission. It also seems unavoidable to think of Graham's contemporary Janet Cardiff, whose brilliant sound/audio works are completely hermetic and rely on a confusion of the senses, or at least of the sensorial and cognitive hierarchies that organize how we understand what we see. *The King's Part* (1999) and *Fantasia for Four Hands* also deal with the issue of recorded sound. *Fantasia* undoubtedly takes its title from the Baroque compositional format for piano, the kind of work by Bach, for example, for which Gould had a particular passion. The title riffs on the composer's notes to the performer, i.e., "for two hands and flute." Suggestive, romantic, and full of almost kitschy virtuosity, this wonderfully descriptive title seems to describe the action and bravado of the four Rodneys who sit at the

piano, vigorously imitating the great piano duo Art Ferrante and Louis Teicher, famous for their rigorous elevator schmaltz. With characteristic humor, Graham situates his farce in a wood-paneled recording studio and is flanked not only by his twin, but by a speaker colored Yves Klein blue. The blue appears to suck the air and sound out of the room, which is somehow convincingly airless and silent anyway. Devoid of sound (one is not convinced that Graham is playing the piano), these pictures of frozen ebullience are also a tribute to Gould's post-live performance ability to fool the listener, through the sleight of technological wizardry, into thinking more than two hands played on any given recording.

Like Gould, Graham privileges the constructed as a way not to fetishize the real. This retreat provides a rather perfect segue back to one of Graham's most compelling and strikingly simple works, *Coruscating Cinnamon Granules*. The black-and-white film made in Graham's kitchen at night is another rumination on light and technology. Cinnamon granules spread over the coil of an electric stove are heated and filmed as they sparkle, fade, and disappear. The four-minute loop, shot with a stationary camera and single roll of film, is exquisitely beautiful, innocent, and ridiculous with its references to altered states of consciousness and late-night snacks. Graham has discussed the work in terms of Duchamp's *Anémic Cinéma* (1925–26) (the punning cinemascope/cinema/cinnamon of the title and the awkward primitiveness of Duchamp's kaleidoscopic imagery) and his own nostalgia for experimental film.[25] The film is viewed in a room built to the size of Graham's own kitchen, a small, prewar cavern of domesticity that also references the cookhouse of Graham's logging-camp memory. Here again, we are blissfully disoriented in the darkness. Graham's recent output as a pop musician, including *I'm a Noise Man* (1999) and the recently released *Rock Is Hard* (2003), is characterized by the same sense of simple pleasure as *Coruscating Cinnamon Granules*. These pop-music forays extend the artist's uncanny ability to parasitically inhabit various pop- and high-culture genres, but they also allow us the unfettered enjoyment of just humming along.

Finally, I want to turn to the work which Graham posits as his return to the performative—a work which

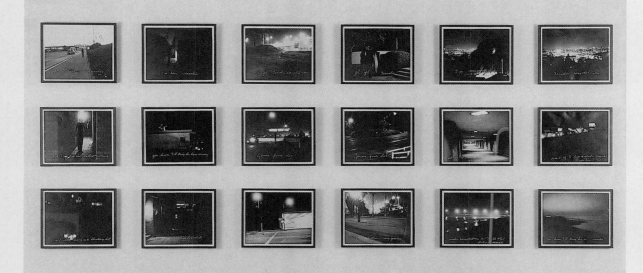

Bas Jan Ader
In Search of the Miraculous (One Night in Los Angeles), 1973
Eighteen black-and-white photographs written on in white ink
20.3 x 25.4 cm (8 x 10 in.) each
Collection Philip E. Aarons, New York

marks a break between the early forest/nature/night experiments where we began and the more recent, more spectacular film productions, including the trilogy, *The Phonokinetoscope*, and *Loudhailer* (2003). *Halcion Sleep*, which predates *Coruscating Cinnamon Granules* by two years, acts again as a kind of abstract footnote to the former's quiet return of the artist to the front and central role as performer in his own work.

If we extend the narrative of Graham's work and situate *Halcion Sleep* within this idea of an emergence from the forest into the city—literally of City Self being dislodged from the haze of Country Self's deep sleep— it becomes clear that the return of the horizontal body to the center of the picture is somehow key. We have on display in the backseat of a car the reverie of the artist, a kind of preconscious screen culled from the artist's childhood memory. Surrounding him are the windows of the car, which function as a moving triptych featuring the journey from outskirts to civilization. From the psychic darkness to the coruscating lights of embodied conscious- ness, the limp artist in the foreground yields nothing. Reversing the trope of the move from the studio to the landscape, Graham's is a journey from outside in. His body of work materializes the shift from the vacant, literary landscape and the verticality of the trees as subject, to landscape as backdrop and cliché with the body of the artist occupying center stage.[26] For it is now the vertical, performing body of the artist himself who not only dominates what Graham calls his western (*How I Became a Ramblin' Man*), tragedy (*Vexation Island*), and costume

drama (*City Self/Country Self*) that make up the trilogy, but Graham as rock star and reluctant (doomed?) pop icon, the persona that drives his musical composition and performance.

Instead of citing Graham's references to the Big Sleep of film-noir heroes as the locus for *Halcion Sleep*, I would like to suggest three fascinating and quite differently conceived works (one created in Los Angeles, the other two in Canada) as antecedents for Graham's film. Bas Jan Ader's *In Search of the Miraculous (One Night in Los Angeles)* (1973) is one of the most haunting works the Dutch-born artist made in his short career. Literally a nighttime traverse across the city, the black-and-white photo work documents the artist's encounters over the course of one night. At times the artist appears in silhou- ette—a Friedrichian figure gazing out across the city in awe, longing, and self-reflection. Indeed, the journey appears to be one inward toward the center of the self. Ader's journey is both touching and hallucinatory. Despite the photographic evidence, we are never quite sure what actually happens anywhere outside our imaginations. The photographs jump from hilltop to city street: the viewer is left to map the locations and views, though given only a few shadowy landmarks to go on.

Graham and Ader share a number of strategies— including repetition, an attraction to the uncanny, physical humor, and gags—and a nagging yearning to cross the ocean and reach the European homeland they eternally resist. Both Graham and Ader recall being influenced by Chris Burden's performance experiments—works such as

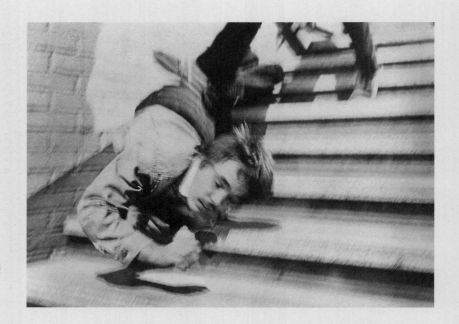

Chris Burden
Kunst Kick, 19 June 1974
Performance at Feldman Fine Arts, Basel
Art Fair, Basel, Switzerland
Courtesy of the artist

Kunst Kick (19 June 1974), a gag in which the artist was humiliated by being kicked repeatedly down flights of stairs, or *Bed Piece* (18 February–10 March 1972), in which he slept in the gallery for a prescribed period of time. In these works it is the consciousness of the artist that is both put on display and eternally withheld from the viewer. We project onto the performing subject: "It is as if for Graham the Freudian term 'screen memory,' a false memory produced to hide a real one, is made literal, in the form of a hallucinatory celluloid fantasy of idyllic escape and artificial paradise."[27] Graham's drug-induced amnesia, his Halcion sleep, inscribes a journey of perpetual obfuscation.

In 1981 the Toronto-based artist John Massey made a 16-mm film titled *As the Hammer Strikes*, which he more recently reconfigured as a three-projection video installation. The work reenacts a journey the artist once made, driving his van from the outskirts to the city center and engaging in conversation with a hitchhiker. Images of the tape recorder originally used to tape the strangely stilted dialogue of two anonymous men finding common ground in a rambling discussion of strip clubs and roadside incidentals, juxtaposed with close-ups of the driver and hitchhiker, combine disarmingly to comment on language and space. The "hammer" of the title is literally the hammering out of banal information in a completely unremarkable situation.

According to Massey, he was interested in the spatial implications of conversation: in short, what it means to talk to another person.[28] What is striking and germane to the discussion of Graham's drug-induced,

parallel crosstown journey is the way that the rural and urban landscape are experienced through the rhythm and movement of narrative and its lack. Space and time, and the movement through, are inscribed by the awkward, at times disjointed, dialogue between two men—one the citified, more sophisticated artist who probes his passenger with the gentle curiosity of an anthropologist, the other a drifter with a speech impediment. The images that constitute the center of the narrative are in black and white, while striptease footage and clips from the TV program *That's Incredible* (1980–84) appear, in lurid color, together with other popular cultural references. These color interludes function, like the car windows in Graham's *Halcion Sleep*, as projections that stand in for the narrative that we either don't have access to (in the case of Graham's somnolent resistance) or can't fully comprehend (in the case of Massey's portrait of two men who might as well be from different planets). The road-movie aspect of Massey's work—the windshield wipers creating syncopated parentheses around the rural landscape and punctuating the otherwise stilted dialogue—is unmistakable and recalls such films as *Five Easy Pieces* (1970), in which the masculinist construction of language is disrupted and rendered impotent.

What all this has to do with Graham seems to be a generalized impulse at representing the relationship of language and communication to landscape. And it is in this connection that I want to conclude with a brief discussion of one final work, partly because in discovering it recently myself, I find Gould's "The Idea of North"

John Massey
As the Hammer Strikes (A Partial Illustration), 1982
Three-channel synchronized DVD installation
(reconstructed from 16-mm film installation)
30 minutes
Courtesy of the artist

CBC poster for Glenn Gould's radio program
The Idea of North, 1967

(1967) one of the most vividly evocative and beautiful works I can think of, and because it in a way returns us to the place where we started—the landscape. "The Idea of North" was a CBC radio broadcast recorded as part of a trilogy on the idea of solitude, or "Different levels of solitude and how enforced solitude affects people."[29] If we have seen that Graham traverses the land on a journey that somehow metaphorically removes him from isolation through a kind of blissful aloneness, Gould's radio broadcast transports the listener to a place of extreme isolation, the Canadian north, through a cacophony of testimonials from people who actually live there. The radio broadcast is literally a fugue of contrapuntal voices orchestrated by the technologically assisted ear and mind of Gould. An addition to the sheer poetics of the idea of a universal blanket of sound that exists in the ether as so much aural information to be plucked from at will, Gould was also clearly influenced by the radical thinking of McLuhan, who anticipated the emergence of a "global village" by predicting that the reach of technology would allow people to live isolated from urban centers, connected only electronically. "My main theme is the extension of the nervous system in the electric age, and thus, the complete break with 5,000 years of mechanical technology."[30]

In his discussion of Gould as cultural phenomenon, Richard Kostelanetz characterizes the relationship of Gould's city and country selves: "In background, the cosmopolite is indubitably a provincial; yet this isolation from cultural fashion probably endowed him with that eccentric individualism that, once the world accepted it,

made him extremely cosmopolitan."[31] What's compelling about Graham is, of course, just this vacillation, which is apparently precisely where his Canadianness lies. From the deep woods of *75 Polaroids* to the self-styled, pajama-clad artist emerging via a self-induced return to a dreamy oblivion, there is an immensely satisfying body of work that juggles these two identities and histories with the delectation of someone who can barely hold them both in his own vision. A light, rangy tune from one of Graham's loungy pop songs called "Man, I Really Miss the Coast" muses on the mixed blessing of his nomadism and his longing for home:

> Man I really miss the coast…
> I'm thinkin about shippin ashore
> I really miss the coast
> You'll never believe who showed up at the door
> Vienna's cool and all but where's the coast?
> The best that I can say is
> Sigmund Freud is still the most

The title of this text is taken from a passage in William Kilbourn's book, *Canada: A Guide to the Peaceable Kingdom* (Toronto: Macmillan of Canada, 1971), xiv. The full quote is as follows: "Outnumbered by the trees and unable to lick them, a lot of Canadians look as though they had joined them…as if…something long lost and dear were being endlessly regretted."

1: Margaret Atwood, *Survival: A Thematic Guide to Canadian Literature* (Toronto: Anansi, 1972), 33.

2: Harold Innis, quoted in Arthur Kroker, *Technology and the Canadian Mind: Innis/McLuhan/Grant* (Montreal: New World Perspectives, 1984), 392.

3: Emile Van Balberghe and Yves Gevaert, in *Rodney Graham: Works from 1976 to 1994*, exh. cat. (Toronto: Art Gallery of York University; Brussels: Yves Gevaert; and Chicago: The Renaissance Society at the University of Chicago, 1994), 64.

4: Artist's notes on *Aberdeen*, in *Rodney Graham*, exh. cat. (London: Whitechapel Art Gallery, 2002), 90. Describing this work, Graham says, "I was curious to see this so-called 'redneck' town towards which Cobain as a songwriter had vented so much fury but of which he was also clearly a product…. Is it the charm of the exotic, the lure of what Brian Wilson of the Beach Boys called 'the nearest faraway place'?" Carolyn Christov-Bakargiev begins her essay in that catalogue remembering that Graham suggested using an eighteenth-century map, predating the colonial settlement of western Canada, as the cover for a mid-1980s exhibition catalogue that included four Canadian artists, which again points to Graham's own ambivalent relationship to his home as wilderness. The precolonial map as cover or illustration has become the common sign for the "discovery" of postcolonial artistic outposts outside western Europe and North America.

5: Lucy R. Lippard, "Vancouver," *ARTnews* 76, no. 5 (September 1968): 26, 70.

6: See description in "Chronology of Artist-Initiated Activity in Canada, 1939–1987," in *From Sea to Shining Sea*, exh. cat. (Toronto: The Power Plant, 1987), 30.

7: Graham specifically cites *Partially Buried Woodshed* (1970). See Matthew Teitelbaum's brief discussion of Robert Smithson's influence in "Returning to the Present or Writing a Place in the World: Rodney Graham," in *Rodney Graham* (1994), 34. There is also a more lengthy discussion of Smithson's time in Vancouver in Robert Linsley's "Landscape and Literature in the Art of British Columbia," in *Vancouver: Representing the Postmodern City*, ed. Paul Delany (Vancouver: Arsenal Pulp Press, 1994), 193–216.

8: See Michael Turner, "This Land Is Your Land," in *Hammertown*, exh. cat. (Edinburgh: The Fruitmarket Gallery; and Vancouver: Contemporary Art Gallery, 2002). Turner says about the emerging Vancouver group of artists: "Landscape figures strongly in the work of these artists. So does space, the availability of which distinguishes a younger west coast from an older, more storied east, perhaps accounting for the monumental scale in which many of these artists have been working. Further to that I would add an interest in social, aesthetic, and technological histories." Ibid., 11.

9: Jeff Wall, "'Marks of Indifference': Aspects of Photography in, or as, Conceptual Art," in *Reconsidering the Object of Art: 1965–1975*, exh. cat. (Los Angeles: The Museum of Contemporary Art; and Cambridge, Massachusetts: The MIT Press, 1995), 255.

10: There is another interesting narrative here: the way Graham's work has been written into, or not, the recent history of Canadian art. While his work has received much attention in Europe, the United Kingdom and, to a lesser extent, New York, and has been the subject of numerous one-person exhibitions in Canada, his work has largely been left out of recent anthologies of postwar Canadian art.

11: Christov-Bakargiev, "An Upside Down and Inside Outside World," in *Rodney Graham* (2002), 13.

12: Robert Smithson, in "'…The Earth, Subject to Cataclysms, Is a Cruel Master'," interview with Gregoire Müller, in *Robert Smithson: The Collected Writings*, ed. Jack Flam (Berkeley, California: University of California Press, 1996), 261.

13: See Wall, "Into the Forest: Two Sketches for Studies of Rodney Graham's work," in *Rodney Graham*, exh. cat. (Vancouver: Vancouver Art Gallery, 1988), 9–37.

14: Ibid., 33. Vis-à-vis Vancouver's colonial history and its relationship to the timber industry, "The masters of B.C.'s semi-colonial, natural resource-based economy regard the natural world as simply an obstinate material form of future money which must be transmuted into real money as quickly as possible. The standing tree is an affront to these 'owners of nature,' whose totem poles must lie in piles on trucks. The same tree, however, remains a real, living totem to the citizen-ecologists struggling to retain tracts of land for the sake of a rational future." Ibid., 14.

15: Linsley, "Landscape and Literature in the Art of British Columbia," in *Vancouver*, 214.

16: Snow, in "A Selected Chronology: 1970–1993," in *The Michael Snow Project: Visual Art, 1951–1993*, exh. cat. (Toronto: Art Gallery of Ontario, The Power Plant, and Alfred A. Knopf Canada, 1994), 515. Snow's work was included in the exhibition "17 Canadian Artists: A Protean View" at the Vancouver Art Gallery in 1976.

17: Raymond Gervais, "The Recorded Music of Michael Snow," *The Michael Snow Project: Music/Sound 1948–1993*, exh. cat. (Toronto: Art Gallery of Ontario, The Power Plant, and Alfred A. Knopf Canada, 1994), 271.

18: Graham, in Alexander Alberro, "Demystifying the Image: The Film and Video Work of Rodney Graham," in *Rodney Graham: Cinema Music Video*, exh. cat. (Vienna: Kunsthalle; and Brussels: Yves Gevaert Verlag, 1999), 75.

19: A facsimile of this label is reproduced in *Rodney Graham* (1994), 100.

20: Michael Dorland, "A Thoroughly Hidden Country: *Ressentiment*, Canadian Nationalism, Canadian Culture," in *SightLines: Reading Contemporary Canadian Art*, ed. Jessica Bradley and Lesley Johnstone (Toronto: Artextes editions, 1994), 44.

21: "To Michael Snow, cinema is a machine; not a machine for filming pictures and events prepared for it, but more like a land-clearing machine, an earthmover, or rather eyemover—that is to

say, a machine that gives the eye the power to upset the visible world." Alain Fleischer, "Michael Snow's Cinemachine," in *Michael Snow: Panoramique. Oeuvres Photographiques & Films/ Photographic Works & Films, 1962–1999*, exh. cat. (Brussels: Société des Expositions du Palais des Beaux-Arts and Cinémathèque royale de Belgique; Paris: Centre national de la photographie; and Geneva, Switzerland: Centre pour l'image contemporaine, Saint-Gervais, 1999), 53.

22: Alberro, "Demystifying the Image," 76.

23: Graham, sleeve notes on *Who Am I?*, shown in conjunction with an exhibition at Angles Gallery, Santa Monica, 1994.

24: Ibid. Graham also mentions the artist Stephen Prina, whose own interest in music and performance parallels Graham's.

25: Author's notes from an interview between the artist and Sara Krajewski, Madison Museum of Contemporary Art, Madison, Wisconsin, 8 March 2003.

26: See Dorland's discussion of the shift from figure to image in "A Thoroughly Hidden Country," 57–59.

27: Alberro, "Loop Dreams: Rodney Graham's *Vexation Island*," *Artforum* 36, no. 6 (February 1998): 108.

28: Massey, in conversation with the author, June 2003.

29: Description quoted from an advertisement for the radio program. For a lovely visual approximation of this broadcast, see the film *Thirty Two Short Films About Glenn Gould* (1993, dir. François Girard).

30: McLuhan, as quoted in Alexander Stille, "Marshall McLuhan Is Back From the Dustbin of History," *The New York Times*, 14 October 2000, B9.

31: Richard Kostelanetz, "The Glenn Gould Variations," in *Canada*, 324.

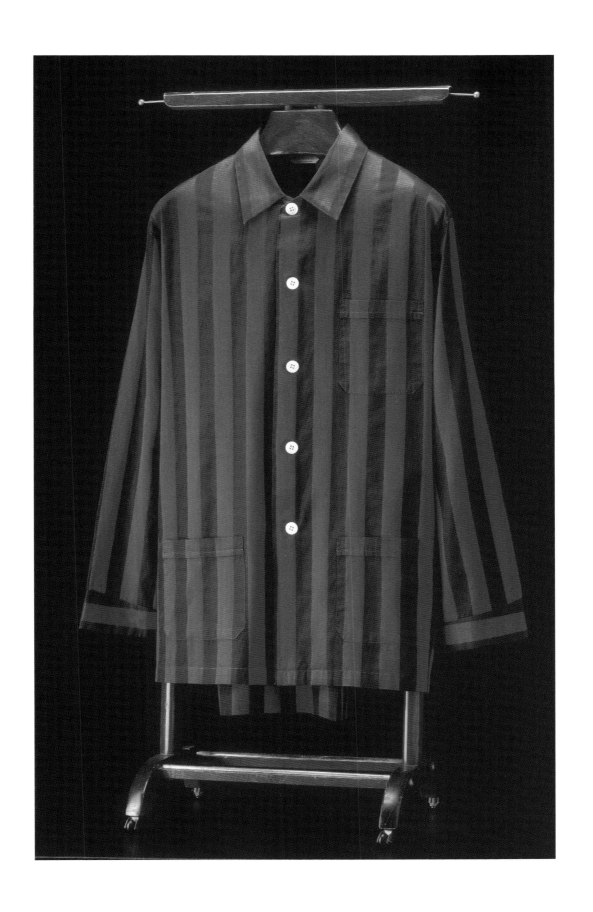

Pajamas from *Halcion Sleep*, 1994

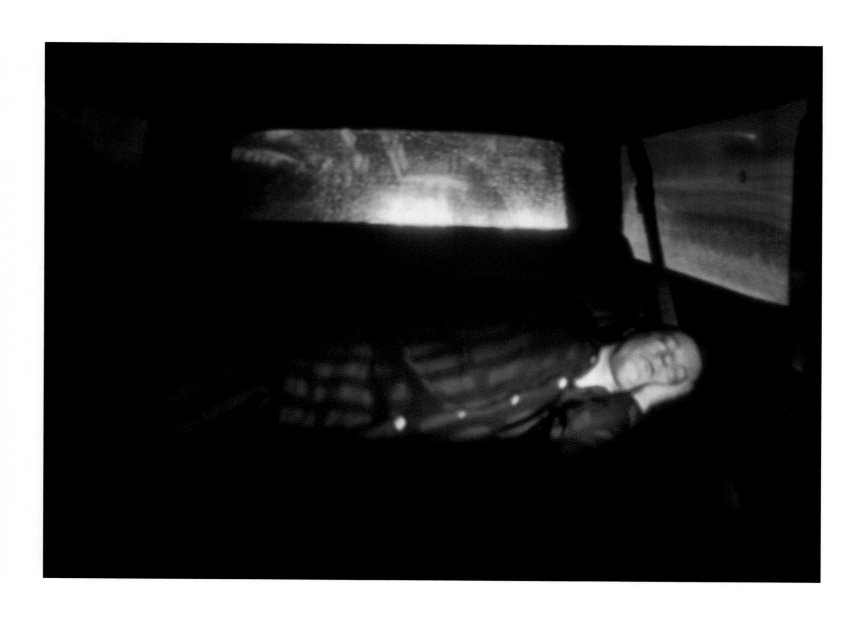

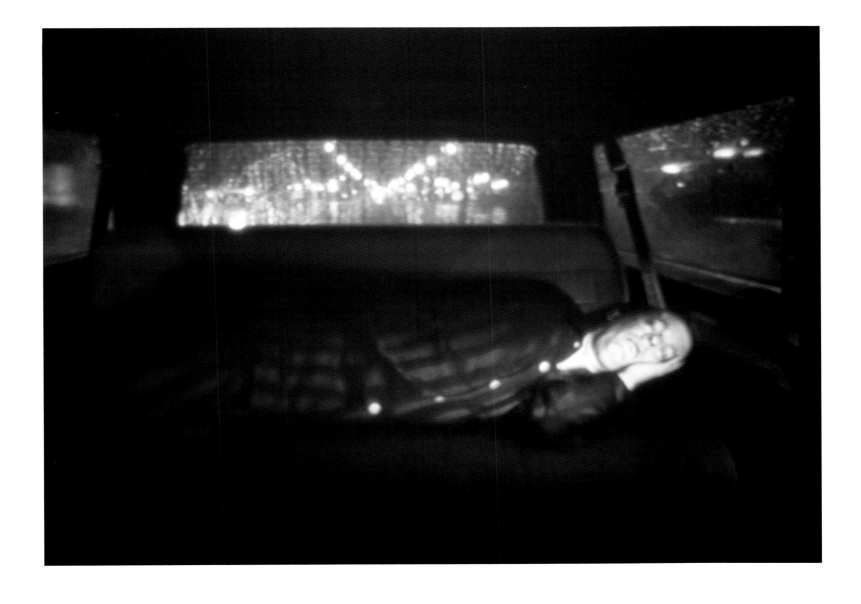

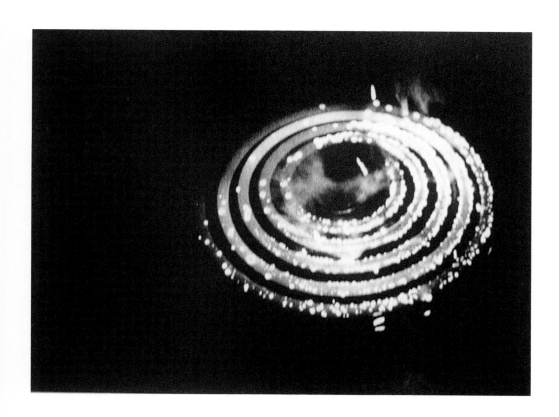

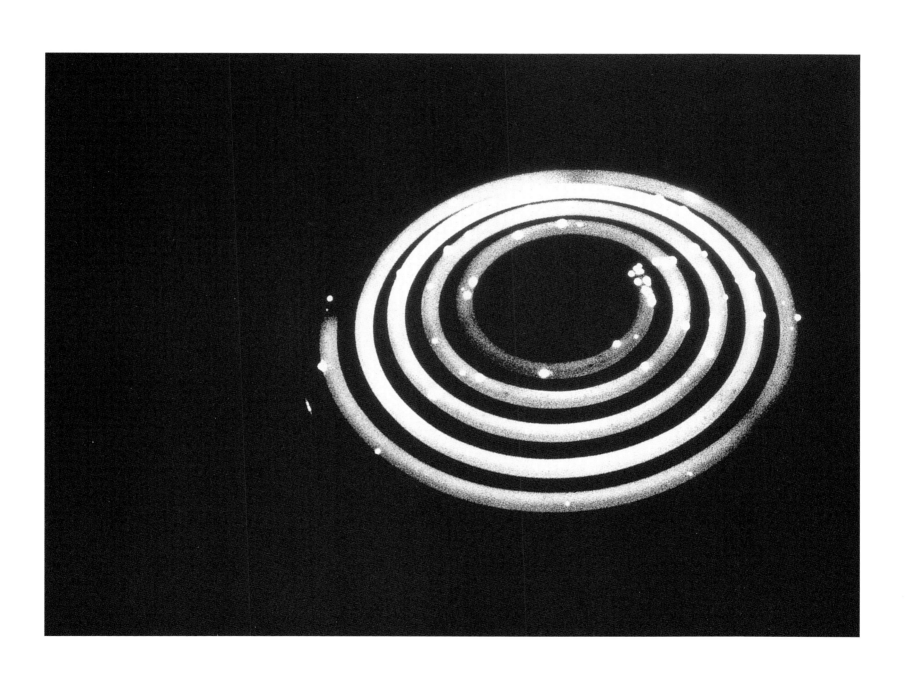

Stills from *Coruscating Cinnamon Granules*, 1996

Looping mechanism from *Coruscating Cinnamon Granules*, 1996

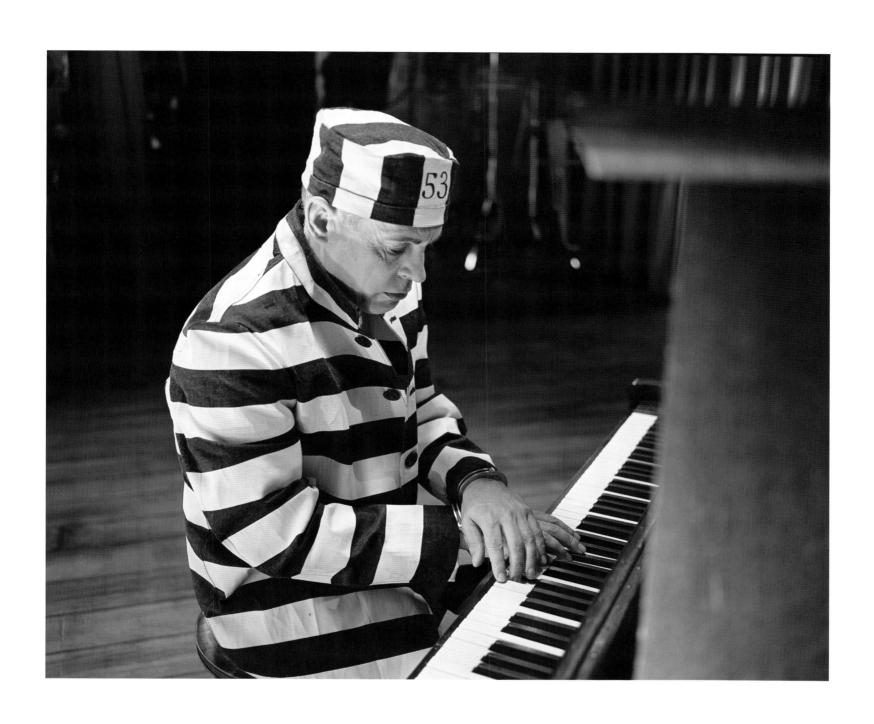

Production still from *A Reverie Interrupted by the Police*, 2003

Details from *Aberdeen*, 2000

Camera Obscura, 1979

Detail of *Camera Obscura*, 1979

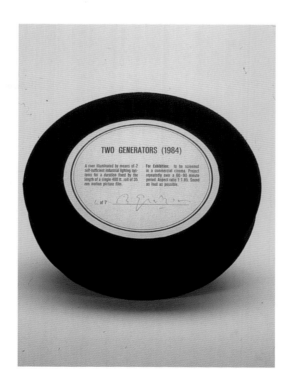

Film canister from *Two Generators*, 1984

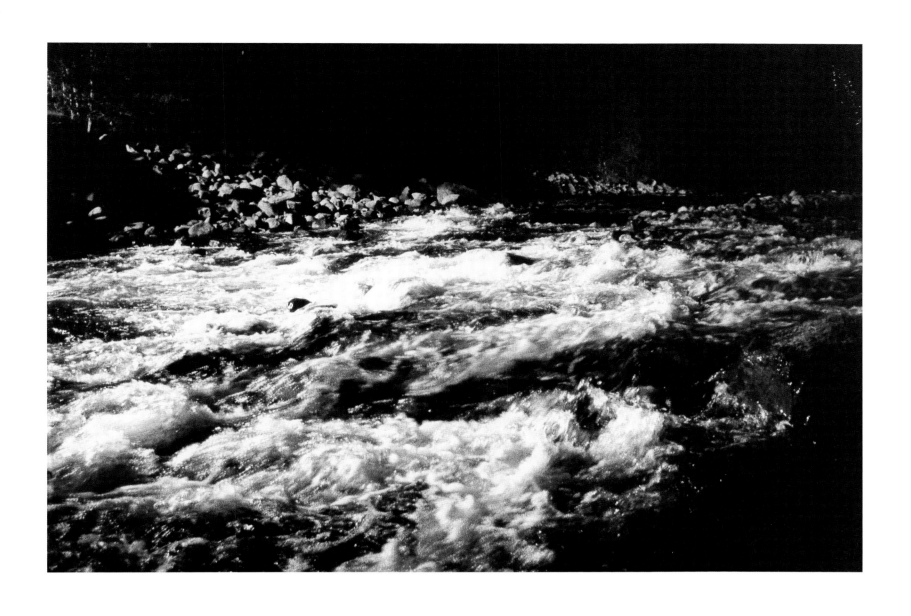

Still from *Two Generators*, 1984

Edge of a Wood, 1999

Details from *75 Polaroids*, 1976
Seventy-five flash photographs mounted, matted, and framed
370 x 370 cm (145 5/8 x 145 5/8 in.) overall
Flick Collection

75 Polaroids, 1976
Installation, Dia Center for the Arts, New York, 1999

Production still from *Loudhailer*, 2003
Two 35-mm films with two film projectors and loopers;
separate CD soundtrack
10 min. double unsynchronized projections on continuous
loops; 3 min. audio soundtrack on continuous loop
Edition of 5 and artist's proof
Displayed with costumes and props
Produced by Donald Young Gallery, Chicago; and Hauser
& Wirth, Zürich
Courtesy Donald Young Gallery, Chicago

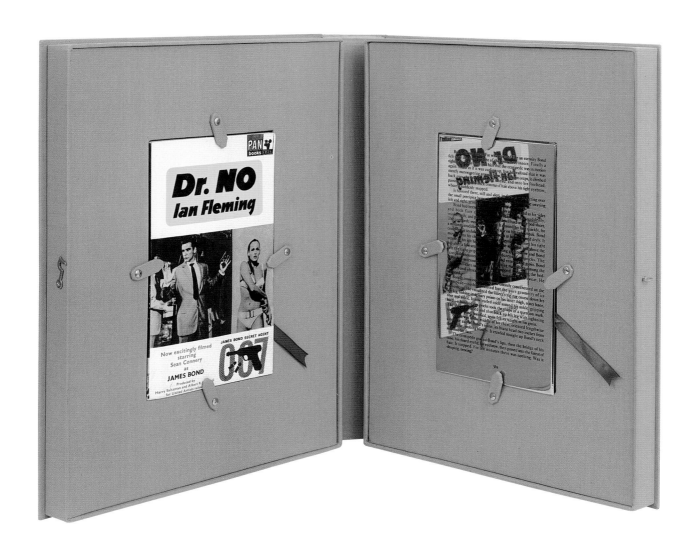

Dr No★, 1991–93
Movie edition of *Dr. No* with stainless-steel
page in fabric-covered case
5 x 32 x 27 cm (2 x 12 5/8 x 10 5/8 in.);
edition of 2

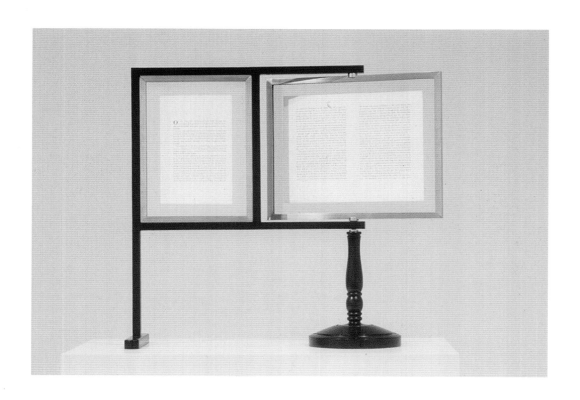

Reading Machine for Lenz, 1993

out, darkness swallowed up all things. He felt gripped by an unnamable fear. He leapt from bed, ran down the stairs to the front of the house; but all in vain, everything was dark, nothing—he himself was a dream. Isolated thoughts rushed through his mind; he held fast to them. It seemed he should be always repeating the "Lord's Prayer". He was lost; an obscure instinct drove him to save himself. He thrust himself against the stones, he tore himself with his nails; the pain began, bringing him to his senses. He threw himself into the fountain, but the water wasn't deep, he splashed about.

People began to gather; they had heard the noise and called to him. Oberlin came running. Lenz had come to himself, he was wholly conscious of the situation, he felt relieved. He felt ashamed now and distressed that he had caused these kind people so much anxiety. He told them he was accustomed to bathing in cold water, and went back to his room. His exhaustion allowed him some repose.

The next morning everything went well. He and Oberlin rode through the valley on horseback; wide mountain slopes which at a great height shrank into a narrow, winding valley, which twisted its way to the heights in many directions; great masses of stone that grew broad at their bases; a few trees, but everything with a gray, somber tinge; a view towards the west across the countryside and the mountain chain that ran in a north-south direction, whose peaks towered there in quiet, earnest strength, as though in a twilit dream. At times intense masses of light rose from the valley like a flood of gold; then clouds again, which lay on the topmost peaks, and then slowly descended into the valley through the forest, and voices awakened on the rocky slopes, one moment like distant echoing thunder and the next like a powerful surge that sounded as though in its uncontrolled jubilation it wanted to celebrate the earth. The clouds, like wild, neighing horses, sprang forward, and the sun shone through them and penetrated the snowfields with its glittering sword, so that a bright, blinding light cut its way down from the summits into the valleys. Or sometimes the storm drove the clouds downwards, tearing them apart to reveal a light blue lake, and then the wind echoed and, from the depths of the gorge, from the tops of the pines, hummed its way up like a cradle song and the chiming of bells. A faint crimson ascended the deep blue of the sky and tiny clouds on silver wings sailed through it, and all the mountain peaks, strong and stable, glittered and sparkled across the landscape. All this tore into his breast; he stood there, gasping for breath, his body bent forwards, eyes and mouth wide open. He felt as if he must pull the storm inside himself, contain all things in himself; he stretched himself out and lay across the earth, he burrowed himself into the universe, as though it were a joy that caused him pain; or else he stopped and laid his head in the moss and half closed his eyes, and then it all went far away from him, the earth sunk from under him, it grew small as a wandering star and dipped into a raging storm whose clear waters swept beneath him. But these were only moments; then he rose, clear-headed, strong, calm, as though a shadow-play had passed before him—he knew nothing of what had happened.

Toward evening he arrived at the summit of the mountain, the snowfield, from which one began to make one's

Detail of text from *Reading Machine for Lenz*, 1993

White Shirt (for Mallarmé) Spring 1993, 1992
(with the collaboration of Ann Demeulemeester)
White cotton shirt around handmade watercolor board and Japanese
tissue paper, boxed and displayed with Stéphane Mallarmé's prose
poem *The Demon of Analogy*
Box: 41.5 x 32 x 6 cm (16 x 12 1/2 x 2 in.); edition of 21

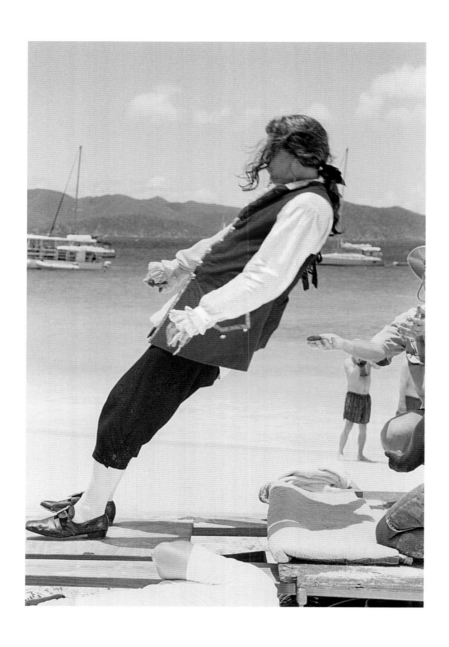

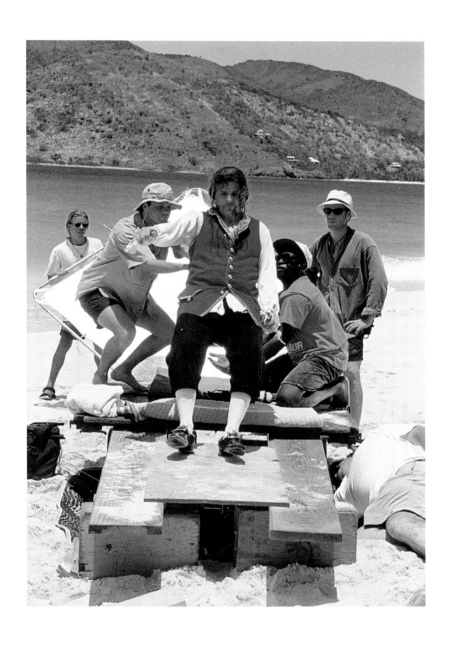

Production stills from *Vexation Island*, 1997

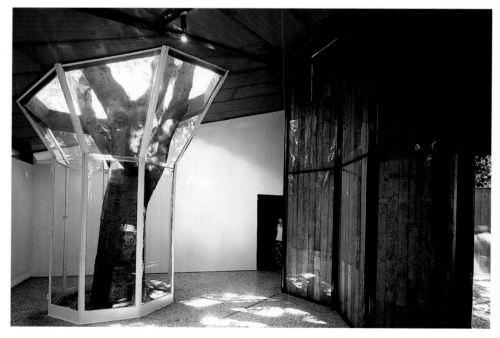

Views of the Canadian Pavilion,
Venice Biennale, Venice, 1997

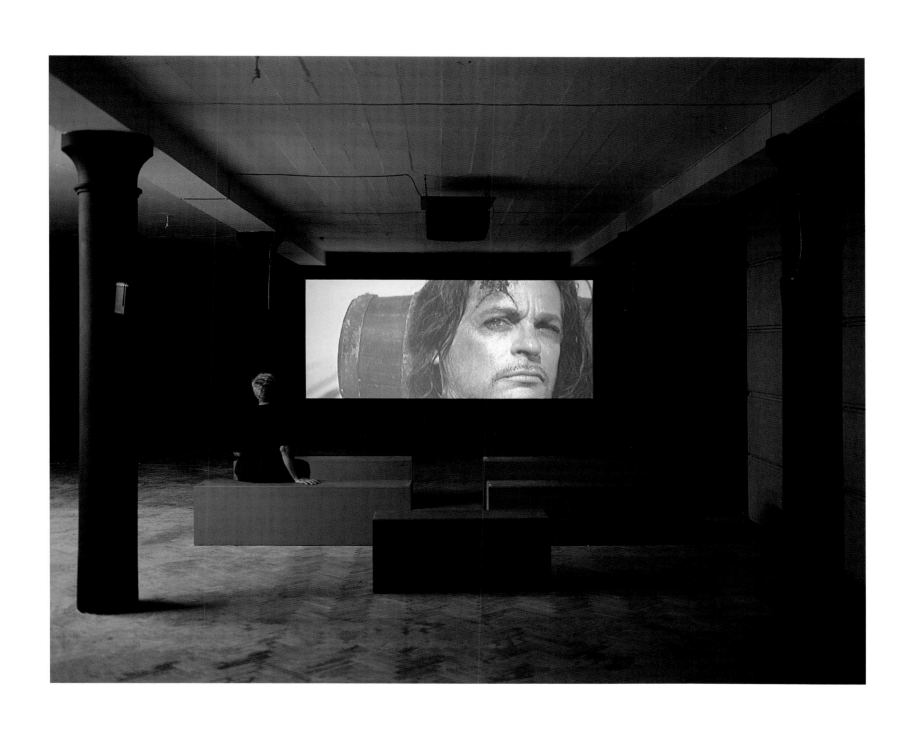

Installation of *Vexation Island*,
Lisson Gallery, London, 1998

175

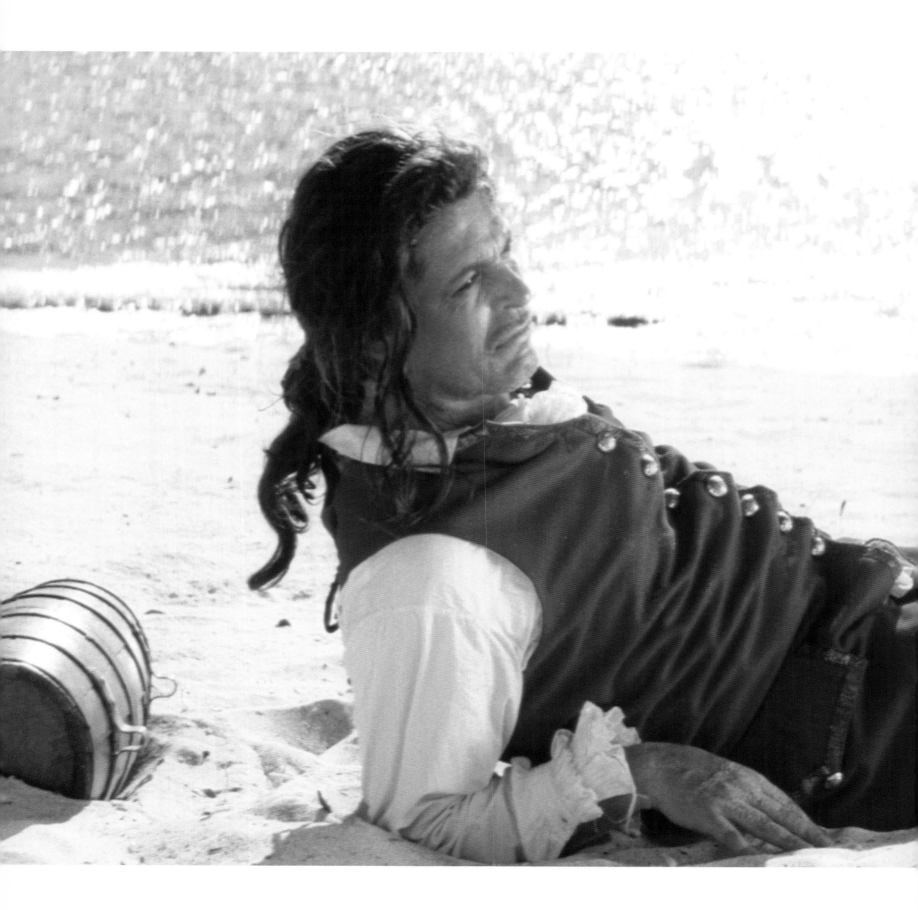

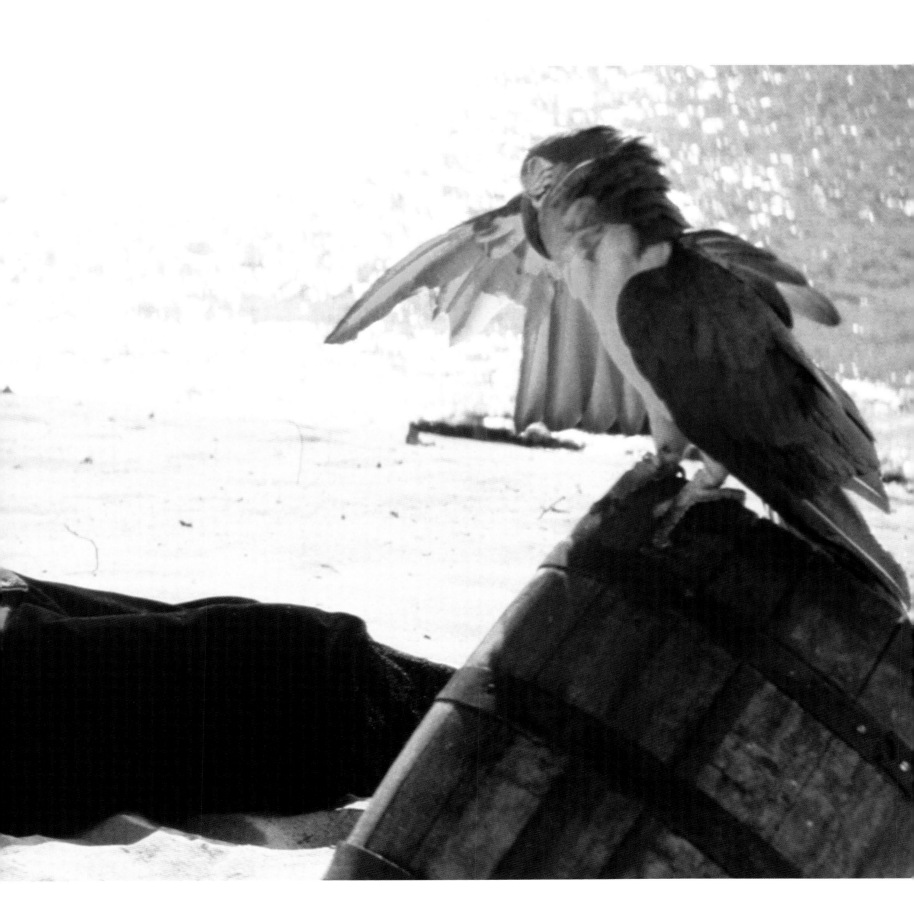

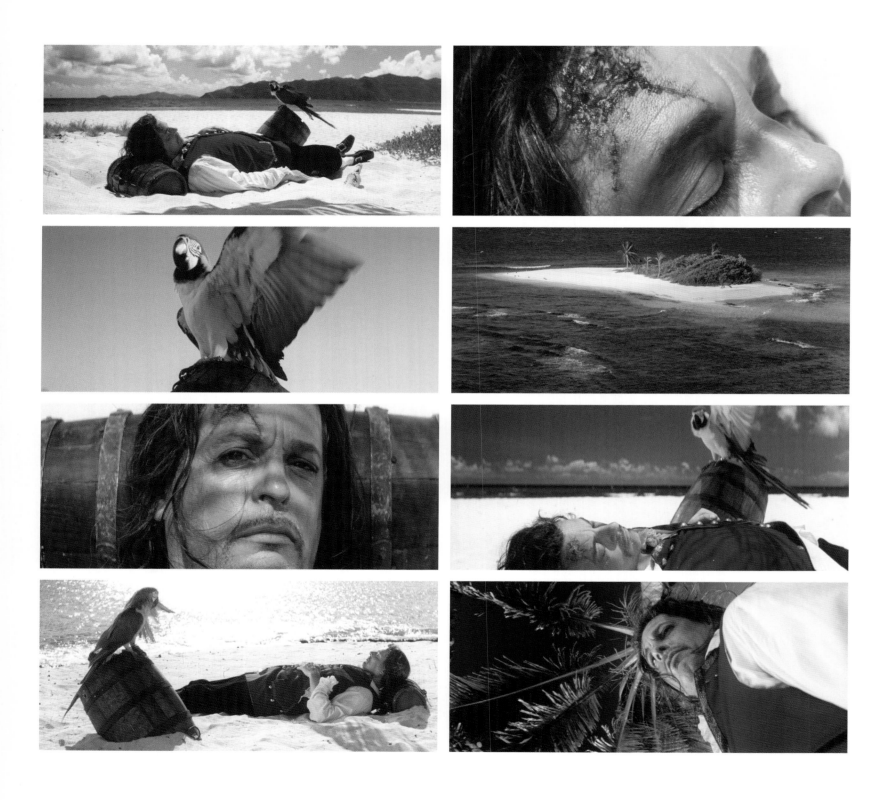

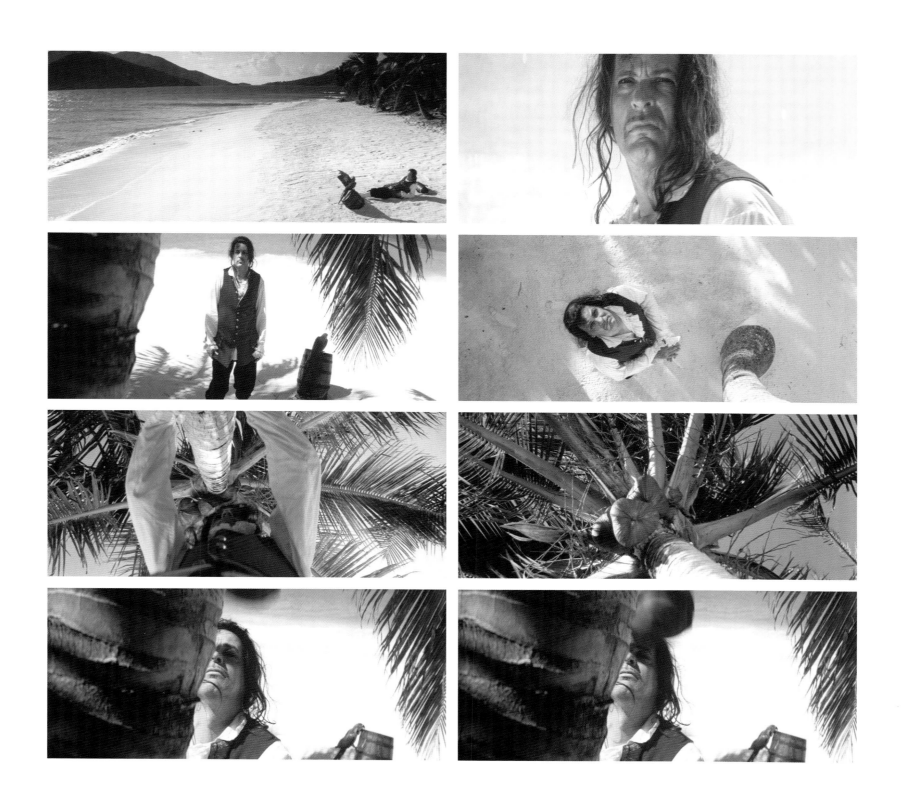

Stills from *Vexation Island*, 1997

"It Always Makes Me Nervous
When Nature Has No Purpose":
An Annotated Chronology of the
Life and Work of Rodney Graham
by
Grant Arnold

Rodney Graham at age four in Harbour Chines

Graham at age 14, smoking a cigar in a
logging camp bunkhouse near Tahsis, B.C.
On the wall behind Graham is his copy of
John Coltrane's *A Love Supreme*, 1964

1949–63

William Rodney Graham is born on 16 January 1949 in Abbotsford, a village in British Columbia's Fraser Valley, about ninety kilometers east of Vancouver. He is the first of three children. His mother, Janet, is a schoolteacher; his father, Richard, is a manager with a logging company owned by Graham's uncle. Partly due to the requirements of his father's work, Graham's family relocates several times during the 1950s. In addition to Abbotsford, they live in a logging camp near Port Douglas and in a suburban housing development, Harbour Chines, between the Fraser River and Burrard Inlet near Vancouver. Accounts of Graham's early years are marked by Huckleberry Finn–style escapades: hiding salamanders under place settings and acting out adventure fantasies in the woods. In a somewhat portentous episode, Graham blacks out while on a rope swing at the edge of a ravine in Harbour Chines. Losing consciousness as he swings out into space, he plummets into the ravine but avoids injury when his fall is cushioned by a rotten log. Among his most vivid memories are the feature films his father projected on a folding screen in a lumber-camp cookhouse:

Recollection long ago led me to the discovery of a personal substratum of screen memories: these include James Stewart at the prison whipping-post in Carbine Williams, *Stewart Granger's narrow escape from impalement by a falling chandelier in* Scaramouche, *snakes and insects extracted from a black puddle and eaten by the starving explorers in* Northwest Passage, *the empty spotlight in* The Red Shoes, *the puppets in* Lili. *The list is finite because these beautiful if tawdry cinematic recollections date from my fourth year when I lived with my family in a logging camp in British Columbia where my father was a camp-manager, cook (during a strike of the catering crew) and projectionist. The latter function he filled only on Sundays, when films were shown in the cookhouse. I attended these screenings and thus…remained in close proximity not only to patriarchal authority but also to the cinematic apparatus itself.*
—Graham, "Siting Vexation Island," in *Island Thought: Canada XLVII Biennale di Venezia* (North York, Canada: Art Gallery of York University, 1997), 9–10.

1964–67

Graham's family moves to the upper-middle-class Vancouver neighborhood of Kerrisdale. Graham begins high school, which he finds "completely repressive." During the year leading up to graduation his primary interest is finding pot, which he notes "wasn't easy." He plays rhythm guitar and sings with several garage bands that emulate the music of the Yardbirds and the Rolling Stones.

1968–71

In 1968 Graham enrolls in the general arts program at the University of British Columbia (UBC) in Vancouver. His courses include history, anthropology, English literature, French literature in translation, studio art, and art history. Graham initially intends to major in literature. However, the art history courses taught by Vancouver artist Ian Wallace, which focus as much on contemporary as historical material, divert his attention toward visual art:

Ian was covering absolutely current things: he would show slides of a [Donald] Judd exhibition currently on in New York and discuss Robert Smithson and Dan Graham. All sorts of people were sitting in on his class because it was so informative about what was going on. It was a real scene, unlike anything I got into in the English department. The art world seemed romantic, exciting.

Wallace's courses provide entry into a community in which current art-world issues are debated. Through Wallace, Graham meets artists Robert Kleyn, Duane Lunden, Christos Dikeakos, Tom Burrows, and Frank Johnston. He reads Jeff Wall's M.A. thesis on Berlin Dada. He also encounters the writing of Claude Lévi-Strauss, Jacques Lacan, and Michel Foucault. He writes a paper on Foucault's analysis of Diego Velázquez's *Las Meninas* (1656) for a course in structural anthropology.

Representation undertakes to represent itself here in all its elements, with its images, the eyes to which it is offered, the faces it makes visible, the gestures that call it into being. But there, in the midst of this dispersion which it is simultaneously grouping together and spreading out before us, indicated compellingly from every side, is an essential void: the necessary disappearance of that which is its foundation—of the person it resembles and the person in whose eyes it is only a resemblance. This very subject…has been elided. And representation, freed finally from the relation that was impeding it, can offer itself as representation in its pure form.
—Foucault, "Las Meninas," in *The Order of Things* (New York: Vintage Books, 1973), 16.

Wallace introduces him to the work of French writer Raymond Roussel. Graham develops a long-standing interest in Roussel's work—its hallucinatory sensibility; punning character; emphasis on repetition; and systematic, gamelike compositional structure:

I choose two almost identical words (reminiscent of metagrams). For example, billiard *[billiard table] and* pilliard *[plunderer]. To these I added similar words capable of two different meanings, thus obtaining two almost identical phrases. The two phrases found, it was a case of writing a story which could begin with the first and end with the latter…. Expanding this method, I began to search for new words relating to* billiard, *always giving them a meaning other than that which first came to mind, and each time this provided me with a further creation.*
—Roussel, *How I Wrote Certain of My Books* (1935; reprint, Boston: Exact Change, 1995), 3–5.

Despite his interest in French literature and philosophy, Graham drops out of French 110 three times. He is not particularly productive in his studio courses.

1972

Graham meets Wall and David Wisdom, who have recently returned to Vancouver from London. Wall becomes a mentor and supporter of Graham's art. Wisdom's extensive knowledge of music in general, and the contemporary rock scene in particular, becomes an important touchstone for Graham.

During the summer Graham, Johnston, and Kleyn work on a project funded through the Opportunity for Youth program, documenting historic architecture of the Fraser Valley. Wallace sometimes accompanies them and photographs the structures they are researching. Graham recounts that he spent the summer "driving around the countryside looking at *Landor's Cottage*–type buildings."

Graham begins a fourteen-year stint as a part-time worker within the provincially run liquor-distribution system.

1973

Graham leaves UBC with the understanding that he has not completed the requirements for a Bachelor of Arts degree.

Graham, Wallace, and Wall receive funding from the Canada Council for the Arts

Detail of *Pleasures of the Text*,
1974

Invitation card, The Pender Street
Gallery, Vancouver, 1976
Photograph on card by Graham

Left to right: Kitty Byrne, Jeff Wall, and Graham of the UJ3RK5,
with the set for Wall's *The Destroyed Room*, 1978

toward the production of a film. Inspired by Alfred Hitchcock's *Marnie* (1964), the film is intended as a "structuralist take on Hitchcock" with a female kleptomaniac as the central character. Although Wall eventually completes a script, the film is never finished. *Stills from a work in progress*, photographic studies for the project, are exhibited in "Pacific Vibrations" at the Vancouver Art Gallery.

Graham meets William Gibson, an American expatriate who arrived in Vancouver in 1972. Gibson will later become widely known as one of the founders of cyberpunk, a literary genre that articulates a pessimistic view of the future in which technology enables the pervasive corporate control of daily life.

EXHIBITIONS
"Pacific Vibrations," Vancouver Art Gallery, Vancouver

1974

Graham produces a series of diazo prints titled *Pleasures of the Text*. The title is a reference to Roland Barthes's *Le plaisir du texte*, published in 1973. The prints are derived from tracings of images of fashion model Karen Graham from advertisements for Estée Lauder cosmetics.

> *In zoological terms, one could say that the site of textual pleasure is not the relation of mimic and model (imitative relation) but solely that of dupe and mimic (relation of desire, of production).*
> —Barthes, *The Pleasure of the Text*, trans. Richard Miller (New York: Hill and Wang, 1975), 55.

1976

Graham produces *75 Polaroids*, his first photographic work, consisting of seventy-five Polaroid photographs made with a flash at night in a forested area on the suburban fringes of Vancouver. The photographs are presented as a frieze extending across three black walls of a purpose-built room in the gallery. *75 Polaroids* is first exhibited at Vancouver's Pender Street Gallery, run by Willard Holmes and Kathleen (Kitty) Byrne. The work is later remade for an exhibition at Galería Marga Paz in Madrid in 1987.

> *The artist is interested in nature—roots, trees, shrubbery, ferns, the sea crashing over rocks. But they are random, uncomposed snapshots, similar in some respects to pictures in family albums with heads partially cropped or the subject off centre. Graham has executed them with a concentrated naivete…. Nevertheless, it is unclear what Graham is doing with these photographs. Are they to be "read" for their coloristic and tonal variations or studied one by one?*
> —Mary Fox, "Frustrated by a Lack of Information," *The Vancouver Sun*, 1 April 1976.

> *The 75 photographs were the final residue of several hundred "experiments" involving the night-time observation of nature undertaken with the aid of a Polaroid 180 camera. The experiments…centred around the contemplation of two simultaneous processes: the fading away of the negative retinal after-image caused by the intense flash of light which brought the objects and sites before my vision for the first time, and the coming into being of the positive photographic image eventually fixed on the Polaroid film.*
> —Graham, "Artist's Notes," in *Rodney Graham: Works from 1976 to 1994* (Toronto: Art Gallery of York University; Brussels: Yves Gevaert; and Chicago: The Renaissance Society at the University of Chicago, 1994), 100.

EXHIBITIONS
"Rod Graham and Rob Kleyn," Pender Street Gallery, Vancouver

1977

In the spring Graham travels to Rome to visit Kleyn. He makes the photographs for *Rome Ruins* (1978) after his camera is stolen from his pension in the Campo de' Fiori. Recalling instructions from an old Kodak brochure, Graham fashions a pinhole camera using cassettes for 126-mm color film together with a matchbox, tinfoil, construction paper, tape, elastic bands, toothpaste, glue, a bottle cap, and the lining from his shaving kit. His object is to make images of the sort of Roman subject matter commonly photographed by tourists, while avoiding conscious choices about framing. For many of the photographs, Graham sticks the camera to railings or walls with a lump of plasticine. The camera is later lost.

> *The photos of Graham's* Rome Ruins, *1978, depict scenes that have been reproduced in all media, countless times—primal scenes for the architectural and artistic fantasies of the Western world. The pinhole camera, assembled from the detritus of the present, pries the archeological phenomena from their modern context.*
> —Kleyn, "Method, Method," *C Magazine*, no. 22 (summer 1989): 38.

Upon his return to Vancouver, Graham and Johnston form the musical duo Gentlemen II. Influenced by Devo, the Gentlemen II produce a lo-fi sound incorporating broken guitars and percussion.

EXHIBITIONS
"Eight West Coast Artists," Institute of Modern Art, Brisbane, Australia. Organized by Pender Street Gallery, Vancouver, as an exchange exhibition. Graham is represented by the *Pleasures of the Text* prints.

1978

The UJ3RK5 (pronounced "you jerks")—a new-wave art-rock band that will eventually achieve cult status in the Canadian music scene—is formed when Graham and Johnston start jamming with Wall and Wallace in the visual art studios at Simon Fraser University (SFU), located in the Vancouver suburb of Burnaby, where Wall teaches. Johnston performs under the name of Frank Ramirez. At various times, the UJ3RK5 also include Gibson, Byrne, Wisdom, Colin Griffiths (also known as Frank Crass), and Danice MacLeod.

During the summer Graham works on his uncle's ranch, near Abbotsford. He lives in a trailer on the property. In addition to gardening, general maintenance, and feeding the animals, his duties occasionally include rounding up cattle on horseback. Without a car, Graham often makes the long trip from Abbotsford by bus, traveling through the countryside and suburbs into Vancouver to practice with the UJ3RK5.

EXHIBITIONS
"Local Colour," Nova Gallery, Vancouver

1979

In the spring Graham enrolls at SFU, attempting to finish the Bachelor of Arts degree he began at UBC. He studies art history with Wall, whose lectures on Romanticism are of particular interest. Graham becomes acquainted with Ken Lum, then also a student at SFU. Wall, Lum, Graham, and Wallace develop a close-knit community based on a shared interest in each other's work and the traditions of the modernist avant-garde.

We originally came together through our mutual attraction to avant-garde negativity, identifying with the history of its transgressions and its ciphers for a combative, antagonistic and sometimes even reclusive and melancholic response to the insufficiency of the world. Our world bonded then to a tradition of critical modernism—often tangentially, and in opposition, but always in relation to it.
—Wallace, from the catalogue essay in *Rodney Graham, Ken Lum, Jeff Wall, Ian Wallace* (New York: 49th Parallel Centre for Contemporary Canadian Art, 1985).

On the evenings of 1–3 August, Graham stages *Illuminated Ravine* on Burnaby Mountain near the SFU campus. To encounter the work, viewers must walk down a forested path to the verge of a ravine. Diesel-powered lighting units, similar to those used in logging camps, are positioned to illuminate the ravine from high up in the surrounding trees. The work is turned on from 9:30 to 11:30 each evening. During this time the light throbs perceptibly with fluctuations in electric power, and the intense din of the generator restricts the possibility of conversation with other viewers.

Later in the summer, Graham installs *Camera Obscura* in a field adjacent to his uncle's ranch. The work consists of a site-specific, walk-in camera obscura fabricated from plywood. Built off-site, the structure is transported to the farm by truck and lowered into place with a crane. The entrance is a light trap, with a white wooden bar positioned to keep out cattle that mistake the structure for a feed shed. On a sunny day (after allowing about five minutes for one's pupils to dilate) a soft-focus, upside-down image of the countryside, with a tree filling the foreground, can be made out on the wall opposite the aperture. Graham later configures the work as an architectural model with text and photographs, scheduled for exhibition at Vancouver's Nova Gallery in September. However, one week before the opening, a dispute with the gallery's proprietors leads to the exhibition's cancellation. On the evening on which the opening was to have occurred, a rain-soaked Graham stands in front of the gallery providing would-be visitors with directions to Wallace's studio, where the work has been installed. The structure in Abbotsford is destroyed in 1981.

The structure...[is] intended to take its place among other semi-permanent "out-buildings" (chicken coops, outhouses, tool sheds) that, decayed or in ruins, lend bucolic charm to the rural landscape.
—Graham, "Artist Notes," 83.

Camera Obscura followed the model of the "earth projects" and related experiments of the 1960s and 70s. It required its audience to drive out of town into the working countryside to experience the actual image, but provided objectified substitutes for that direct encounter in the architectural model and the inverted photographic print which were displayed in a gallery. The work could not be seen as a whole in any one place, and its disunity expressed a sense...of the widening split between city and country, glimpsed against a background of the decay of regional agriculture under the domination of American agribusiness which supports the aimless suburbanization of great B.C. farmland.
—Wall, "Into the Forest: Two Sketches for Studies of Rodney Graham's Work," in *Rodney Graham* (Vancouver: Vancouver Art Gallery, 1988), 33.

In the two recent works Illuminated Ravine *and* Camera Obscura, *Rodney Graham's intention is to make pictures without getting mired in the intransigence of what pictures mean. The works are a mixture of overt conceptual rigour and covert personal style; the former is found in his use of site location and choice of materials and the latter is expressed in the pictures which result. The*

works are therefore neither anonymous and impersonal nor personal signatures.
—Russell Keziere, "Rodney Graham: Illuminated Ravine, Camera Obscura," *Vanguard* 8, no. 9 (November 1979): 29.

The UJ3RK5 are represented by two songs, "Naum Gabo" and "UJ3RK5 Work For The Police," on *Vancouver Complication*, an anthology of Vancouver's burgeoning punk and new-wave music scene produced by Pinned Records.

EXHIBITIONS
"Camera Obscura" (solo), installation near Abbotsford, British Columbia
"Illuminated Ravine" (solo), installation on the campus of Simon Fraser University, Burnaby, British Columbia
"Rodney Graham" (solo), studio of Ian Wallace, Vancouver

1980
The UJ3RK5 release a self-titled EP on the Vancouver label Quintessence. Distribution rights are acquired by Polydor. The record reportedly reaches number one on San Francisco's new-wave charts. The four cuts on the EP include "Eisenhower & the Hippies." The song's lyrics are a synopsis of a review written by Dan Graham of a 1967 exhibition of Dwight Eisenhower's paintings at the New York Cultural Center.

Eisenhower & the hippies
Could be cleaning a cop car
The president's gettin' progressively smarter
Quite similar to hippy upstarter
Just like a painting by old Ike
Could be their vision of the countryside
O I LIKE IKE
—from "Eisenhower & the Hippies" by the UJ3RK5, lyrics by Johnston (Ramirez)

During this time, Graham also plays with the Young Winstons (which includes Griffiths of the UJ3RK5), Blanche Whitman (which includes Byrne of the UJ3RK5), and Corsage.

After spending three semesters at SFU, Graham leaves without graduating.

Graham's *Camera Obscura* is selected for exhibition at the Hal Bromm Gallery in New York by Dan Graham. The latter had become familiar with the former's work during visits he made to Vancouver during the mid-1970s.

The UJ3RK5 disband in late fall.

EXHIBITIONS
"Critic's Choice," Hal Bromm Gallery, New York

1981
The Young Winstons are represented on a compilation of Vancouver punk and new wave titled *Bud Luxford Presents: On Sale Inside*, produced by Grant Records.

Graham's interest in the work of John Knight and Sherrie Levine leads him to consider the alteration of works by other artists or writers as a strategy for his own work.

1982
Graham sells his guitar due to lack of funds and stops playing music.

Detail of T-shirt produced for concert featuring the
Gang of Four and the UJ3RK5 at the Commodore
Ballroom, Vancouver, May 1980

Cover, *UJ3RK5*, 1980. Cover photograph
shot by Jeff Wall in the studio of Ian Wallace

 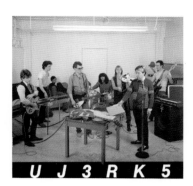

1983

Graham produces *Lenz*, the first of an extended body of book works he will create over the following decade. *Lenz* is an appropriation of a short, unfinished work of fiction of the same name by the nineteenth-century German writer Georg Büchner. Based on the life of Jakob Michael Reinhold Lenz, a minor eighteenth-century poet and acquaintance of Johann Wolfgang von Goethe, Büchner's story describes Lenz's journey through a foreboding mountain landscape in search of Pastor Oberlin, and his psychological breakdown as his sense of self slips out of grasp. Graham's work consists of the first 1,434 words of Carl Richard Mueller's English translation of Büchner's novella, typeset to exactly five justified pages, creating a narrative loop in which the reader, like the narrative's main character, is continually retracing his/her steps. *Lenz* is produced as a sixteen-page prospectus (edition of 210) and a cloth-bound book of 336 pages that includes a slipcase (edition of 10).

The next morning everything went well. He and Oberlin rode through the valley on horseback; wide mountain slopes which at a great height shrank into a narrow, winding valley, which twisted its way to the heights in many directions; great masses of stone that grew broad at their bases; a few trees, but everything with a gray, somber tinge…. At times intense masses of light rose from the valley like a flood of gold; then clouds again, which lay on the topmost peaks, and then slowly descended into the valley through the forest, and voices awakened on the rocky slopes, one moment like distant echoing thunder and the next like a powerful surge that sounded as though in its uncontrolled jubilation it wanted to celebrate the earth.
—from *Lenz*. Graham's narrative loop occurs at "through the forest."

Graham's strategy is one of temporality: time is conveyed as a process without synthesis, repetitive, unreconciling, leading to death rather than permanence. Graham prefers a position of non-understanding rather than manipulate the screen of received ideas…. In the final estimate, Graham, it would seem, is verifying for us that there is no single narrative but, rather, a play of reflections in which each word is like an echo without a cause.
—Arni Runar Haraldsson, "In-Quest of Folly: Reading Rodney Graham's *Lenz*," *C Magazine*, no. 5 (spring 1985): 38.

Concurrent with his work on *Lenz*, Graham researches the possibility of making art by inserting his own text into an existing work. He first considers the writings of Lacan as material in which to intervene, but finds them unsuitable. He turns his attention to the work of Sigmund Freud and subsequently spends a year and a half researching Freud.

Graham produces his first Freud-based work, *Freud Citation*, a photograph of the cover of *Die Gattung Cyclamen L.* (The Genus Cyclamen L.) by F. Hildebrand (1898) with a text referring to the book's role in Freud's analysis of his "Dream of the Botanical Monograph," which appeared in *The Interpretation of Dreams* (1899).

Blanche Whitman, with Graham on guitar and Phil Smith on vocals and keyboards, is represented by three songs (recorded in April 1982) on *The Phil Smith Album*, released by Vancouver's Zulu Records.

1984

Graham makes *Two Generators*, his first film work. Closely related to *Illuminated Ravine*, *Two Generators* shows the nighttime illumination of a section of a small river near Vancouver using industrial lighting units powered by two diesel generators. The duration of the film—about four minutes—is determined by the length of a standard roll of 35-mm film stock. Graham initially considers presenting the film as a loop in

a gallery setting, but, at the suggestion of Wallace, concludes that the work should be presented in a cinema. The format for screening *Two Generators* requires the projectionist to dim the theater lights, project the film until it runs through the projector and xenon light fills the screen, turn on the room lights, rewind the film, dim the room lights, and repeat the process for a predetermined period of time.

The house lights are raised after each projection and then lowered again after an interval for rewinding the film. Seeing the film for an hour is like watching the institution of cinema as a whole operate over a long period of time.
—Wall, "Into the Forest," 34.

The way Graham has arranged the showing of Two Generators *is reminiscent of the obsessive way we might listen to a favourite new song, playing it over and over again until we are almost nauseous from the excess of pleasure. In fact, the film, both in its length and in the macho aspect of the heavy equipment, exudes a rock aesthetic, not unlike the anvil beating of early Glenn Branca compositions.*
—Kleyn, "Method, Method," 45 n. 20.

Graham begins work on *The System of Landor's Cottage*, a work based on and encompassing "Landor's Cottage: A Pendant to *The Domain of Arnheim*" (1850), a short story by Edgar Allan Poe. Graham conceives of the work as a kind of *texte genèse* in the tradition of Roussel's *Nouvelles impressions d'Afrique* (1932) and *Locus Solus* (1914). Poe's short story describes a small cottage set in an idyllic valley. Graham sets out to produce a novel incorporating Poe's work and the style of his prose. He conceives of an annex to the cottage described by Poe and adds an extensive description to Poe's text of this new architectural feature, together with the fantastic objects it houses.

Passing into the parlor, I found myself with Mr. Landor—for this, I afterwards found, was his name. He was civil, even cordial in his manner, but just then, I was more intent on observing the arrangements of the dwelling which had so much interested me, than the personal appearance of the tenant. Thus it was that when my host, after his initial civilities, suddenly, inexplicably and in a manner most brusque, excused himself "for a moment," and followed the woman I took to be his wife into the west wing, I availed myself of the opportunity to more closely examine my surroundings.
I must admit that my curiosity regarding the source and meaning of the strange illuminations emanating from the dwelling's smallest wing had already directed my attention to one of the two doors on the parlor's north wall. This was the door to the west of a small window overlooking a view of the rivulet and just east of what I took to be the entrance to the building's major north wing. I opened this door to reveal the interior of the annex.
—from *The System of Landor's Cottage*. The first two sentences are by Poe, the others mark the beginning of Graham's text describing the annex he has added to the cottage.

EXHIBITIONS

"Poco Rococo," Port Coquitlam Mall, Port Coquitlam, British Columbia (organized by Ken Lum)

1985

Two Generators is exhibited for the first time as part of an exhibition at the 49th

Invitation card, Coburg Gallery, Vancouver, 1986

Cover, Graham's replica of Friedrich Hildebrand's *Die Gattung Cyclamen L.*, 1987

Die Gattung Cyclamen (Installation for Münster), 1987
Dummy books and posters
Books: 25.2 x 17 x 1.6 cm (10 x 6 1/2 x 1/2 in.) each
Posters: 38 x 28 cm (15 x 11 in.) each

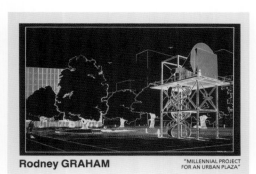

Parallel Centre for Contemporary Canadian Art, New York. Graham's work is brought to the attention of Rüdiger Schöttle by Lum and Dan Graham. It is subsequently presented for the first time in Europe in a group exhibition at Galerie Rüdiger Schöttle in Munich.

EXHIBITIONS
"Rodney Graham, Ken Lum, Jeff Wall, Ian Wallace," 49th Parallel Centre for Contemporary Canadian Art, New York
"Barbara Ess, Rodney Graham, Ken Lum," Galerie Rüdiger Schöttle, Munich, Germany
"Thought Objects," Cash/Newhouse Gallery, New York

1986
Graham produces *Millennial Project for an Urban Plaza*, which proposes an installation that includes a camera obscura on a tower and a sapling planted in a public plaza. The camera obscura is to be located so that once the tree reaches maturity, its upside-down image will appear on the screen inside the structure. The color of the structure is a particular shade of yellow used on heavy industrial and logging equipment sold by Finning, a multinational corporation with a significant presence in Vancouver.

> In the Millennial Project, *the functional shed of the earlier* Camera Obscura *is transformed into a curious and intricate yellow pavilion, whose protruding compound pin-hole resembles some visionary piece of nineteenth century astronomical equipment. And, in a generic sense, this compound eye is indeed astronomical because it sees far away, not into space but into time, not into the heavens but into the city. The* Millennial Project *is thus a time-machine, as its title indicates.*
> —Wall, "Into the Forest," 35.

Graham travels to Europe to attend "Ricochet," a group exhibition in Rome organized by Vancouver artist Robert Linsley. He meets Jörg Johnen in Cologne and travels to Münster to meet Kasper König. He subsequently makes a proposal for the "Skulptur Projekte in Münster" exhibition König is organizing for the following year.

Upon his return to Vancouver, Graham is fired from his part-time job in the liquor distribution system, as the reason for his absence is deemed inappropriate.

Later, *The System of Landor's Cottage* is included in a solo exhibition at Johnen & Schöttle as a work in progress. At the opening, Graham meets the Brussels-based publisher Yves Gevaert, and they discuss possible future projects.

Graham produces *Die Traumdeutung*, the first of a series of works in which he inserts books into replicas of Minimalist sculptures by Donald Judd.

EXHIBITIONS
"Rodney Graham" (solo), Johnen & Schöttle, Cologne, Germany
"Ricochet," Sala 1, Centro internazionale, Rome
"Fokus: Canada 1960–1985," Cologne International Art Fair, Cologne, Germany
"Rodney Graham, James Welling," Coburg Gallery, Vancouver

1987
Graham is represented in "Skulptur Projekte in Münster 1987" by an installation in which twenty-four books—each of their covers a replica of Hildebrand's *Die Gattung Cyclamen L.*—are installed in the windows of Münster bookshops. The work, *Die Gattung Cyclamen (Installation for Münster)*, is derived from an episode described in Freud's *The Interpretation of Dreams*, in which a glimpse of Hildebrand's book in the window of a Vienna bookstore is recognized as the impetus for Freud's "Dream of the Botanical Monograph."

> *Appearing like a keynote in a number of bookshop windows in different parts of the town…we come across what seems to be a reprint of Friedrich Hildebrand's monograph* Die Gattung Cyclamen L.…. *In fact, this is the work of the Canadian artist Rodney Graham. Its cover is an exact facsimile of Hildebrand's original, but inside are only blank pages. The book, in other words, has become an object, a symbol of its content rather than an actual container for them, and the starting point for an autonomous chain of associations…. Not only does Graham's dummy volume set the associative process in motion, then, it also makes it its theme. This external object, this book of blank pages, points toward the depths of the mind. At the same time, it casually and un-selfconsciously blends with its environment—this is an art that wants to retreat under the hood of the everyday, to withdraw, if not into invisibility, at least into a discreet reserve.*
> —Max Wechsler, *Artforum* 26, no. 1 (September 1987): 120. Review of *Die Gattung Cyclamen L. (The Genus Cyclamen L.)*, 1987, installation view at Regenbergsche Bookstore.

> *With his contribution to the* Skulptur Projekte in Münster *in 1987, Rodney Graham's work was instantly catapulted into the consciousness of the European art world.*
> —Dirk Snauwaert, "Recursive Automatisms," in *Getting It Together in the Country: Some Works with Sound Waves, Some Works with Light Waves and Some Other Experimental Works* (Munich, Germany: Kunstverein; Münster, Germany: Westfälischer Kunstverein; Berlin: Berliner Künstlerprogramm/DAAD; and Cologne, Germany: Oktagon Verlag, 2000): 22.

The System of Landor's Cottage is completed. The work comprises an architectural model, drawings, a dummy book, and a 312-page novel (edition of 250) published by Gevaert. It provides the focus for Graham's first solo exhibition in a public art museum, organized by Philip Monk, which opens in November at the Art Gallery of Ontario (AGO). A leather-bound deluxe edition of *The System of Landor's Cottage* (edition of four) is published by Gevaert and the AGO. Graham simultaneously exhibits several of his ersatz Minimalist sculptures (mimicking works by Judd and Robert Smithson) with inserted books at Toronto's Ydessa Gallery.

> *Graham's work…insists on its* transitional *status within an infinite flux of writing and art-making, like all good Minimalist art. Unlike Minimalism, however, it also claims a place within the flux of interior decor, architectural history and nouveau-riche taste in self-help.*
> —John Bentley Mays, "When Is a Book Not a Book?," *The Globe and Mail*, 5 December 1987.

Doing research for an exhibition proposed for La Monnaie Opera House in Brussels, Graham learns of the account of nineteenth-century German composer Engelbert Humperdinck's role in the initial production of Richard Wagner's opera *Parsifal* (1877–82). Humperdinck added additional music to the original score to solve a technical problem in which there was insufficient time for a scene change. Graham's investigations determine that Humperdinck's strategy was similar to his own intervention in *Lenz*, as Humperdinck had written no new music, but rather manipulated a portion of Wagner's score to create a loop of thirty-three bars that could be played as many times as necessary for the scenery change to be completed.

Architectural model, *The System of Landor's Cottage*, 1984–87
Paper, wood, mylar, organic material, fabric, sawdust
35 x 66.7 x 51.5 cm (13 3/4 x 26 1/8 x 20 1/8 in.)

Invitation card, Art Gallery of Ontario, Toronto, 1987

Cover, *Freud Supplement (170a–170d)*, 1988

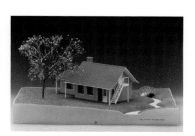

EXHIBITIONS

"The System of Landor's Cottage" (solo), Art Gallery of Ontario, Toronto
"Rodney Graham" (solo), Ydessa Gallery, Toronto
"Skulptur Projekte in Münster," Münster, Germany
"Non in Codice," Galleria Pieroni and The American Academy, Rome
"Material Ethics," Milford Gallery, New York
"Dan Graham, Rodney Graham, Robert Smithson, Jeff Wall," Christine Burgin Gallery, New York
"Kunst mit Fotographie," Galerie Ralph Wernicke Gallery, Stuttgart, Germany
"Cinema Objects," De Appel Foundation, Amsterdam

1988

Graham's *Freud Supplement (170a–170d)*, a textual insertion into Freud's "Dream of the Botanical Monograph" from *The Interpretation of Dreams*, is published in *Parachute*. *Nouvelles Impressions d'Afrique*, a small Judd-like sculpture containing Roussel's book of the same title, is produced in collaboration with Gevaert and Christine Burgin Gallery. Other sculptural works Graham produces include *Le Séminaire*, which contains a book by Lacan; *Cours de linguistique générale*, containing a book by Ferdinand de Saussure; and *Jokes/Case Histories* and *Standard Edition*, both with books by Freud.

> *This phantasy had led on to reflections of how awkward it is, when all is said and done, for a physician to ask [for] medical treatment for himself from his professional colleagues. The Berlin eye-surgeon would not know me, and I should be able to pay his fees like anyone else. It was not until I recalled another event that the significance of this "question of the fee" became apparent to me. I had only recently begun to repay a rather ancient debt, accrued during the course of my student years and comprising a sum of money which had been largely spent on the books and monographs from which I loved to study.*
> —Freud, *The Interpretation of Dreams*, and Graham, *Freud Supplement (170a–170d)*. The latter begins with the word "another."

Holmes organizes an exhibition surveying Graham's oeuvre, which opens at the Vancouver Art Gallery in July.

> *Though capable as being read as a witticism mocking the extreme empiricism of Judd's work, inverting the sculpture's "what you see is what you get" character through their representation as slipcases for Freud texts, Graham's sculptures re-situate Nature in Judd's work, though not as an "organic flood" of subjectivity…. Nature exists here through the figure of Freud, whose understanding of the uncanny as being dependent on the continual recurrence and repetition of what has been repressed makes him the essential figure inhabiting all of Graham's landscapes.*
> —Holmes, introduction to *Rodney Graham* (1988), 8.

Graham meets Shannon Oksanen, a Vancouver-based artist. They eventually develop a long-term romantic relationship.

EXHIBITIONS

"Rodney Graham" (solo), Vancouver Art Gallery, Vancouver
"Rodney Graham" (solo), Johnen & Schöttle, Cologne, Germany
"Rodney Graham" (solo), Christine Burgin Gallery, New York
"Rodney Graham" (solo), Galerie Philip Nelson, Lyon, France
"Made in Camera," Galleri Sten Eriksson, Stockholm

"Facsimile," De Zaak Foundation, Groningen, The Netherlands
"Rodney Graham, Robert Kleyn, Jeff Wall, Ian Wallace," Studio Casoli, Milan, Italy
"Essential Form," Walter Phillips Gallery, Banff, Alberta
"A Drawings Show," Cable Gallery, New York

1989

Working with a hired photographer and a large-format camera, Graham produces his first series of inverted tree photographs: seven large-scale black-and-white images of solitary oak, linden, willow, and chestnut trees from Flanders.

> *I decided not to limit myself to this cumbersome walk-in camera obscura structure and made some inverted images of trees just by using a field camera…. I was thinking of the category of portraiture, and of all that 19th-century photography of trees—very straightforward documents…. I was particularly interested in it as an iconic image, something you would see in a textbook illustrating the idea of the inversion of an image in general, showing the mechanism of the optics of the eye.*
> —Graham, in Barry Schwabsky, "Inverted Trees and the Dream of a Book: An Interview with Rodney Graham," *Art on Paper* 5, no. 1 (September–October 2000): 65–66.

> *It is self-evident that this manner of reproducing reality resembles the ideas of the proto-structuralist Saussure whose ideas were decisive in defining the problem of "the word" as a sign of the thing.*
> —Luk Lambrecht, "Rodney Graham at Micheline Szwajcer, Yves Gevaert, Antwerp," *Flash Art*, no. 149 (November–December 1989): 152.

Graham's research into Humperdinck's addition to the *Parsifal* score leads to the production of several works related to Wagner's opera, including *Parsifal Score. One Signature*, a transcription of the Humperdinck supplement onto a paper signature that facilitates a looped reading, together with a twelve-volume publication in which the supplement repeats seventy-seven times per volume.

EXHIBITIONS

"Rodney Graham: ¿Qué hace la Naturaleza por la noche?" (solo), Galería Marga Paz, Madrid
"Rodney Graham" (solo), Galerie Micheline Szwajcer, Antwerp
"Rodney Graham" (solo), Stedelijk Van Abbemuseum, Eindhoven, The Netherlands
"Books and Writings by Rodney Graham" (solo), Yves Gevaert, Brussels
"Rodney Graham" (solo), Christine Burgin Gallery, New York
"Rodney Graham: Are You a Doctor, Sir?" (solo), Or Gallery, Vancouver
"A Good Read: The Book as Metaphor," Barbara Toll Fine Arts, New York
"Theatergarden Bestiarium," P.S. 1 Institute for Art and Urban Resources, New York; Casino de la Exposición (presented as "Teotrojardin Bestiarium"), Seville, Spain; and Entrepôt-Galerie de Confort Moderne (presented as "Jardin-Théâtre Bestiarium"), Poitiers, France
"Prospekt 89: Eine internationale Ausstellung aktueller Kunst," Frankfurter Kunstverein, Frankfurt, Germany
"Rodney Graham, Fariba Hajamadi, Christina Iglesias, John Murphy," Christine Burgin Gallery, New York
"3rd Invitational Exhibition," Cold City Gallery, Toronto
"Wiener Diwan: Sigmund Freud heute," Museum Moderner Kunst, Vienna

187

1990

Continuing his work with Humperdinck's insertion into Wagner's music, Graham produces *Parsifal (1882–38,969,364,735)*, a time-based musical installation in which he introduces a number of loops of different lengths into Humperdinck's supplement, in correspondence with a mathematical system. The bracketed numbers in the title refer to 1882—the year of *Parsifal*'s premiere in Bayreuth, Germany—and 38,969,364,735, the year in which the opera, performed according to Graham's modified score, would reach its finale if it had commenced simultaneously with the original performance. Graham also produces a compact disc with orchestral highlights from *Parsifal (1882–38,969,364,735)*.

In a way the piece is trivial. It is purely conceptual. You have to locate yourself in both the concept and the original anecdote. I guess what I am trying to say is that it does not succeed as a piece of music. On the CD of my piece all the musical excerpts sound pretty much identical. In some ways it is a musical joke. To me it redeems itself only because it is a joke of cosmic proportions.
—Graham, discussing *Parsifal (1982–38,969,364,735)*, in "A Little Thought: Rodney Graham and Matthew Higgs in Conversation," in *Rodney Graham* (London: Whitechapel Art Gallery, 2002), 77.

…it is only in these cracks and "caesuras" that allegory and baroque effects can be brought to fruition. Such is the case with Rodney Graham's work with his predilection for certain narrative texts…. Or his insertion of volumes of Freud into Donald Judd sculptures [sic], which signifies the territorialisation of the said caesuras within incomplete statements. We might even go so far as to consider his works as the very paradigm of neo-baroque allegorical strategy…. In baroque, reality and representation freely encroach on each other's territory, bringing about an indistinguishability where the life of dreams and the dreams of life acknowledge each other from either side of a broken, shattered membrane, a fine line that shuttles from interior to exterior and vice versa.
—Jose Luis Brea, "Neo-Baroque: A Wind Without a North." *Flash Art*, no. 154 (October 1990): 127.

Graham also produces *Casino Royale (Sculpture de Voyage)*, the first of several works that take Ian Fleming's James Bond novels as their starting point. *Casino Royale (Sculpture de Voyage)* is to be installed in a hotel room so that one can lie in a bed, look up, and read the section from Fleming's text (c. 1953) in which a naked Bond, tied to a chair from which the seat caning has been removed, is thrashed on the buttocks and genitals by the story's villain:

There was a packet of Gauloises on the table and a lighter. Le Chiffre lit a cigarette and swallowed a mouthful of coffee from the glass. Then he picked up the cane carpet-beater and, resting the handle comfortably on his knee, allowed the flat trefoil base to lie on the floor directly under Bond's chair.
He looked Bond carefully, almost caressingly, in the eyes. Then his wrists sprang suddenly upwards on his knee.
The result was startling.
Bond's whole body arched in an involuntary spasm. His face contracted in a soundless scream and his lips drew right away from his teeth. At the same time his head flew back with a jerk showing the taut sinews of his neck. For an instant, muscles stood out in knots all over his body and his toes and fingers clenched until they were quite white. Then his body sagged and perspiration started to bead all over his body. He uttered a deep groan.
Le Chiffre waited for his eyes to open.

"You see, dear boy?" He smiled a soft, fat smile. "Is the position quite clear now?"
—from the Fleming text in *Casino Royale (Sculpture de Voyage)*

EXHIBITIONS

"Rodney Graham: Parsifal" (solo), Johnen & Schöttle, Cologne, Germany
"Rodney Graham: Books" (solo), Lisson Gallery, London
"Rodney Graham" (solo), Christine Burgin Gallery, New York
"Rodney Graham" (solo), Galerie Rüdiger Schöttle, Munich, Germany
"Rodney Graham" (solo), Galerie Micheline Szwajcer, Antwerp, Belgium
"Rodney Graham, Ian Wallace," Galerie Rüdiger Schöttle, Munich, Germany
"Weitersehen (1980→1990→)," Museum Haus Esters and Museum Haus Lange, Krefeld, Germany
"Hanne Darboven, Rodney Graham, Antonio Muntadas, Lawrence Weiner," Galería Marga Paz, Madrid
"Oeuvres sur papier," Galerie Philip Nelson, Lyon, France
"Real Allegories," Lisson Gallery, London
"Figures et lectures," Galerie Samia Saouma, Paris
"Hacia el paisaje," Centro Atlántico de Arte Moderno, Las Palmas, Gran Canaria, Spain
"Arbora Versa," Contemporary Art Gallery, Vancouver
"Gary Brooks, Dan Graham, Rodney Graham, Allan McCollum, Thomas Ruff, James Welling," Johnen & Schöttle, Cologne, Germany
"Contemporary Art 1990," Centre international d'art contemporain de Montréal, Montréal

1991

Graham produces *Dr. No*, a companion piece to *Casino Royale (Sculpture de Voyage)*. *Dr. No* is a supplement to the well-known Bond novel (c. 1958): a bookmark with a text written by Graham (taken in part from a work by Alain Robbe-Grillet) that, when inserted between pages fifty-six and fifty-seven of the first edition of the novel, extends and loops an excruciating scene in which a poisonous centipede traverses Bond's naked body:

Bond's consciousness was now entirely concentrated on the centipede—nothing existed but the pure geometry of its movements. He visualized the insect's zig-zag course down his left leg, linking imaginary points on his inner thigh, outer knee, shin and ankle. It now curled itself around his ankle, gripping hard—a hundred pin-pricks took the shape of a question mark. The shape unfurled and shot back up his leg with lightning speed, and Bond, horrified, again felt its weight in his groin.
Now it was in the middle of his chest, oriented lengthwise along the axis of Bond's spine, its blunt head two inches from the jugular, probing blindly. It crawled straight up Bond's neck and onto his face.
The centipede grazed Bond's lips, then the bridge of his nose, his closed eyelid, his eyebrow, then passed into the forest of hair. It stopped. For ten minutes there was nothing. Was it sleeping, nesting?
—from *Dr. No* by Graham, in the manner of Fleming

Referencing Smithson's *Dead Tree*, placed in the Städtische Kunsthalle in Düsseldorf in 1969, Graham produces *White Oak Trunk Unearthed During the Construction of the Common, York University* for the exhibition "Crossroads" at the Art Gallery of York University. The work consists of a dead, white oak tree displayed on the grounds of the university and a maquette of a permanent installation proposed

Invitation card, La Maison de la Culture et de la Communication, Saint-Etienne, France 1991

Poster, Documenta IX, Brüder Grimm-Museum, Kassel, Germany, 1992

Drawing by Derek Root for Graham's *Five Interior Design Proposals for the Grimm Brothers' Studies in Berlin,* 1992

for the university's new academic building, scheduled for completion the following year, in which the tree stump would be displayed in a glass case.

> *Perhaps architecture is best seen as "repressed language," that is, a language of things forgotten during the acquisition of verbal language. Architecture—particularly the architecture of the city—exemplifies the notion that the history made by man is turned into a petrified image of nature.*
> —Kleyn, *Crossroads,* exh. cat. (North York, Ontario: Art Gallery of York University, 1991), 16.

EXHIBITIONS

"Rodney Graham" (solo), La Maison de la Culture et de la Communication, Saint-Étienne, France

"Rodney Graham" (solo), Galerie Rüdiger Schöttle, Munich, Germany

"Oikos," Galerie Gabrielle Maubrie, Paris

"Rodney Graham, Stephen Prina, Christopher Williams," S. L. Simpson Gallery, Toronto

"Vanitas," Galerie Crousel-Robelin, Paris

"La revanche de l'image," Galerie Pierre Huber, Geneva, Switzerland

"Nieuwe Vleugel," Stedelijk Van Abbemuseum, Eindhoven, The Netherlands

"Crossroads," Art Gallery of York University, North York, Ontario

"Lost Illusions: Recent Landscape Art," Vancouver Art Gallery, Vancouver

"Tony Cragg, Rodney Graham, Cristina Iglesias, Juan Muñoz, Jan Vercruysse," Galería Marga Paz, Madrid

"Seven Vancouver Artists," Wilkey Fine Arts, Seattle, Washington

1992

At Documenta IX, Graham exhibits *Five Interior Design Proposals for the Grimm Brothers' Studies in Berlin* in the Brüder Grimm-Museum in Kassel, Germany. The five drawings are based on watercolor paintings from 1861 by Moritz Hoffmann that depict the studies of Jacob and Wilhelm Grimm. At that time, the brothers lived in the same house and had adjoining, symmetrically oriented studies that were connected by a door. Using AutoCAD renderings of the rooms by Kleyn, Graham "moved" the furnishings, paintings, books, and other contents within each room to create other possible arrangements in which each room reflected the other as closely as possible. The final drawings are by Derek Root in the style of nineteenth-century interior-design illustrations. The installation of the drawings in the Brüder Grimm-Museum also includes books, paintings, sculpture, and other items that appear in Hoffmann's paintings of the Grimms' studies. Graham notes that the impetus for the work came from the correspondence between the Hoffmann paintings and a passage from Søren Kierkegaard's *Repetition* (1843) that describes a double chamber similar to the Grimm Brothers' studies:

> *One climbs the stairs to the first floor in a gas-illuminated building, opens a little door, and stands in the entry. To the left is a glass door leading to a room. Straight ahead is an anteroom. Beyond are two entirely identical rooms, identically furnished, so that one sees the room double in the mirror. The inner room is tastefully illuminated. A candelabra stands on a writing table; a gracefully designed armchair upholstered in red velvet stands before the desk. The first room is not illuminated. Here the pale light of the moon blends with the strong light from the inner room. Sitting in a chair by the window, one looks out on the great square, sees the shadows of passersby hurrying along the walls; everything is transformed into a stage setting. A dream world glimmers in the background of the soul. One feels a desire to toss on a cape, to steal softly*

> *along the wall with a searching gaze, aware of every sound. One does not do this but merely sees a rejuvenated self doing it.*
> —Kierkegaard, cited by Graham in "Artist's Notes," 97.

Reworking the unrealized project represented in *Millennial Project for an Urban Plaza,* Graham designs *Millennial Project for an Urban Plaza with Cappuccino Bar.* In addition to the theater of the camera obscura, the maquette for this second version includes a tilted platform on which viewers can sip cappuccino and contemplate the sapling planted in front of the structure, in anticipation of the moment when the tree will reach a height sufficient for its image to appear in the camera obscura.

Working with Antwerp-based fashion designer Ann Demeulemeester, Graham produces *White Shirt (for Mallarmé) Spring 1993.* The work consists of a black cardboard box containing a white men's dress shirt folded as if on display in a clothing shop. Lying within the shirt is a sheet of white tissue paper with the text of Stéphane Mallarmé's prose poem *The Demon of Analogy* (1874). The paper, seen through the fabric of the shirt, bears the title of the poem and the phrase "La Pénultième est morte," together with Mallarmé's signature. The shirt is made by Demeulemeester to fit Graham. Ideally, the work is to be exhibited simultaneously in a gallery and a clothing boutique.

> *White Shirt* (for Mallarmé) *is a sartorial oration in which Mallarmé's text rests, to be disclosed fold by fold. The work embeds all temporalities: that of the past through mourning, those of the ephemeral present and future through fashion, infallibly bringing to mind those other lines from Mallarmé, in* Tombeau (de Verlaine)*:*
> > *"This immaterial mourning oppresses of manifold Nubile creases the ripened star of tomorrows."*
> —Marie-Ange Brayer, "Techniques of Appropriation and Interpolation in Five of Rodney Graham's Text Works," in *Rodney Graham: Works 1976 to 1994,* 115.

EXHIBITIONS

"Rodney Graham" (solo), Galerie One Five, Antwerp, Belgium

"Rodney Graham" (solo), Galerie Philip Nelson, Lyon, France

"Rodney Graham: 'Les Dernières Merveilles de la science'" (solo), Yves Gevaert, Brussels

Documenta IX, Brüder Grimm-Museum, Kassel, Germany

"Double Identity," Johnen & Schöttle, Cologne, Germany

"Rodney Graham et Ken Lum," Galerie Philip Nelson, Lyon, France

"Càmeres Indiscretes," Centre d'Art, Santa Mònica, Barcelona, Spain

"Cámaras indiscretas," Circulo de Bellas Artes, Madrid

"Art by Numbers," Angles Gallery, Santa Monica, California

"Los últimos días," Salas del Arenal, Seville, Spain

"Stars Don't Stand Still in the Sky—Hommage à Stéphane Mallarmé," Kunstmuseum, Winterthur, Switzerland

"L'ère binaire: Nouvelles interactions," Musée d'Ixelles, Brussels

"Une Seconde Pensée du Paysage," Domaine de Kerguéhennec, Centre d'art contemporain, Bignan, France

"Inscapes," De Appel Foundation, Amsterdam

"Books, Prints and Objects Published by Yves Gevaert," Stedelijk Van Abbemuseum, Eindhoven, The Netherlands

1993

Graham completes *School of Velocity*. The origins of the work can be traced back to 1978, when Graham read an article that argued Galileo Galilei's Law of Free Fall (postulating that the distance traveled by a falling body is directly proportional to the square of the time it takes to fall, and therefore gravity causes acceleration rather than speed) was linked to the physicist's knowledge of music and his inner sense of musical tempo. Further impetus was provided by Graham's acquisition of a copy of *School of Velocity*, an ensemble of piano exercises by Carl Czerny aimed at accelerating a student's technique. Graham's score for *School of Velocity* is arrived at through the application of Galileo's law to Czerny's exercises, so that:

> The first marked beat…of Czerny's School *is the first marked beat of my* School, *the second marked beat of Czerny becomes the fourth marked beat of my work, the third marked beat in the original becomes the ninth beat in my work, and so on until the 1116th note of Czerny falls on the 1,245,456th beat of my (greatly expanded) work. The musical spaces that my composition creates are filled with rests—in fact my* School *is nothing more than the systematic interpolation of rests following Galileo's Law.*
> —Graham, "Artist's Notes," 87.

Graham's *School* is limited to the first 1,116 notes of Czerny's exercises, so that the duration of his work is equivalent to one day. The completed work includes Graham's score programmed for performance on a Yamaha disklavier piano, with 1,443 pages of the score installed on the surrounding walls. A second version of the work is made up of twenty-four volumes, each containing one hour of music.

Graham produces *Irradiation*, a boxed set of eight-by-ten-inch glass negatives of the first forty-four pages from section four of *Bibliographie analytique des principaux phénomènes subjectifs de la vision* (1878) by Joseph Plateau, which describes optical effects caused by the observation of stars at night. Plateau, a nineteenth-century Belgian physicist, was the inventor of a toy that gave the illusion of moving images, known as the Phenakistoscope or Phantasmascope. His other research once involved staring at the midday sun for twenty-five seconds in order to study the after-effects of such an exposure. This led to the ongoing deterioration of his vision, until he became completely blind by age forty-two.

> Together, the white shirt of the Symbolist poet Mallarmé and the brilliant blindness of the star-gazing Plateau link the high-capitalist sober costume of masculinity to the blindness of male authority to the sight of women, colour, and other things beyond its circumscribed gaze. The "dinner jacket required" ambiance of Ian Fleming's fantasies is complexly montaged by Graham in order to highlight the scenes of torture that haunt their extravagant vision of male subjectivity, literally on display as a perpetual front slipped between the covers of pulp fiction and white linen. Meanwhile, the absent player goes on, day after day, playing the same exercises, falling through space as the sublimate of patriarchy: the robotic, man-made object.
> —William Wood: "Rodney Graham: Lisson Gallery," *Canadian Art* 11, no. 1 (spring 1994): 71.

EXHIBITIONS

"Rodney Graham" (solo), Angles Gallery, Santa Monica, California
"Rodney Graham" (solo), Lisson Gallery, London
"Rodney Graham: Concordance to the Standard Edition" (solo), Galerie Micheline Szwajcer, Antwerp, Belgium
"Rodney Graham: Irradiation" (solo), Yves Gevaert, Brussels

"Hans-Peter Feldmann, Rodney Graham, Allen Ruppersberg," 303 Gallery, New York
"Aanwinsten/Acquisitions 1989–1993," Stedelijk Van Abbemuseum, Eindhoven, The Netherlands
"Canada, une nouvelle génération," FRAC des Pays de la Loire, Gétigné-Clisson, France
"Binaera: 14 Interaktionen—Kunst und Technologie," Kunsthalle, Vienna
"Bas Jan Ader, David Deutsch, Lewis deSoto, Maureen Gallace, Rodney Graham, Mary Lucier," Nicole Klagsbrun Gallery, New York
"Time and Tide: The Second Tyne International Exhibition of Contemporary Art," Newcastle-upon-Tyne, England
"Voyage to Cythera," Palazzo Vendramin Calergi, Venice, Italy
"Corners Filled With What Is Swept Into Corners," Galerie Micheline Szwajcer, Antwerp, Belgium
"Seeing the Forest Through the Trees," Contemporary Arts Museum, Houston
"Beneath the Paving Stones," Charles H. Scott Gallery, Vancouver

1994

In a move away from appropriation, Graham makes *Halcion Sleep*, the first film/video work in which he appears. *Halcion Sleep* is a document of a performance in which Graham reenacts a regression based on his earliest memory, "that of briefly, only briefly, awakening from a luxurious and secure sleep in the back of my parents [sic] car on the way home from some family road-trip, before drifting back to sleep." The action is also a conscious play on the standard film-noir trope where the protagonist is drugged and taken to the outskirts of the city to be interrogated. The work may (or may not) be related to an incident during the late 1970s in which Graham was interrogated and subjected to a lie-detector test concerning a theft from the liquor distribution system in which he worked.

To perform *Halcion Sleep*, Graham rents a room at the Coquitlam Sleepy Lodge in Coquitlam, a suburb of Vancouver that encompasses his childhood home of Harbour Chines. He takes a double dose of the sedative Halcion, a drug chosen in part for the "pleasant thoughts of the past evoked by its name—that of the bird of legend (halcyon) who builds her nest in the sea." Unconscious, he is carried from the room, placed on the back seat of a van, and driven to his apartment in the center of Vancouver. The videotape documenting the action begins after the journey has started and ends before the trip is completed. It consists of a looped twenty-six minute take of Graham's pajama-clad body and the view out the back window of the van as it moves through the rain-swept night.

> That was a piece I made when I was completely depressed. It was made out of desperation…that was the first performance where I used myself, and was ultimately about myself. It was an experiment and it was successful in the sense that it opened up subsequent avenues for performances using myself. It was interesting to do as I'm not normally the sort of person that likes to present myself in that way. Even though I've always played in bands I was always the guitar player hidden on the side of the stage. I was never interested in projecting my own personality, so it was a cathartic experience…. I think I had reached the point where I didn't want to make art that was consciously citing other art or was dependent upon a prior knowledge of other works.
> —Graham, in "A Little Thought," 77–78.

> While [Halcion Sleep] offers a critique of the journey of self-discovery associated with the Romantic tradition, the view of the artist repeatedly traversing the boundaries of the city also offers up a view of the melancholic body marked by the desire for a state of serenity and bliss as it is separated from the past,

Postcard from the Sleepy Lodge Motel, Coquitlam,
British Columbia

Invitation card, "Camera Obscura Mobile:
Rodney Graham," Harcourt Arboretum,
FRAC Haute-Normandie, Sotteville-lès-Rouen,
France, 1996

Map of *Camera Obscura Mobile* at the Harcourt Arboretum

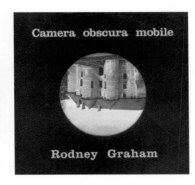

which appears as a barely decipherable pattern of lights vanishing into the
darkness in the rain-splattered window above Graham's sleeping form.
—Grant Arnold, "Shared Terrain/Contested Spaces: New Work by Fifteen
B.C. Artists," in *topographies: aspects of recent BC art* (Vancouver: Vancouver
Art Gallery, 1996), 39.

EXHIBITIONS

"Rodney Graham: Works from 1976 to 1994" (solo), Starkmann Library Services,
 Winchester, Massachusetts; and Art Gallery of York University, Toronto
"Rodney Graham" (solo), Fundació Espai Poblenou, Barcelona, Spain
"Fotografien und Multiples: Dan Graham, Rodney Graham, Jenny Holzer," Galerie
 Rüdiger Schöttle, Munich, Germany
"In the Field: Landscape in Recent Photography," Margo Leavin Gallery, Los Angeles
"Serial," Angles Gallery, Santa Monica, California
"Beeld," Museum voor Hedendaagse Kunst, Ghent, Belgium
"Des objets sans fondation," Résidence Secondaire, Carré Saint-Nicolas, Paris
"Painter Editions," Gimpel Fils Gallery, London

1995
After a hiatus of almost thirteen years, Graham returns to playing guitar. Together
with Jade Blade, Bill Napier-Hemy, John Cody, and Oksanen, he forms Volumizer,
a punk-influenced rock band that performs material written by Blade. The name of
the band comes from a device that attaches to a hair dryer to add volume to
a hairstyle.

*Conceptual art showed me possibilities that were tremendous...because I lacked
certain traditional skills, say, as a painter or a sculptor. Conceptual art opened
up possibilities where I could work, collaborating with other people, having things
made, supervising the production rather than making it myself. And for a while
it was really liberating to work that way. Now I feel it's at the end of a cycle for
me. I'm going to go into something else, and I don't quite know what. But I feel
a change coming.*
—Graham, quoted in Alan G. Artner, "Music to His Mind," *Chicago
Tribune*, 8 October 1995, sec. 7, 9.

EXHIBITIONS

"Rodney Graham: Works from 1976 to 1994" (solo), Castello di Rivoli, Turin, Italy; and
 The Renaissance Society at the University of Chicago, Chicago
"Rodney Graham" (solo), 303 Gallery, New York
"Rodney Graham" (solo), Johnen & Schöttle, Cologne, Germany
"Rodney Graham: Oeuvres freudiennes/Oeuvres wagnériennes" (solo), Musée
 départemental d'art contemporain, Rochechouart, France
"About Place: Recent Art of the Americas," The Art Institute of Chicago, Chicago
"Artistes/Architectes," Le Nouveau Musée/Institut d'art contemporain,
 Villeurbanne, France
"Seeing Things," Galerie Antoni Estrany, Barcelona, Spain
"Spirits on the Crossing: Travellers to/from Nowhere; Contemporary Art in Canada
 1980–94," Setagaya Art Museum, Tokyo; National Museum of Modern Art, Kyoto,
 Japan; and Museum of Modern Art, Hokkaido, Japan
"Bild-Erinnerung: Teil 1; Rodney Graham, Jenny Holzer," Galerie Rüdiger Schöttle,
 Munich, Germany

1996
Loretta Yarlow, director of the Art Gallery of York University, and Graham submit a
proposal to the Canada Council to represent Canada at the upcoming Venice
Biennale. As their past applications, including one that put forward *School of Velocity*,
weren't successful, Graham proposes to exhibit photographs of trees from various
regions across Canada, a project that might be seen as particularly appropriate for
the Canadian Pavilion at Venice, which has a tree growing through it.
 Continuing his research on Freud's "Dream of the Botanical Monograph," Graham
produces *Schema: Complications of Payment*. The work consists of a painting that
charts the flow of money in relation to a debt incurred by Freud to his estranged
colleague Joseph Breuer and by Breuer's niece to Freud. Graham proposes that these
debts are intimately connected to the interpretation of Freud's dream. The work also
includes a videotape of a lecture Graham presented on the "Dream of the Botanical
Monograph" at UBC, twelve posters advertising the lecture (each in a different color),
and a printed abstract of the lecture. It is unclear whether the work is related to
Graham's own financial crisis concerning a debt owed to Revenue Canada, the taxa-
tion arm of the Canadian government.
 Graham shoots *Coruscating Cinnamon Granules* on a single roll of 16-mm film
stock in the kitchen of his apartment. The looped film is to be projected in a purpose-
built room that replicates the kitchen's dimensions. Graham describes the work as:

*A glittering mini-spectacle that resembles a constellation of stars that appear
before one's eyes after a mild blow to the head, created by simply spreading
granulated particles of the common household spice over the surface of a spiral
electric cooking element before turning the element on in darkness.*
—Graham, "Siting Vexation Island," 12–13.

Camera Obscura Mobile, a camera obscura in the form of a 1904 United States Post
Office rural delivery carriage, is realized for an exhibition in the Château d'Harcourt
near Rouen, France.

*By locating the...US mail delivery wagon in the French countryside I was
cognizant of at least two facts pertaining to French philosophy; that Blaise
Pascal is commonly known to have had a sudden and shattering insight into
the radical contingency of existence when he was hurled from a runaway
carriage; and also, to have played a part in developing Paris's first efficient
taxi carriage service. Flows can be regulated but the unpredictable always
occurs: the* clinamen.
—Ibid., 14.

Man Or Astroman? covers the UJ3RK5's "Eisenhower & the Hippies" on *Oh Canaduh!*,
a compilation CD released by Lance Rock Records as a tribute to the Vancouver
music scene of the late 1970s and early 80s.
 In December the Canada Council announces that Graham will represent Canada
at the Venice Biennale in 1997.

EXHIBITIONS

"Rodney Graham: Works from 1976 to 1994" (solo), Morris and Helen Belkin Art
 Gallery, Vancouver
"Camera obscura mobile: Rodney Graham" (solo), FRAC Haute-Normandie, installed
 at Château d'Harcourt, Sotteville-lès-Rouen, France
"Rodney Graham" (solo), Lisson Gallery, London
"Rodney Graham: Editions" (solo), Nicole Klagsbrun Gallery, New York
"Lesen," Kunsthalle, St. Gallen, Switzerland
"Die Schrift des Raumes: Kunst Architektur Kunst," Kunsthalle, Vienna
"Victor Burgin, Dan Graham, Rodney Graham, John Hilliard," Lisson Gallery, London

Invitation card, Lisson Gallery, London, 1996

Graham and Shannon Oksanen on the set of
Vexation Island, 1997

Poster, "Rodney Graham: Vexation Island,"
FRAC Languedoc-Roussillon, Montpellier,
France, 1998

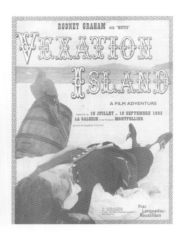

"The Architecture of Dreams," Museo Regional de Guadalajara, Guadalajara, Mexico
"topographies: aspects of recent BC art," Vancouver Art Gallery, Vancouver
"The Culture of Nature," Kamloops Art Gallery, Kamloops, British Columbia
"Rodney Graham, Geoffrey James, Richard Long," Angles Gallery, Santa Monica, California

1997

Shortly after he is designated as the Canadian representative for the Venice Biennale, Graham reconsiders his proposal for the exhibition. During a visit to the Canadian pavilion early in the year, Graham is struck by the rustic character of the boarded-up structure, which, he notes, resembles a stockade from the Disney film *Treasure Island* (1950) and also reflects Canada's subordinate position in the developed world.

> It resembles nothing so much as an architectural manifesto—a rustic hut-type, complete with tree and of a distinctly European, specifically Laugerian, inspiration. In its placement—in relation to the open space defined by the French, British and German pavilions—it suggests an example of the humblest form of rural architecture: the out building. As a repository for tools or animals (gardening shack, chicken shed), it has a subordinate relation to the main house. This is a space in which I work comfortably…. I want to turn my back on the real tree in favour of its phantasmagoric projection—this time in Technicolor and Cinemascope—by making the pavilion into a cinema for the duration of the Biennale. And again, this end is best served by keeping it boarded up.
> —Graham, "Siting Vexation Island," 17–18.

Graham conceives of a costume drama based on his interest in violent episodes that link states of consciousness, his desire to have a tree play a significant role in the film, and research indicating that the average length per visit to a Biennale pavilion is eight minutes. *Vexation Island*, with Graham and a parrot named Muffin as its two characters, is shot in April in the British Virgin Islands on 35-mm film stock with sound. Production values emulate those of Hollywood cinema. For presentation in the boarded-up pavilion, the completed eight-minute film is transferred to video and projected as an endless loop.

> But the sole cinematographic consciousness is not us, the spectator, nor the hero; it is the camera—sometimes human, sometimes inhuman or superhuman. Take, for example, the movement of water, that of a bird in the distance, and that of a person on a boat: they are blended into a single perception, a peaceful whole of humanised Nature. But then the bird, an ordinary seagull, swoops down and wounds the person: the three fluxes are divided and become external to each other. The whole will be reformed, but it will have changed…
> —Gilles Deleuze, *Cinema 1: The Movement-Image* (Minneapolis: University of Minnesota Press, 1986), 20.

> the few outstanding national entries do little to erase the overall impression that the '97 Biennale left much to be desired…. Among the exceptions is the Canadian pavilion, with an infuriatingly hilarious film cycle by Rodney Graham, Vexation Island, 1997, in which the artist, decked out as a pirate, spends virtually the entire film snoozing on an empty tropical beach, watched over by his parrot as the camera occasionally zooms in on his gashed forehead. Upon awakening, he rises and shakes the coconut tree whose fruit knocked him out in the first place, and the sequence starts all over again.
> —Dan Cameron, "47th Venice Biennale," *Artforum* 36, no.1 (September 1997): 119–20.

> One nevertheless suspects that in the world of fiction there must somewhere be an island on the order of Vexation, but one wherein the snuffling swine-things are not wild pigs, and where the ghost that begins to chatter maniacally as each purple dusk descends is not a parrot. And where, it may well be, forsaken divinities resort or the Sirens still make their haunt, their voices crying and dying in hollows of salt-washed rock.
> —Gibson, "A Vexation Island Miscellany," in *Island Thought*, 19–20.

EXHIBITIONS
"Rodney Graham: Vexation Island" (solo), Canadian Pavilion, XLVII Venice Biennale, Venice
"Rodney Graham" (solo), 303 Gallery, New York
"Rodney Graham" (solo), Angles Gallery, Santa Monica, California
"Past, Present, Future," XLVII Venice Biennale, Venice, Italy
"Città/Natura," Palazzo delle Esposizioni, Rome
"Wood Work," Fisher Landau Center for Art, Long Island City, New York
"Sites of the Visual: Rodney Graham, Steve Pippin, David Tomas," Art Gallery of Windsor, Windsor, Ontario; and Leonard and Bina Ellen Gallery, Concordia University, Montréal
"Patrick Painter Editions," S. L. Simpson Gallery, Toronto
"Niemandsland," Museum Haus Esters and Museum Haus Lang, Krefeld, Germany
"The 20th: 1977–1997," The Bartlett Exhibition and Performance Space, Simon Fraser University, Vancouver

1998

> there is another layer to Graham's film [Vexation Island] that Bataille's text [The Solar Anus] illuminates. "The sea continuously jerks off," writes Bataille. "The erection and the sun scandalize, in the same way as the cadaver and the darkness of cellars." Here it's not hard to recall the figure of Graham holding the trunk of the tree between his hands, shaking it until it releases a coconut, at which point he falls back into a stupor. The scene invokes nothing less than a "wet dream"—cinema as collective wet dream, oneiric fantasy, a medium that is already, by Graham's reckoning, a corpse.
> —Alexander Alberro, "Loop Dreams: Rodney Graham's *Vexation Island*," *Artforum* 36, no. 6 (February 1998): 108.

In June, Graham begins recording music for what will eventually be released as *The Bed-Bug, Love Buzz, And Other Short Songs in the Popular Idiom*.

Graham and Oksanen are married in June in a ceremony at the home of Gibson.

EXHIBITIONS
"Rodney Graham" (solo), Wexner Center for the Arts, Columbus
"Rodney Graham" (solo), Galerie Micheline Szwajcer, Antwerp, Belgium
"Rodney Graham: Vexation Island and Other Works" (solo), Art Gallery of York University, Toronto
"Rodney Graham: Vexation Island" (solo), FRAC Languedoc-Roussillon, Montpellier, France
"Rodney Graham" (solo), Johnen & Schöttle, Cologne
"Sharawadgi," Felsenvilla, Baden, Austria
"The Magic of Trees," Fondation Beyeler, Riehen, Switzerland
"Single Screen," Norwich Gallery, Norwich School of Art and Design, Norwich, England
"The Serial Attitude," Wexner Center for the Arts, Columbus, Ohio; and Addison Gallery of American Art, Phillips Academy, Andover, Massachusetts

Cover, *The Bed-Bug, Love Buzz, And Other Short Songs in the Popular Idiom,* 1999

Graham in the anechoic chamber at the University of British Columbia, Vancouver, 1999

Invitation card, "How I Became a Ramblin' Man," Donald Young Gallery, Chicago, 1999

"Projected Allegories," Contemporary Arts Museum, Houston
"Dust Breeding: Photographs, Sculpture and Film," Fraenkel Gallery, San Francisco
"Rodney Graham, Stephan Balkenhol," Galerie Rüdiger Schöttle, Cologne, Germany
"Speed: Visions of an Accelerated Age," The Photographers' Gallery, London; White-chapel Art Gallery, London; and MacDonald Stewart Art Centre, Guelph, Ontario
"Rodney Graham, Charles Ray," Donald Young Gallery, Seattle
"Then and Now," Lisson Gallery, London
"Reservate der Sehnsucht," hARTware Projekte, Dortmund, Germany
"A Sense of Place," Angles Gallery, Santa Monica, California
"Trance: New Work in Video," Philadelphia Museum of Art, Philadelphia
"Composed: Rodney Graham, Christian Marclay, David Schafer," Angles Gallery, Santa Monica, California

1999

The King's Part is produced for a solo exhibition of Graham's work that opens in May at the Kunsthalle in Vienna. Originally conceived for Documenta IX in 1992, the work involves recording a flautist "key clicking" (performing the fingering for the keys without blowing into the flute) the Third Flute Concerto (mid-eighteenth century) by Frederick the Great of Prussia in an anechoic chamber. The audio recording is then played back in a lead-coated, felt-lined room of Graham's own design. The exhibition also includes Graham's installation *I'm a Noise Man* in which gallery visitors can sit on beanbag chairs and listen to recordings of Graham's pop music. The exhibition catalogue contains a CD with the music from *I'm a Noise Man.* Songs on the CD include "Man, I Really Miss the Coast," written by Graham and John Collins (of The New Pornographers), with Graham on vocals, electric guitar, keyboards, and melodica; Oksanen on vocals; Collins on bass and electric guitar, electric sitar, and drum machine; and Brady Cranfield on drums and shaker.

> *Vienna's cool and all but where's the coast?*
> *The best that I can say is*
> *Sigmund Freud is still the most*
> —from "Man, I Really Miss the Coast," on *I'm a Noise Man*

In May Graham receives the 1999 Jean A. Chalmers National Visual Arts Award.
The Bed-Bug, Love Buzz, And Other Short Songs in the Popular Idiom is released by the Dia Center for the Arts in conjunction with the exhibition "Rodney Graham and Vera Lutter: *Time Traced.*" Drawing upon influences from Saint Etienne to the Beach Boys, the CD is a collection of pop songs with music and lyrics by Graham (some in collaboration with Collins).

> *People said that I seemed to be consciously experimenting with different musical genres, but really I was simply trying to find the type of music that I felt comfortable with. Trying to find my own voice…. I'm trying to use my song writing and performing as a way to make a different type of art, one that draws more directly on my own experiences as opposed to being solely dependent upon, say, its referential context. I'm trying to convey something that is more visceral.*
> —Graham, in "A Little Thought," 80–81.

Graham produces his second costume drama, *How I Became a Ramblin' Man,* in which he plays a wandering cowboy/troubadour who relaxes beside a stream, sings a melancholic ballad, mounts his horse, and rides off into the golden-hued landscape. The work is first screened at the Donald Young Gallery in Chicago in September.

> *I've been following this pal o' mine,*
> *Through the canyons of my wasted time,*
> *Headed for the setting sun just shy of twenty-one*
> *City life just got me down*
> *Seems I was an encumbrance on that God forsaken town,*
> *Figured it was time to start just wanderin' around.*
> —from *How I Became a Ramblin' Man*

EXHIBITIONS

"Rodney Graham: Cinema Music Video" (solo), Kunsthalle, Vienna
"Rodney Graham: How I Became a Ramblin' Man" (solo), Donald Young Gallery, Chicago
"Rodney Graham: Vexation Island and Other Works" (solo), National Gallery of Canada, Ottawa
"Rodney Graham: Vexation Island" (solo), Museum of Contemporary Art, Miami
"Rodney Graham: Vexation Island" (solo), Morris and Helen Belkin Art Gallery, University of British Columbia, Vancouver
"Rodney Graham: Works 1983–1998" (solo), Christine Burgin Gallery, New York
"Plain Air," Barbara Gladstone Gallery, New York
"Duration and Whenever," Angles Gallery, Santa Monica, California
"Sharon Lockhart, On Kawara, Rodney Graham," Friedrich Petzel Gallery, New York
"Faiseurs d'histoires," Casino Luxembourg-Forum d'art contemporain, Luxembourg
"Regarding Beauty: A View of the Late Twentieth Century," Hirshhorn Museum and Sculpture Garden, Smithsonian Institution, Washington, D.C.
"Searchlight: Consciousness at the Millennium," CCA Wattis Institute for Contemporary Arts, San Francisco
"Rodney Graham and Vera Lutter: *Time Traced,*" Dia Center for the Arts, New York
"Head Over Heels: A Work of Impertinence," Musée d'art contemporain, Montréal
"Painter Editions," Patrick Painter, Inc., Santa Monica, California
"Private Eye: Crimes & Cases," Haus am Waldsee, Berlin

2000

Graham begins a year-long residency in Munich and Berlin under the auspices of the Berliner Künstlerprogramm/DAAD. Among the works he produces are *Aberdeen,* an installation involving projected slides of Kurt Cobain's hometown and an accompanying CD with sampled music by The Poppy Family, Creedence Clearwater Revival, Petula Clark, Alice Cooper, and Eric Burdon; *Fishing on A Jetty,* a two-part photographic work based on a scene from Hitchcock's *To Catch a Thief* (1955, a film described by Graham as "a less than illustrious non-masterpiece") with Graham taking Cary Grant's part as a bogus fisherman feigning blindness; and *Siesta Room in the Country,* a maquette for a revised version of *Camera Obscura,* in which the viewer contemplates an image of the landscape from a rotating king-size bed. Graham commissions Oksanen and Scott Livingstone to produce *A Little Thought,* a "rock video" based on Graham's song of the same title.

> *"A little thought gone astray*
> *Can leave your mind in disarray"*
> *At least that's what I heard you say*
> *When we drove that Jag up on someone's lawn*
> *And we hit the porch with the headlights on*
> —from "A Little Thought"

Getting It Together in the Country, a vinyl record with four songs by Graham on one side, and his guitar improvisations for the desert love scene from Michelangelo

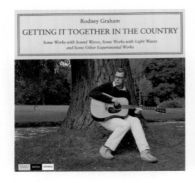

Antonioni's *Zabriskie Point* (1970) on the other, is produced as part of a catalogue
to accompany solo exhibitions in Munich, Münster, and Berlin.

> *A room and no room service*
> *How long must one endure this?*
> *It always makes me nervous*
> *When nature has no purpose*
> —from "Nature Has No Purpose" from *Getting It Together in the Country*

In the fall, Graham produces *City Self/Country Self*, the third in his trilogy of costume
dramas. The film is based on a nineteenth-century Épinal pamphlet, a children's book
describing the misadventures of a country bumpkin on his first visit to Paris. Graham
plays both the bumpkin and the bourgeois dandy who kicks the bumpkin in the pants.
The work, along with the elaborate costumes elegantly displayed on mannequins,
is first presented in the exhibition "What Is Happy, Baby?," which opens at the Lisson
Gallery in December.

> *These works [Vexation Island, How I Became a Ramblin' Man, City
> Self/Country Self] are conceived more as Hollywood style star vehicles
> and less as auteur films—I never direct them, and in fact it gives me
> pleasure to relinquish this role. All three works deal with relationships to
> and representatives of nature, of city and country within established
> filmic conventions.*
> —Graham, from notes on *City Self/Country Self*, in *Rodney Graham*
> (2002), 52.

> *Getting the joke in Graham's work means accepting the fact that the joke is
> always on you: that within the act of understanding one is always finishing off
> and polishing Graham's jokes for him through a kind of self-duplication of
> one's own making…. In this sense, Graham's work delivers art's* promesse
> du bonheur *in terms of a happiness both fulfilled and constantly broken.
> For whenever one gets the joke and comes away happy, this modicum of content
> rests on the firm belief that it was actually transferred from the work to the
> viewer and not dreamt up by the clown standing there posing as the audience
> for contemporary art.*
> —Shep Steiner, "Rodney Graham: Au delà des principes de la blague,"
> *Last Call* 1, no. 1 (summer 2001): 2.

What Is Happy, Baby? is released as a CD in conjunction with the Lisson Gallery
exhibition.

> *Say what you will—modern life remains a bitter pill*
> *And country life's a magazine*
> *What is happy, baby?*
> *What happened to all the simple pleasantries of youth?*
> *What is happy, baby?*
> *In the sixteenth century, what is happy, baby?*
> *In the penitentiary, what is happy, baby?*
> *If someone came right up and said, what is happy, baby?*
> *Or if it hit you on the head, what is happy, baby?*
> —from "What Is Happy, Baby?" on *What Is Happy, Baby?*

Graham produces *Can of Worms*, a backlit transparency of a paint can, its light box
equipped with an improbably long and tangled electrical cord. Clearly a reference
to the work of Wall, *Can of Worms* can be seen as a lament for the dissolution of the
close-knit social community once made up of Wall, Lum, Wallace, and Graham.

EXHIBITIONS
"Some Works with Sound Waves, Some Works with Light Waves, and Some Other
 Experimental Works" (solo), Kunstverein, Munich, Germany
"Rodney Graham: Getting It Together in the Country" (solo), Westfälisches
 Landmuseum für Kunst und Kulturgeschichte, Münster, Germany
"Rodney Graham: Getting It Together in the Country" (solo), Presentation House
 Gallery, North Vancouver, British Columbia
"Rodney Graham" (solo), Fraenkel Gallery, San Francisco
"Rodney Graham: What Is Happy, Baby?" (solo), Lisson Gallery, London
"Rodney Graham and Bruce Nauman: '…the nearest faraway place…,'" Dia Center
 for the Arts, New York
"Flight Patterns," The Museum of Contemporary Art, Los Angeles
"The Greenhouse Effect," Serpentine Gallery, London
"Let's Entertain: Life's Guilty Pleasures," Walker Art Center, Minneapolis; Portland
 Art Museum, Portland; and Musée national d'art moderne, Centre Georges
 Pompidou, Paris (presented as "Au-delà du spectacle")
"Tout le temps/Every Time," Biennale de Montréal, Montréal
"Sound Video Film," Donald Young Gallery, Chicago
"Double Whammy," Atelier Gallery, Vancouver

2001
On March 8, *Softcore (More Solo Guitar Music for the Sex Scene, Zabriskie Point)* is
shot before a live audience at Galerie Micheline Szwajcer in Antwerp. In the video,
Graham noodles on his guitar in front of a projection of the seven-minute desert sex
scene from Antonioni's *Zabriskie Point*. The film sequence is looped and runs for 108
minutes, the length of the original film.

> *The work is an artistic distillation of an activity that has occupied me (and
> countless other amateur guitarists) for probably hundreds and hundreds of
> hours over my lifetime: that is "noodling" in front of the TV…*
> —Graham, from the unpublished exhibition notes for "Rodney Graham:
> Music and Noise," Kunsthalle, Zürich, 2002.

During his residency in Berlin, Graham completes *The Phonokinetoscope*, an instal-
lation with a film loop and a record player. The film shows Graham dropping acid and
elegantly tripping through Berlin's Tiergarten on a bicycle (riding backwards on the
handlebars at one point). The title of the work is taken from the Kinetoscope, a device
invented by Thomas Edison in an attempt to synchronize sound and images. In
Graham's *The Phonokinetoscope*, synchronization is left up to the viewer, who can
place the record player's tone arm at any point on the grooves that encode the accom-
panying song "You're the Kind of Girl That Fits in with My World," allowing a range
of image/sound combinations.

> *In my song I tried to summon a feeling of…Pink Floyd's classic stoner-rock
> sound track for the sequence in Antonioni's* Zabriskie Point *where a house is
> repeatedly blown up in slow-motion…. But then there's also Burt Bacharach
> and Hal David's so-beautiful so-stupid "Raindrops Keep Fallin' on My Head,"
> featured in…*Butch Cassidy and the Sundance Kid *where Katherine Ross
> and Paul Newman frolic on a bicycle in the countryside…. Bas Jan Ader rode
> his bicycle into an Amsterdam canal not long after* Butch Cassidy *came out,
> and his work is as important to me as Bacharach's soft pop. Ader's life work*

Poster, fundraising concert
at the Or Gallery,
Vancouver, 2001

Advertisement for exhibitions at 303
Gallery, New York, and Galerie Nelson,
Paris, 2001

Cover, 45-rpm record by Wim Sonneveld
and Godfried Bomans

Brochure with detail from *Fantasia for Four
Hands*, K21 Kunstsammlung Nordrhein-Westfalen
im Ständehaus, Düsseldorf, 2003

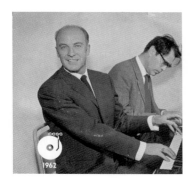
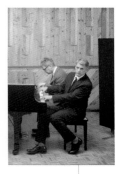

centered around the idea of voyage and underscored the truism "Sometimes when you take a trip you don't come back."
—Graham, in "A Thousand Words: Rodney Graham Talks About *The Phonokinetoscope*," *Artforum* 40, no. 3 (November 2001): 117.

If Graham's drug for THE PHONOKINETOSCOPE is LSD, then our drug is his music. With its "Stairway to Heaven" opening and its "Come in Number 51, Your Time is Up" spaced-out heaviness later on, it made me euphoric…. As it is though, the film remains resolutely unpsychedelic in appearance, except for the faintly occult quality of the manifestations of women. "You're the kind of girl that fits in with my world" intones the song and she does appear, first in the grass as the queen of diamonds and then as the statue of the young queen of Prussia.
—Mathew Hale, "And I'm Wondering Who Could Be Writing This Song," *Parkett*, no. 64 (May 2002): 118.

I'm the "i" they failed to dot
From the land that time forgot
I just lost my train of thought
I saw someone sitting on a rock
You're the kind of girl that fits in with my world
Who is it that does not love a tree?
I planted one, I planted three
Two for you and one for me
Botanical anomaly
But you're the kind of girl that fits in with my world
—from "You're The Kind Of Girl That Fits in with My World"

Graham and Oksanen separate, but remain on amicable terms.

EXHIBITIONS
"Rodney Graham" (solo), Hamburger Bahnhof, Berlin
"Rodney Graham" (solo), Milwaukee Art Museum, Milwaukee
"Rodney Graham: The Phonokinetoscope" (solo), 303 Gallery, New York
"Rodney Graham" (solo), Donald Young Gallery, Chicago
"Rodney Graham" (solo), Galerie Micheline Szwajcer, Antwerp
"Invention of the Kineto-Phonograph" (solo), Galerie Nelson, Paris
"These Days," Vancouver Art Gallery, Vancouver
"Rodney Graham, Gary Hill," Donald Young Gallery, Chicago
"Let's Entertain: Life's Guilty Pleasures," Museo Rufino Tamayo, Mexico City; and Miami Art Museum, Miami
"Feature: Art, Life and Cinema," Govett-Brewster Art Gallery, New Plymouth, New Zealand
"Looking With/Out: East Wing Collection No. 05," Courtauld Institute of Art, London
"Vancouver Collects—Between Passion and Logic: Modern and Contemporary Art," Vancouver Art Gallery, Vancouver
"Video Work," Lisson Gallery, London
"Rodney Graham, Ebru Özseçen, Rosemarie Trockel," Lindig in Paludetto, Nürnberg, Germany
"Luminous," Bellevue Art Museum, Bellevue, Washington
"Summer of Sound," Henry Art Gallery, Seattle
"Making Time: Considering Time as a Material in Contemporary Video & Film," UCLA Hammer Museum, Los Angeles
"Art>Music: Rock, Pop, Techno," Museum of Contemporary Art, Sydney, Australia

"010101: Art in Technological Times," San Francisco Museum of Modern Art, San Francisco
"Dévoler: Vivent les FRAC (*suite*)," Institut d'art contemporain, Villeurbanne, France

2002

In the spring, Graham receives an honorary doctorate from the Emily Carr Institute of Art and Design in Vancouver. He begins recording music for his album *Rock Is Hard*.
Gaga for Gigi, Volumizer's debut CD, is released by Vancouver's Mint Records.
Continuing on with the question of synchronization, Graham's discovery that he owns two copies of Tiffany's cover version of the 1967 Tommy James and the Shondells hit "I Think We're Alone Now" leads to some at-home DJ experiments in phasing and asynchrony, resulting in his own recording of the song.
Graham produces *Fantasia for Four Hands*, which consists of two photographs, each with a double portrait of Graham playing a grand piano. The work is based on an image from the jacket of a 45-rpm record released in 1962 by the Dutch musician/comedian duo Wim Sonneveld and Godfried Bomans.

Last year a friend gave me a Dutch 45-rpm record [by Sonneveld and Bomans] from 1961 with a cover that he thought would interest me. It showed two men seated at the same piano, one of them turned towards the camera, and the other hunched over, playing intently. I listened to the record…this comedy duo…seemed to be performing a routine of jokes about classical music in a genre close to that of Victor Borge (whom I greatly admired as a child, whom I count as an early inspiration for my own music jokes—particularly Parsifal—and who once played the "Minutenwalzer" in under a minute while sitting on a powderkeg with a one minute fuse—what a genius).

I resolved to do a double self-portrait in the manner of Jeff Wall by using this record cover as a model. Then it occurred to me to add novelty to the work by doubling it again in the manner of Ferrante and Teicher (i.e. with two pianos facing one another). The ring worn [in] the version of me in the foreground was the closest thing I could find to the large ring worn by my precursor and counterpart, although his was not Masonic. The Masonic ring I found put me in mind of Yves Klein['s] membership in a secret society (the Roscrucians?) and that led to my making the hopsack-covered acoustic panel a shade of ultramarine as close as I could get to International Klein Blue.
It was my intention to create a kind of frozen cinematic effect in the back and forth flickering of attention that is caused by two pictures representing slightly different scenes…
—Graham, unpublished artist's notes on *Fantasia for Four Hands* for "Rodney Graham: Music and Noise" at the Kunsthalle, Zürich.

Graham designs *Weather Vane* as an edition for *Parkett*. The work is a functioning domestic-scale weather vane, laser cut from stainless steel, based on a Derek Root drawing of Graham riding a bicycle backwards.

EXHIBITIONS
"Rodney Graham" (solo), Whitechapel Art Gallery, London
"Rodney Graham: Music and Noise" (solo), Kunsthalle, Zürich, Switzerland
"Rodney Graham: Bible Works," Goodwater, Toronto
2002 Biennale of Sydney, Sydney, Australia
"L'ascension du paysage: Fragments de voyage dans l'espace de l'art 1948–2002," Centre d'art contemporain, Istres, France
"Avant que la mer fut au monde, Rochechouart portoit les ondes," Musée départe-

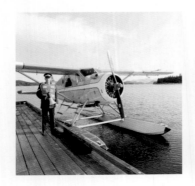
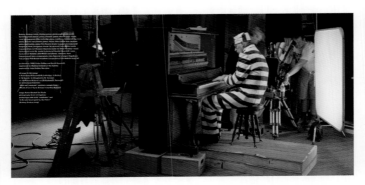

mental d'art contemporain, Rochechouart, France

"Rock My World: Recent Art and the Memory of Rock 'n' Roll," CCAC Wattis Institute for Contemporary Arts, San Francisco

"Remix: Contemporary Art and Pop Music," Tate Liverpool, Liverpool, England

"New Deal," Centre d'art contemporain, Geneva, Switzerland

"Regarding Landscape," Art Gallery of York University, The Koffler Gallery, and Museum of Contemporary Canadian Art, Toronto

"Transformer," Pori Art Museum, Pori, Finland

"La vie en temps réel/Life in Real Time," L'espace VOX, Montréal

2003

Partly out of interest in the drawings of Antonin Artaud, Graham takes up drawing and painting for the first time since the mid-1970s. In the spring, as war in Iraq approaches, he makes a series of drawings intended to put a hex on American president George W. Bush. Invited by Hans Ulrich Obrist to participate in "Utopia Station" at the Venice Biennale, Graham produces *Black Squares (my top 100)*, consisting of 100 black monochrome paintings on the covers of used vinyl LP records.

In June Graham's *Millennial Time Machine*, a landau carriage converted into a camera obscura, is permanently installed on the UBC campus near the Morris and Helen Belkin Art Gallery. At the unveiling ceremony, Graham learns that the university had awarded him a degree in 1973 and that he had in fact graduated from the bachelor of arts program he began in 1968.

During the summer Graham begins work on three film and video projects. *Loudhailer* is based on a scene from the 1973 film *The Wicker Man*, directed by Robin Hardy (in which Edward Woodward plays a devoutly Christian policeman and virgin). *Loudhailer* features Graham dressed in Royal Canadian Mounted Police (RCMP) uniform and an enormous orange life jacket, standing on the pontoon of a DeHavilland Beaver aircraft that floats on a sheltered bay somewhere along the coast of British Columbia. Graham holds a loudhailer through which he appears to call to the shore. The four-minute-long work is shot with two cameras and projected so the aircraft is split in half and the images are out of synchronization. The audio component consists of nature sounds and a rambling dialogue occasionally interrupted by the phrase "send out a dinghy."

Rheinmetall/Victoria 8 is a 35-mm film loop of a sequence of long static details of a 1930s vintage German typewriter. The static camera position together with the simple, but magical, special effects—the use of flour to simulate falling snow that eventually covers the machine—recall the work of the French magician and cinema pioneer Georges Méliès.

A Reverie Interrupted by the Police refers to both René Clair's *À nous la liberté* (1931) and *Modern Times* (1936) by Charlie Chaplin (who was the subject of a lawsuit asserting parts of his *Modern Times* plagiarized Clair's film). Graham plays a convict who is escorted to a piano (prepared in a John Cage–like fashion) and proceeds to play an improvised atonal composition, regularly punctuated with long silences in the manner of *School of Velocity*, while wearing handcuffs. The work is presented as a video projection with live sound.

Graham's album *Rock Is Hard* is self-released as a double vinyl LP, with production stills from *Loudhailer* and *A Reverie Interrupted by the Police* forming the artwork for the jacket. Fastidiously produced with horn sections, choruses of back-up vocalists, and intense, fuzz-boxed guitar solos, the album is more rock-oriented than *The Bed-Bug, Love Buzz*. *Rock Is Hard* includes covers of "Nighttime (I'm a Lover)" (1968), a pop hit for Tommy James and the Shondells; and "Belles of Paris" (1978) by the Beach Boys, together with fourteen original songs by Graham, including "Just How Low Does Your Love-Meter Go?," "I'm a Time Waster," and "Music for the Very Old."

One more round of this and I'm bound to lose control
Life is so unfair, then you fall into a very dark hole
Seems I slipped
When I lost my tourniquet grip
And no one ever said things will change
It will always always be the same
It's high time my very last cent was well and truly spent:
Income versus outcome—that's my predicament
At long, long last, after all these years
The shocking truth can be told:
This is music for the very very old
—from "Music for the Very Old" on Rock Is Hard

EXHIBITIONS

"Rodney Graham" (solo), K21 Kunstsammlung Nordrhein-Westfalen im Ständehaus, Düsseldorf, Germany; and MAC-Galleries contemporaines des Musées de Marseille, Marseille, France

"Rodney Graham" (solo), Madison Art Center, Madison

"Rodney Graham" (solo), Hauser & Wirth, Zürich, Switzerland

"Rodney Graham" (solo), Donald Young Gallery, Chicago

"Rodney Graham, Gary Hill, Joshua Mosley," Donald Young Gallery, Chicago

"Extended Play: Art Remixing Music," Govett-Brewster Art Gallery, New Plymouth, New Zealand

"Utopia Station," Venice Biennale, Venice, Italy

"Soundtracks: Re-play," Edmonton Art Gallery, Edmonton; The Power Plant, Toronto; Blackwood Gallery, The University of Toronto at Mississauga, Toronto; and The Doris McCarthy Gallery, The University of Toronto at Scarborough, Toronto

"On the Wall: Wallpaper by Contemporary Artists," Rhode Island School of Design Museum, Providence; and The Fabric Workshop and Museum, Philadelphia

"The Distance Between Me and You," Lisson Gallery, London

"C'est arrivé demain," 7th Biennale d'art contemporain de Lyon, La Sucrière, Lyon, France; Musée d'Art Contemporain, Lyon, France; Institut d'Art Contemporain, Villeurbanne, France; Le Musée des Beaux-Arts, Lyon, France; and Le Rectangle, Centre d'Art de la Ville de Lyon, Lyon, France

"Outlook," Benaki Museum, Athens School of Fine Art, Athens

"Doublures: Vêtements de l'art contemporain," Musée national des beaux-arts du Québec City

Unattributed quotes are by Graham and are from interviews conducted by the author during March, April, and May of 2003—except those under 1994 describing *Halcion Sleep,* which are from "Siting Vexation Island," 13.

Checklist of the Exhibition
and Bibliography

Camera Obscura, 1979
Architectural model, Cibachrome photograph of inverted tree,
chromogenic photograph of installation, and text
Model: 52.5 x 91 x 45.8 cm (20 5/8 x 35 7/8 x 18 in.)
Cibachrome photograph: 150 x 125.5 cm (59 x 49 3/8 in.)
Chromogenic photograph: 23 x 33.2 cm (9 x 13 1/8 in.)
Text panel: 20 x 20 cm (7 7/8 x 7 7/8 in.)
Original outdoor installation near Abbotsford, British Columbia
Collection of the Vancouver Art Gallery

Two Generators, 1984
35-mm film, film canister, and artist-designed label
Film: 4:30 min. projected repeatedly for 60–90 min.
Edition of 7 and artist's proof
Collection of the Art Gallery of Ontario, Toronto

Millennial Project for an Urban Plaza, 1986
Architectural model, diagram, and text
Model: 70.5 x 62.9 x 42.5 cm (27 3/4 x 24 3/4 x 16 3/4 in.)
Diagram and text: 56.5 x 56.5 cm (22 1/4 x 22 1/4 in.) each
Collection of the Vancouver Art Gallery

Camera Obscura Mobile, 1989
Scale architectural model with framed photograph: wood, MDF,
fabric, paint, metal, and chromogenic photograph
Model: 51.5 x 41.5 x 124.7 cm (20 1/4 x 16 3/8 x 49 1/8 in.)
Table: 60.5 x 69.5 x 213.9 cm (23 7/8 x 27 3/8 x 84 1/4 in.)
Photograph: 87 x 75 cm (34 1/4 x 29 1/2 in.)
Collection of the Art Gallery of Ontario, Toronto
Purchased with funds donated by AGO Members

Linden, Hundelgem, from *Flanders Trees*, 1989
Monochrome color photograph
240 x 180 cm (94 1/2 x 70 7/8 in.)
Exhibition copy courtesy the artist

Linden, Hundelgem, from *Flanders Trees*, 1989
Monochrome color photograph
240 x 180 cm (94 1/2 x 70 7/8 in.)
Exhibition copy courtesy the artist

Linden, Ronse, from *Flanders Trees*, 1989
Monochrome color photograph
240 x 180 cm (94 1/2 x 70 7/8 in.)
Exhibition copy courtesy the artist

Oak, Kaggevinne, from *Flanders Trees*, 1989
Monochrome color photograph
240 x 180 cm (94 1/2 x 70 7/8 in.)
Exhibition copy courtesy the artist

Oak, Mellaar, from *Flanders Trees*, 1989
Monochrome color photograph
240 x 180 cm (94 1/2 x 70 7/8 in.)
Exhibition copy courtesy the artist

Paardenkastanje, Millen-Riemst, from *Flanders Trees*, 1989
Monochrome color photograph
240 x 180 cm (94 1/2 x 70 7/8 in.)
Exhibition copy courtesy the artist

Willow, Mullem, from *Flanders Trees*, 1989
Monochrome color photograph
240 x 180 cm (94 1/2 x 70 7/8 in.)
Exhibition copy courtesy the artist

Casino Royale (Sculpture de Voyage), 1990
Plexiglas and chromium-plated steel mural display case, and paperback
book in a white cardboard box with four-color off-set poster
Case: 7 x 25 x 31 cm (2 3/4 x 9 7/8 x 12 1/4 in.)
Box: 90 x 57 cm (35 3/8 x 22 1/2 in.)
Collection Yves Gevaert, Brussels

Dr. No, 1991–94
Color video transferred to DVD
33:55 min. projected on continuous loop
Edition of 3
Courtesy the artist and Galerie Johnen & Schöttle, Cologne

Reading Machine for Parsifal. One Signature, 1992
Rotating brass display unit on a stand for reading, Plexiglas, and glass
188 x 80 x 75 cm (74 x 31 1/2 x 29 1/2 in.)
Edition of 3
Collection of the Vancouver Art Gallery

Casino Royale—Sculpture de Voyage Deluxe, 1993
Plexiglas and brass mural display case, hardcover book (first edition
of *Casino Royale* by Ian Fleming), screwdriver, screws, and engineer's
level in leather suitcase
15 x 56 x 39 cm (5 7/8 x 22 x 15 3/8 in.)
Collection of the Israel Museum, Jerusalem. Gift of Jill and Jay Bernstein,
Old Westbury, New York, to the American Friends of the Israel Museum in
honor of the 30th anniversary of the Israel Museum

Reading Machine for Lenz, 1993
Text on paper, glass, Plexiglas, and wood
55.2 x 59.7 x 19.7 cm (21 3/4 x 23 1/2 x 7 3/4 in.)
Edition of 3
Collection of Jeanne Parkin, Toronto

Halcion Sleep, 1994
Black-and-white video transferred to DVD
26 min. projected on continuous loop, silent
Edition of 3 and artist's proof
Displayed with pajamas
Collection of the Vancouver Art Gallery

Coruscating Cinnamon Granules, 1996
16-mm film installation
3 min. projected on continuous loop, silent
Edition of 3 and artist's proof
Wood and wall board structure with theater seats
274.3 x 470.5 x 314.3 cm (108 x 185 1/4 x 123 3/4 in.)
Collection of the National Gallery of Canada, Ottawa. Purchased 1999

Vexation Island, 1997
35-mm film transferred to DVD
9 min. projected on continuous loop
Edition of 4 and 2 artist's proofs
Displayed with props and artist's notes
Produced by Lisson Gallery, London
Collection of the Morris and Helen Belkin Art Gallery, University of British Columbia,
Vancouver. Purchased with the support of the Canada Council Acquisition Assistance
Program and the Morris and Helen Belkin Foundation, 1998

Edge of a Wood, 1999
Black-and-white video transferred to DVD
7:54 min. double projection on continuous loop
Edition of 4 and 2 artist's proofs
Produced by Donald Young Gallery, Chicago
The Museum of Contemporary Art, Los Angeles
Purchased with funds provided by the Acquisition and Collection Committee

How I Became a Ramblin' Man, 1999
35-mm film transferred to DVD
9 min. projected on continuous loop
Edition of 4 and 2 artist's proofs
Produced by Donald Young Gallery, Chicago
Collection Musée d'art contemporain, Montréal

Aberdeen, 2000
80-slide projection installation, CD, and earphones
20 min.; edition of 3 and artist's proof
Courtesy Donald Young Gallery, Chicago

City Self/Country Self, 2000
35-mm film transferred to DVD
4 min. projected on continuous loop
Edition of 4 and 2 artist's proofs
Displayed with costumes, masks, and props
Produced by Lisson Gallery, London
Collection of the Vancouver Art Gallery. Vancouver Art Gallery Acquisition Fund

Fishing on a Jetty, 2000
Two chromogenic photographs
250 x 360 cm (98 3/8 x 141 3/4 in.)
Edition of 3, artist's proof, and production proof
Collection of Phil Lind, Toronto

A Little Thought, 2000
Super 8 film transferred to DVD
3:45 min. continuous loop
Edition of 12 and 2 artist's proofs
Collection of Jeanne Parkin, Toronto

Softcore (More Solo Guitar Music for the Sex Scene,
Zabriskie Point), 2001
108 min. continuous loop
Courtesy the artist

Fantasia for Four Hands, 2002
Two chromogenic photographs
256.5 x 195.5 cm (101 x 77 in.) each
Edition of 4 and artist's proof
Collection of Gerald Sheff and Shanitha Kachan, Toronto (Toronto venue)
Private collection (Los Angeles and Vancouver venues)

The Phonokinetoscope, 2002
16-mm film installation with vinyl disc and modified turntable
4:45 min. projected on continuous loop; dimensions variable
Edition of 4 and 2 artist's proofs
Produced by Galerie Philip Nelson, Paris; and 303 Gallery, New York
Courtesy 303 Gallery, New York

A Reverie Interrupted by the Police, 2003
35-mm film transferred to DVD
7:59 min. projected on continuous loop
Edition of 5 and artist's proof
Produced by Donald Young Gallery, Chicago; and Hauser & Wirth, Zürich
Courtesy Donald Young Gallery, Chicago

Rheinmetall/Victoria 8, 2003
35-mm film, Cinemeccanica Victoria 8 35-mm film projector and looper
10:50 min. projected on continuous loop, silent
Edition of 5 and artist's proof
Produced by Donald Young Gallery, Chicago; Hauser & Wirth, Zürich; 303 Gallery,
New York; and Galerie Johnen & Schöttle, Cologne and Munich
Courtesy Donald Young Gallery, Chicago

A selection of books, vinyl records, CDs, drawings, posters, and archival
ephemera from the collections of the artist; Vancouver Art Gallery; and
Yves Gevaert, Brussels, are also included in the exhibition.

BIBLIOGRAPHY
Compiled by Grant Arnold

CATALOGUES OF SOLO EXHIBITIONS

• *Oeuvres freudiennes/Oeuvres wagnériennes.*
Rochechouart, France: Musée départemental
de Rochechouart; and Brussels: Yves Gevaert,
1996.
• *Rodney Graham.* Vancouver: Vancouver Art
Gallery, 1988.
• *Rodney Graham.* Eindhoven, The Netherlands:
Stedelijk Van Abbemuseum, 1989.
• *Rodney Graham.* London: Whitechapel Art
Gallery, 2002.
• *Rodney Graham.* Ostfildern-Ruit, Germany:
Hatje Cantz Verlag, 2003.
• *Rodney Graham: Cinema Music Video.* Vienna:
Kunsthalle; and Brussels: Yves Gevaert Verlag,
1999. Includes the audio CD *I'm a Noise Man.*
• *Rodney Graham; Getting It Together in the
Country: Some Works with Sound Waves, Some
Works with Light Waves and Some Other
Experimental Works.* Munich, Germany:
Kunstverein; Münster, Germany:
Westfälischer Kunstverein; Berlin:
Künstlerprogramm/DAAD; and Cologne,
Germany: Oktagon Verlag. Includes vinyl LP
audio recording.
• *Rodney Graham; Island Thought: Canada XLVII
Biennale di Venezia.* Toronto: Art Gallery of
York University, 1997.
• *Rodney Graham: Malle-poste américaine (ca 1904)
convertie en caméra obscura mobile.* Sotteville-
lès-Rouen: FRAC Haute-Normandie, 1997.
• *Rodney Graham: Parsifal.* Cologne, Germany:
Johnen & Schöttle, 1990.
• *Rodney Graham: Vexation Island and Other Works.*
Toronto: Art Gallery of York University, 1998.
• *Rodney Graham: Works from 1976 to 1994.*
Toronto: Art Gallery of York University;
Brussels: Yves Gevaert; and Chicago: The
Renaissance Society at the University of
Chicago, 1994.

CATALOGUES OF GROUP EXHIBITIONS

• *010101: Art in Technological Times.* San Francisco:
San Francisco Museum of Modern Art, 2001.
• *Aanwinsten/Acquisitions 1989–1993.* Eindhoven,
The Netherlands: Stedelijk Van Abbemuseum,
1993.
• *About Place: Recent Art of the Americas.*
Chicago: The Art Institute of Chicago, 1995.
• *Un accrochage ou des coins remplis de ce qui a été
raflé dans des coins/Hoeken gevuld met wat in
hoeken werd geveegd/Corners Filled with What Is
Swept Into Corners.* Antwerp, Belgium: Galerie
Micheline Szwajcer, 1993.
• *Arbora Versa.* Vancouver: Contemporary Art
Gallery, 1990.
• *Artistes/Architectes.* Villeurbanne, France:
Le Nouveau Musée/Insitut d'art contempo-
rain, 1995.

• *Beneath the Paving Stones.* Vancouver: Charles
H. Scott Gallery, 1993.
• *Biennale of Sydney 2002: (The World May Be)
Fantastic.* Sydney: Biennale of Sydney, 2002.
• *Binaera: 14 Interaktionen—Kunst und
Technologie.* Vienna: Kunsthalle, 1993.
• *Books, Prints and Objects Published by Yves
Gevaert.* Eindhoven, The Netherlands:
Stedelijk Van Abbemuseum, 1992.
• *Cámaras indiscretas.* Madrid: Círculo de Bellas
Artes, 1992.
• *Càmeres indiscretes.* Barcelona, Spain:
Generalitat de Catalunya, Department de
Cultura, 1992.
• *Canada, une nouvelle génération.* Gétigné-
Clisson, France: FRAC des Pays de la Loire,
1993.
• *Crossroads.* North York, Ontario: Art Gallery
of York University, 1991.
• *Documenta IX.* Stuttgart, Germany: Edition
Cantz; and New York: Harry N. Abrams, 1992.
• *L'ère binaire: Nouvelles interactions.* Brussels:
Musée d'Ixelles, 1992.
• *Essential Form.* Banff, Alberta: Walter Phillips
Gallery, 1989.
• *Extended Play: Art Remixing Music.* New
Plymouth, New Zealand: Govett-Brewster
Art Gallery, 2003.
• *Eye of Nature.* Banff, Alberta: Walter Phillips
Gallery, 1991.
• *Facsimile.* Groningen, The Netherlands:
Stichting De Zaak, 1988.
• *Faiseurs d'histoires.* Luxembourg: Casino
Luxembourg–Forum d'art contemporain,
1999.
• *Feature: Art, Life and Cinema.* New Plymouth,
New Zealand: Govett-Brewster Art Gallery,
2001.
• *Flight Patterns.* Los Angeles: The Museum
of Contemporary Art, 2000.
• *Graham, Prina, Williams.* Toronto: S. L.
Simpson Gallery, 1991.
• *The Greenhouse Effect.* London: Serpentine
Gallery, 2000.
• *Hacia el paisaje.* Las Palmas, Gran Canaria,
Spain: Centro Altántico de Arte Moderno,
1990.
• *Inscapes.* Amsterdam: De Appel Foundation,
1992.
• *Jardin-Théâtre Bestiarium.* Poitiers, France:
Entrepôt-Galerie de Confort Moderne, 1989.
• *Kunst mit Fotografie.* Stuttgart, Germany:
Galerie Ralph Wernicke, 1987.
• *Lesen.* St. Gallen, Switzerland: Kunsthalle,
1996.
• *Let's Entertain: Life's Guilty Pleasures.*
Minneapolis: Walker Art Center, 2000.
• *Lost Illusions: Recent Landscape Art.* Vancouver:
Vancouver Art Gallery, 1991.
• *Made in Camera.* Stockholm: VAVD Editions,
1988.
• *Making Time: Considering Time as a Material in*

Contemporary Video & Film. Los Angeles: UCLA
Hammer Museum, 2001.
• *Mowry Baden, Roland Brener, Christos Dikeakos,
Fred Douglas, Dean Ellis, Rodney Graham,
Tod Greenaway, Ian Wallace.* Vancouver:
Pender Street Gallery, 1977.
• *Non in Codice.* Rome: Accademia Americana,
Centro Culturale Canadese, and Galleria
Pieroni, 1987.
• *On the Wall: Wallpaper by Contemporary Artists.*
Providence: Rhode Island School of Design
Museum, 2003.
• *Private Eye: Crimes & Cases.* Berlin: Haus
am Waldsee, 1999.
• *Projected Allegories: A Video Series.* Houston:
Contemporary Arts Museum, 1998.
• *Prospekt 89: Eine internationale Ausstellung
aktueller Kunst.* Frankfurt, Germany:
Frankfurter Kunstverein, 1989.
• *Regarding Beauty: A View of the Late Twentieth
Century.* Washington, D.C.: Hirshhorn
Museum and Sculpture Garden, Smithsonian
Institution, 1999.
• *Reservate der Sehnsucht/Reserves of Longing.*
Dortmund, Germany: Kulturbüro Stadt
Dortmund and hARTware projekte e.V., 1998.
• *Ricochet.* Rome: Sala 1, Centro internazionale
d'arte contemporanea, 1986.
• *Rodney Graham and Bruce Nauman: "…the
nearest faraway place…".* New York: Dia
Center for the Arts, 2000.
• *Rodney Graham and Vera Lutter:* Time Traced.
New York: Dia Center for the Arts, 1999.
• *Rodney Graham, Ken Lum, Jeff Wall,
Ian Wallace.* New York: 49th Parallel Centre
for Contemporary Canadian Art, 1985.
• *Rodney Graham, Robert Kleyn, Jeff Wall,
Ian Wallace.* Milan: Studio Casoli, 1988.
• *Die Schrift des Raumes: Kunst Architektur
Kunst.* Vienna: Kunsthalle, 1996.
• *Searchlight: Consciousness at the Millennium.*
San Francisco: California College of Arts
and Crafts; and New York: Thames and
Hudson, 1999.
• *Sharawadgi.* Baden, Austria: Felsenvilla, 1998.
• *Sites of the Visual: Rodney Graham, Steven
Pippin, David Tomas.* Windsor, Ontario:
Art Gallery of Windsor, 1997.
• *Skulptur Projekte in Münster.* Cologne,
Germany: DuMont Buchverlag, 1987.
• *Speed: Visions of an Accelerated Age.* London:
The Photographers' Gallery; Guelph, Ontario:
MacDonald Stewart Art Centre; and Amster-
dam: Netherlands Design Institute, 1998.
• *Spirits on the Crossing. Travellers to/from Nowhere:
Contemporary Art in Canada 1980–94.* Tokyo:
Setagaya Art Museum; Kyoto, Japan: National
Museum of Modern Art; and Hokkaido,
Japan: Museum of Modern Art, 1995.
• *Teatrojardin Bestiarium.* Seville, Spain: Casino
de la Exposición, 1989.

- *Theatergarden Bestiarium: The Garden as Theater as Museum*. Long Island City, New York: Institute for Contemporary Art, P.S. 1 Museum; and Cambridge, Massachusetts: The MIT Press, 1990.
- *These Days*. Vancouver: Vancouver Art Gallery, 2001.
- *Time and Tide: The Tyne International Exhibition of Contemporary Art*. London: Academy Editions, 1993.
- *Topographies: Aspects of Recent B.C. art*. Vancouver: Vancouver Art Gallery, 1996.
- *Tout le temps/Every Time*. Montréal: Centre international d'art contemporain, 2000.
- *Transformer*. Pori, Finland: Pori Art Museum, 2002.
- *Los últimos días/The Last Days*. Seville, Spain: Salas del Arenal and Sección Española para la Exposición Universal de Sevilla, 1992.
- *La vie en temps réel/Life in Real Time*. Montréal: L'espace Vox, 2002.
- *Weitersehen (1980→1990→)*. Krefeld, Germany: Krefelder Kunstmuseen, 1990.

REVIEWS AND ESSAYS

- Alberro, Alexander. "Loop Dreams: Rodney Graham's *Vexation Island*." *Artforum* 36, no. 6 (February 1998): 72–75, 108.
- Ainardi, Dolène. "Rodney Graham: Maison de la Culture, Saint-Étienne." *Art Press*, no. 159 (June 1991): 90.
- Andersson, Patrik. "Rodney Graham: Lisson Gallery." *Material* (Stockholm), no. 31 (winter 1997): 12.
- Artner, Alan G. "Music to His Mind." *Chicago Tribune*, 8 October 1995, sec. 7, 9.
- Balkema, Annette W., and Henk Slager, eds. *The Photographic Paradigm*. Amsterdam: Rodopi, 1997.
- Barrot, Olivier, and Sophie Schmidt. "New York contemporain de Chelsea au Meat Market." *L'oeil* (Paris), no. 526 (May 2001): 30–37.
- "B.C. Artist Invited to Venetian Celebration." *The Vancouver Sun*, 18 December 1996.
- Beil, Ralf. "Black Box: Der Schwarzraum in der Kunst." *Berner Kunstmitteilungen* (Bern), no. 330 (June–July 2001): 2–7.
- Berndes, Christiane. "Raymond Roussel en Marcel Duchamp. De invloed van het spel met woorden op de beeldende kunst." *Raymond Roussel*, 54–67. Arnhem, The Netherlands: Hogeschool voor de Kunsten, 1994.
- Borden, Wil. "Ingewikkelde en eenvoudige kunst in Van Abbe." *Eindhovens Dagblad* (Eindhoven, The Netherlands), 23 December 1989.
- Bourriaud, Nicolas. "L'art a livre ouvert." *BeauxArts Magazine*, no. 178 (March 1999): 64–72.
- Bowen, Lisa Balfour. "Documenta 9." *Artfocus* (Toronto) 1, no. 1 (fall 1992): 6–10.

- Bradley, Kim. "Rodney Graham: Fundació Espai Poblenou, Barcelona, November 29–February 28." *Parachute*, no. 79 (July–September 1995): 57–58.
- Braet, Jan. "Een droom over een boek." *Knack* (Brussels) (10–16 January 1990): 124–27.
- Brayer, Marie-Ange. "Rodney Graham." *Forum International* (Antwerp, Belgium) 2, no. 10 (November–December 1991): 46–51.
- ———. "Rodney Graham: Une involution optique, le nom augmenté." *Exposé* (Orléans, France), no. 1 (spring–summer 1994): 116–23.
- ———. "L'effraction du récit chez Rodney Graham." *Parachute*, no. 76 (October–December 1994): 34–37.
- ———. "Rodney Graham: Through the Mirror." *Art Press*, no. 205 (September 1995): 55–58.
- Brea, Jose Luis. "Neo-Baroque: A Wind Without a North." *Flash Art*, no. 154 (October 1990): 125–28.
- Britto Jinoria, Orlando. "Bienales y encuentros de arte contemporaneo." *Lapiz* (Madrid) 19, no. 167 (November 2000): 62–67.
- Burnett, Craig. "Who Is the Artist, Baby? Rodney Graham at the Lisson Gallery, London." *Modern Painters* (London) 14, no. 1 (spring 2001): 70–71.
- Cameron, Dan. "47th Venice Biennale." *Artforum* 36, no. 1 (September 1997): 118–20.
- Chaine, Stani. "Rodney Graham. A Minima." *Lyon Poche* (Lyon, France) (13–19 April 1988): 27.
- Chattopadhyay, Collette. "Flight Patterns: Landscapes of the Pacific Rim." *ART AsiaPacific*, no. 31 (July–September 2001): 26–28.
- Christov-Bakargiev, Carolyn. "Something Nowhere." *Flash Art*, no. 140 (May–June 1988): 80–85.
- Cooke, Lynne. "Rodney Graham: A Tale of a Hat/Geschichte eines Hutes." *Parkett*, no. 64 (May 2002): 96–113.
- "Costumi ottocenteschi e sfilate in città: In mostra l'ultimo video di Rodney Graham." *Arte* (Milan, Italy), no. 340 (December 2001): 223.
- Cranfield, Brady. "Relaxing with Rodney Graham: Interview with Brady Cranfield." *The Discorder* (Vancouver), no. 227 (March 2002): 16–17.
- Cumming, Laura. "Watch carefully." *The Observer* (London), 29 September 2002.
- Cyphers, Peggy. "Rodney Graham: Christine Burgin." *Arts Magazine* 65, no. 7 (March 1991): 97.
- Dafoe, Chris. "Rodney Graham Tickles the Ivories." *The Globe and Mail*, 11 May 1996.
- Day, Peter. "Rodney Graham." *Canadian Art* 5, no. 2 (summer 1988): 28.
- De Bruyn, Eric. "Rodney Graham: Christine Burgin." *Artscribe*, no. 86 (March–April 1991): 71.

- Deroudille, René. "Rodney Graham: Galerie Nelson." *Lyon Matin* (Lyon, France), 15 April 1988.
- Diep, Tran. "La bibliothèque en volumes de Rodney Graham." *Lyon Libération* (Lyon, France), 8 April 1988.
- Dordeit, Olivier. "Rodney Graham: Question de representation." *Parcours* (Montréal) 2, no. 1 (autumn 1995): 46–47.
- Duncan, Michael. "Report from Sydney: Self-Created Worlds." *Art in America* 90, no. 10 (October 2002): 60–65.
- Exley, Roy. "Straight to Video." *Design Week* (London) 15, no. 16 (21 April 2000): 16–20.
- Feaver, William. "Rodney Graham at Lisson." *ARTnews* 100, no. 3 (March 2001): 165.
- Ferré, Sylvie. "De la biennale trop sage…à la Documenta glaciale!" *INTER* (Quebec City), no. 69 (1998): 77–79.
- Furlong, William. "Rodney Graham." *Audio Arts* (London) 16, no. 2 (1997): side one.
- Gale, Peggy. "The Sleeper: Rodney Graham in Venice." *Canadian Art* 14, no. 2 (summer 1997): 54–59.
- ———. "Rodney Graham, Art Gallery of York University." *Canadian Art* 11, no. 4 (winter 1994): 77–78.
- Garlake, Margaret. "Throw a Six and Go to Venice." *Gallery* (Harare), no. 13 (September 1997): 20–23.
- Gauville, Hervé. "Parsifal a trouvé son Saint-Graham." *Libération* (Paris), 25 March 1991.
- Gigli, Nicoletta. "Gran tour d'estate." *Arte* (Milan, Italy), no. 311 (July 1999): 66–77.
- ———. "Investire nei nuovi miti." *Arte* (Milan, Italy), no. 348 (August 2002): 82–89.
- ———, and Renato Diez. "Il mercato dopo Art Basel." *Arte* (Milan, Italy), no. 349 (September 2002): 62–69.
- Glasmeier, Michael. *Loop: Zur Geschichte und Theorie der Endlosschleife am Beispiel Rodney Graham*. Cologne, Germany: Salon Verlag, 2002.
- Godfrey, Tony. "Roni Horn, Craigie Horsfield, and Contemporary Artists' Video." *The Burlington Magazine* 142, no. 1168 (July 2000): 456–58.
- Gopnik, Blake. "Masters of All They Survey." *The Globe and Mail*, 28 November 2000.
- Grundberg, Andy. "When Upside Down Is Right Side Up." *The New York Times*, 21 December 1990.
- Guilbaut, Serge. "Rodney Graham et Francis Alÿs." *Parachute*, no. 87 (July–September 1997): 12–21.
- Guzman, Antonio. "Rodney Graham." *Opus International* (Paris), no. 128 (summer 1992): 32–33.
- Hafner, Hans-Jürgen. "Loop: Alles auf Anfang." *Kunstforum International* (Mainz, Germany), no. 158 (January–March 2002): 350–51.

• ———. "Buzzes...Others Inside Out... Hans-Jürgen Hafner on Rodney Graham." *C Magazine* 77 (spring 2003): 22–25.

• Hale, Mathew. "And I'm Wondering Who Could Be Writing This Song." *Parkett*, no. 64 (May 2002): 116–29.

• Haraldsson, Arni Runar. "In-Quest of Folly: Reading Rodney Graham's 'Lenz'." *C Magazine* 5 (spring 1985): 34–38.

• Hart, Claudia. "Rodney Graham: Christine Burgin Gallery." *Artforum* 26, no. 10 (summer 1988): 137.

• Hauffen, Michael. "Rodney Graham: 'Some Works with Sound Waves, Some Works with Light Waves and Some Other Experimental Works.'" *Kunstforum International* (Mainz, Germany), no. 152 (October–December 2000): 382.

• Heartney, Eleanor. "Sighted in Münster." *Art in America* 75, no. 9 (September 1987): 140–43, 201.

• Holg, Garrett. "Rodney Graham: Donald Young." *ARTnews* 99, no. 1 (January 2000): 172.

• Holmes, Willard. "Here Our Look Sees Itself." *Parachute*, no. 60 (October–December 1990): 20–23.

• Hudson, Peter. "Come Again: Rodney Graham's Repeating Island." *MIX* (Toronto) 24, no. 3 (winter 1998–99): 28–29.

• Humphrey, David. "New York Fax: Rodney Graham, Steve McQueen, Erzsébet Baerveldt." *Art Issues*, no. 52 (March–April 1998): 34–35.

• Imhof, Dora. "Black Box: Der Schwarzraum in der Kunst." *Kunstforum International* (Mainz, Germany), no. 156 (August–October 2001): 458–59.

• Jeffries, Bill. "Rodney Graham: Vancouver Art Gallery, July 23–August 29." *Parachute*, no. 53 (December 1988–February 1989): 44–46.

• Johnson, Ken. "Rodney Graham at Christine Burgin." *Art in America* 79, no. 4 (April 1991): 165.

• Jones, Ronald. "Rodney Graham: 303 Gallery, New York." *Frieze*, no. 23 (summer 1993): 76–77.

• Juhl, Carsten. "Den 47. ende Kunstbiennale I Venezia." *Ojeblikket* (Copenhagen) 7, no. 34 (winter 1997): 14–15.

• Kantor, Jordan. "Loop: P.S.1." *Artforum* 40, no. 8 (April 2002): 137–38.

• Keziere, Russell. "Illuminated Ravine. Camera Obscura." *Vanguard* 8, no. 9 (November 1979): 29.

• Kleyn, Robert. "Method, Method." *C Magazine*, no. 22 (summer 1989): 38–45.

• Königer, Maribel. "Rodney Graham/Ian Wallace. Galerie Rüdiger Schöttle, 23.3–28.4.1990." *Kunstforum International* (Mainz, Germany) (June 1990): 333–34.

• Kopenkina, Olga. "Mul'timediinaya kartina v galereyakh Nyu-Yorka: Enjoy!" *Moscow Art Magazine*, nos. 28–29 (2000): 100–03.

• Krummel, Clemens. "Meta-virulent." *Texte zur Kunst* (Cologne, Germany), no. 40 (December 2000): 181–86.

• Lambrecht, Luk. "Rodney Graham at Micheline Szwajcer, Yves Gevaert, Antwerp." *Flash Art*, no. 149 (November–December 1989): 151–52.

• Lane, Mallory. "Juxtaposition." *Art Review* (London) 53 (October 2001): 52–55.

• Le Foll, Nathalie. "Photographie et industrie." *Connaissance des Arts*, no. 590 (January 2002): 9.

• Lebredt, Gordon. "Rodney Graham: Ydessa Gallery, Toronto." *C Magazine* (spring 1988): 52–53.

• ———. "A Piece of Poe." *Vanguard* 17, no. 2 (April–May 1988): 45–46.

• Legros, Hervé. "Rodney Graham." *BeauxArts Magazine*, no. 97 (January 1992): 84–85.

• Lewis, James. "Rodney Graham: Christine Burgin Gallery." *Artforum* 29, no. 6 (February 1991): 124.

• Liang, Jack. "Another Day in Paradise: The Film and Video Work of Rodney Graham." *Parachute*, no. 95 (July–September 1999): 12–19.

• Linsley, Robert. "In Pursuit of the Vanishing Subject: James Welling and Rodney Graham." *C Magazine*, no. 16 (December 1987): 26–29.

• ———. "Rodney Graham." *Artefactum* (Antwerp, Belgium) 8, no. 37 (February–March 1991): 6–9.

• Mahoney, Elisabeth. "Dream Machines: Dundee Contemporary Arts." *Art Monthly*, no. 235 (April 2000): 23–26.

• Marchi, Valerie. "L'image en movement et en musique." *L'oeil* (Paris), no. 531 (November 2001): 65.

• Mason, Joyce, Joanne Tod, and Suzy Lake. "European Scrapbook: Music, Light and Other Conundrums; So This Is." *C Magazine*, no. 55 (September–November 1997): 25–31.

• Mays, John Bentley. "Artistic Treasure Hunt Yields Curious Insights." *The Globe and Mail*, 17 June 1987.

• ———. "When Is a Book Not a Book?" *The Globe and Mail*, 5 December 1987.

• ———. "Nine Canadian Artists, Nine Remarkable Choices." *The Globe and Mail*, 16 June 1992.

• ———. "A Rare Chance to View the Talent of Two Home Boys." *The Globe and Mail*, 15 October 1994.

• Meister, Helga. "Für die Zukunft bin ich jedenfalls optimistisch." *Kunstforum International* (Mainz, Germany), no. 160 (June–July 2002): 457–60.

• Mercado, Santiago. "Rodney Graham, Jan Vercruysse: Galería Marga Paz." *Arena* (Madrid) (June 1989): 95–96.

• Milroy, Sarah. "Primeval Meets Postmodern in B.C. Show." *The Globe and Mail*, 28 September 1996.

• ———. "The Artist as Mobius Strip." *The Globe and Mail*, 7 June 1997.

• ———. "How He Became a Ramblin' Man." *National Post*, 21 November 2000.

• ———. "Onward and Upward." *The Globe and Mail*, 13 August 2001.

• Müller, Silke. "Gefangen in der Schleife." *ART: Das Kunstmagazin* (Hamburg, Germany) (November 2001): 115–16.

• Nordstrom, Jennifer. "The Illuminated Ravine by Rodney Graham at Naheeno Park/Nov. 6." *The Peak* (Burnaby, British Columbia), 14 November 1991.

• "Parsifal unterwegs." *Kunst-Bulletin* (Bern) (October 1990): 12–13.

• Pérez Villén, Ángel Luis. "La vanitas nebarroca." *Lapiz* (Madrid) 10, no. 87 (May–June 1992): 64–67.

• Pesch, Martin. "Reservate der Sehnsucht." *Kunstforum International* (Mainz, Germany), no. 142 (October–December 1998): 401–02.

• Poledna, Mathias. "Vexation Island." *Texte zur Kunst* 7, no. 27 (September 1997): 150–52.

• Ramsay, Ellen. "Rodney Graham, James Welling." *Vanguard* 16, no. 1 (February–March 1987): 33–34.

• Richard, Frances. "A Private Reading: The Book as Image and Object; Senior & Shopmaker Gallery." *Artforum* 40, no. 4 (December 2001): 119.

• Ritter, Peter. "Let's Entertain." *Flash Art*, no. 214 (October 2000): 98–99.

• Riva, Alessandro. "Pezzo per pezzo segreti e curiosità della Biennale." *Arte* (Milan, Italy), no. 289 (September 1997): 88–95.

• Ross, Val. "Vancouver Artist Chosen for Biennale." *The Globe and Mail*, 16 December 1996.

• Rush, Michael. "Fire and Water: Three Media Installations." *PAJ*, no. 58 (January 1998): 81–86.

• ———. "Video Installation Art." In *New Media in Late 20th-Century Art*, 116–67. London: Thames & Hudson, 1999.

• Sausset, Damien. "Rodney Graham: Wagner et Nirvana." *L'oeil* (Paris), no. 524 (March 2001): 88.

• Schmitz, Edgar. "A Shot in the Head." *Kunstforum International* (Mainz, Germany), no. 152 (October–December 2000): 417–18.

• Schumacher, Mary Louise. "Artist Takes Unusual Angles." *Milwaukee Journal Sentinel*, 7 March 2003.

• Schwabsky, Barry. "Non in Codice." *Flash Art*, no. 138 (January–February 1988): 117.

• ———. "Inverted Trees and the Dream of a Book: An Interview with Rodney Graham." *Art on Paper* 5, no. 1 (September–October 2000): 64–69.

• Scott, Michael. "Music of This Sphere Lasts a Long Time." *The Vancouver Sun*, 9 March 1996.
• ———. "Graham's Paradise Has Loose Thread." *The Vancouver Sun*, 25 November 2000.
• Searle, Adrian. "Weird and wonderful." *The Guardian* (Manchester, England), 24 September 2002.
• Sheets, Hilarie M. "Strange Comfort." *ARTnews* 101, no. 8 (September 2002): 140–43.
• Shone, Richard. "Venice Biennale and Other Exhibitions." *The Burlington Magazine* 139, no. 1134 (September 1997): 651–53.
• Sinclair, Ross. "11 Tyne International." *Art Monthly*, no. 169 (September 1993): 27–28.
• Slyce, John. "Rodney Graham: Lisson Gallery." *Art Monthly*, no. 243 (February 2001): 40–41.
• ———, and Matthew Collings. "Video Art: A Top Twenty." *Modern Painters* (London) 13, no. 2 (summer 2000): 30–33.
• Smith, Roberta. "Gazing in a Mirror: The Omnipresent Camera." *The New York Times*, 10 September 1999.
• Smolik, Noemi. "Neue Welt: Kunstverein." *Artforum* 40, no. 4 (December 2001): 130.
• Sommerman, Eileen. "Eileen Sommerman's Paris." *C Magazine*, no. 71 (fall 2001): 33–35.
• Spada, Sabina. "Non solo musica: La letteratura romantica nel film de Rodney Graham." *Arte* (Milan, Italy), no. 329 (January 2001): 208.
• Stals, José Lebrero. "Rodney Graham: Johnen & Schöttle." *Flash Art*, no. 155 (November–December 1990): 158–59.
• Staple, Polly. "Video Show House." *Art Monthly*, no. 238 (July–August 2000): 11–14.
• Steiner, Shepherd. "Rodney Graham: Au delà des principes de la blague." *Last Call* (Vancouver) 1, no. 1 (summer 2001): 1–2.
• ———. "'What Is Happy, Baby?', or Jokes and Their Relation to the Work of Rodney Graham." *Parachute*, no. 103 (July–September 2001): 2–3.
• Stern, Steven. "River Deep Mountain High." *Frieze*, no. 71 (November–December 2002): 62–67.
• Swartz, Jeffrey. "Rodney Graham: Opening to Equivocal Strictures." *Lapiz* (Madrid), no. 67 (April 1990): 30–37.
• ———. "Rodney Graham: Fundació Espai Poblenou." *ARTnews* 94, no. 4 (April 1995): 159.
• Taylor, Kate. "Site for Sore Eyes Treated to Some Strong Medicine." *The Globe and Mail*, 27 September 1991.
• Tegenbosch, Pietje. "Soloprestaties in Van Abbe. Van een process dat geen einde kent. James Coleman, Rodney Graham, Jouke Kleerebezem." *Volkskrant* (Amsterdam), 5 January 1990.

• Troncy, Eric. "Soft Touch." *Artscribe*, no. 88 (September 1991): 54–57.
• Vetrocq, Marcia E. "The 1997 Venice Biennale: A Space Odyssey." *Art in America* 85, no. 9 (September 1997): 66–77.
• Volk, Gregory. "Back to the Bosphorus." *Art in America* 90, no. 3 (March 2002): 42–47.
• Wall, Jeff. "Dans la forêt: Deux ébauches d'étude sur l'oeuvre de Rodney Graham." In *Dans la forêt: Deux ébauches d'étude sur l'oeuvre de Rodney Graham, suivi de 'Lenz' par Rodney Graham*. Brussels: Yves Gevaert, 1996.
• Walsh, Maria. "Utopias: Mead Gallery, Warwick Arts Centre." *Art Monthly*, no. 241 (November 2000): 30–33.
• Watson, Scott. "Zweimal Canada Dry: Sechs Künstler aus Vancouver." *Wolkenkratzer Art Journal* (Frankfurt, Germany) (March–April 1988): 28–33.
• ———. "The Generic City and its Discontents." *Arts Magazine* 65, no. 6 (February 1991): 60–64.
• Wauters, Anne. "Lhoist: Internal Uses." *Art Press*, no. 229 (November 1997): 34–38.
• Wechsler, Max. *Artforum* 26, no. 1 (September 1987): 120. Review of *Die Gattung Cyclamen L. (The Species Cyclamen L.)*, 1987, installation view at Regenbergsche Bookstore.
• Weh, Vitus H. "Sharawadgi." *Kunstforum International* (Mainz, Germany), no. 143 (January–February 1999): 410–11.
• Wilson, Michael. "New York Round-up: Rodney Graham, 303 Gallery." *Art Monthly*, no. 251 (November 2001): 40–43.
• ———. "Loop: P.S.1 Contemporary Art Center." *Art Monthly*, no. 253 (February 2002): 25–27.
• ———. "Window Shopping." *Flash Art*, no. 171 (summer 1993): 140.
• Van Winkel, Camiel. "Rodney Graham at the Van Abbemuseum, Eindhoven." *Kunst & Museum Journaal* (Amsterdam) 1, no. 5 (1990): 41–42.
• Wood, William. "Rodney Graham: Lisson Gallery." *Canadian Art* 11, no. 1 (spring 1994): 70–71.
• Yood, James. "Rodney Graham: Donald Young Gallery." *Artforum* 38, no. 3 (November 1999): 147.
• Zahn, Olivier. "Rodney Graham: Parsifal 1882–38,969,364,735 AD." *Texte zur Kunst*, no. 3 (summer 1991): 183–85.

PUBLICATIONS AND WRITINGS BY THE ARTIST

• "Artist's Notes." In *Rodney Graham: Works from 1976 to 1994*, 79–109. Toronto: Art Gallery of York University; Brussels: Yves Gevaert; and Chicago: The Renaissance Society at the University of Chicago, 1994.

• Artist's notes in *Rodney Graham*. London: Whitechapel Art Gallery, 2002.
• *Freud Supplement (170a–170d)*. *Parachute*, no. 50 (March–May 1988): 30–31.
• *Freud Supplement (170a–170d)*. New York: Christine Burgin Gallery; Brussels: Yves Gevaert; Cologne, Germany: Johnen & Schöttle; and Lyon, France: Galerie Nelson, 1989.
• "Une interpretation du rêve diurne de Freud, le matin suivant son rêve de la mongraphie botanique." In *Sur ma manière de travailler: Actes du colloque Art et Psychanalyse II*. Montréal: Editions Parachute, 2002.
• "The King's Part." In *Rodney Graham: Cinema Music Video*, 69–70. Vienna: Kunsthalle, 1999.
• "A Path of Association Not Followed in Freud's Analysis of His Own 'Dream of the Botanical Garden Monograph.'" *Collapse* (Vancouver), no. 2 (December 1996): 63–70.
• "The Piazza." In *Some Detached Houses*, 57–68. Vancouver: Contemporary Art Gallery, 1990.
• *The Piazza 4.1*. Brussels: Yves Gevaert; and New York: Christine Burgin Gallery, 1989.
• Project for *Art/Text*, no. 59 (November 1997–January 1998): 54–59.
• "Siting Vexation Island." In *Rodney Graham; Island Thought: Canada XLVII Biennale di Venezia*, 9–18. Toronto: Art Gallery of York University, 1997.
• "Smithson's Brain." In *Robert Smithson: Operations on Nature*. Toronto: Art Gallery of Ontario, 1995.
• *The System of Landor's Cottage. A Pendant to Poe's Last Story*. Brussels: Yves Gevaert; and Toronto: Art Gallery of Ontario, 1987.
• *Le système du cottage Landor*. Translated into French by Thierry Dubois. Brussels: Yves Gevaert, 1988.
• "A Thousand Words: Rodney Graham Talks About *The Phonokinetoscope*." Introduction by Rachel Kushner.

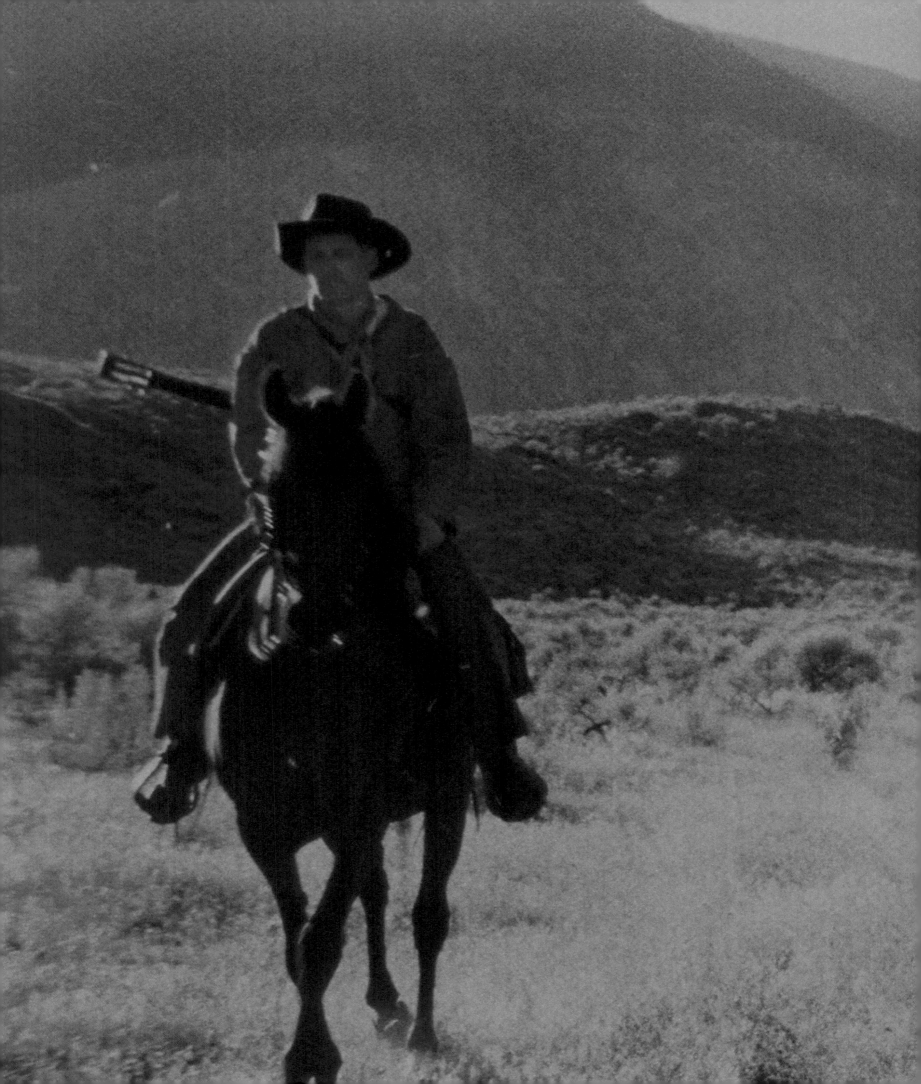

*Photographs appear courtesy of the artist and lenders.
The following list, keyed to page numbers, applies to photographs
provided by other sources:*

Courtesy Donald Young Gallery, Chicago, pp. 49, 55 bottom,
85, 102–03, 154–55, 168, 181, photo: Tom Van Eynde, pp. 1,
3–4, 40, 95, 97, 121; Courtesy Flick Collection, p. 163, photo:
Barbora Gerny, Basel: pp. 13, 56–59; Courtesy Lisson Gallery,
London, pp. 31, 148–49, photo: Dave Morgan, pp. 14–15,
38–39, photo: John Riddy: pp. 46–47, 167, photo: Oliver
Martin Gambier, p. 54, photo: Stephen White, pp. 55 top,
147; Courtesy Yves Gevaert, Brussels, pp. 16–17, 37, 42–45,
61, 78, 115, 119, 171; photo: Scott Livingstone, pp. front
cover, 22–23, 153, 165, 181, 197; photo: Shannon Oksanen,
pp. 32, 64, 73, 105, 172–73; Courtesy Vancouver Art Gallery,
pp. 52–53, 114, 169, photo: Teresa Healy, p. 132; Courtesy
Hauser & Wirth Collection, St. Gallen, Switzerland, photo:
A. Burger, Zurich, pp. 100–01, 110–11; photo: Robert Keziere,
pp. back cover, 127; Courtesy Art Gallery of Ontario, Toronto,
pp. 131 right, 158; Courtesy Catriona Jeffries Gallery,
Vancouver, photo: Chris Gergley, p. 134 right; Courtesy Bas
Jan Ader Estate/Patrick Painter Editions, Hong Kong, p. 139;
© Canadian Broadcasting Corporation (CBC). Reproduced
with the permission of the CBC and Stephen Posen. Photo
courtesy National Library of Canada/Glenn Gould fonds/
MUS 109, p. 141 right; Courtesy 303 Gallery, New York,
p. 146; Courtesy Art Gallery of York University, Toronto,
photo: © Attilio Maranzano, p. 174–75; and photo: David
Wisdom, pp. 183 right, 184 right.

Director of Publications: Lisa Mark
Editor: Jane Hyun
Assistant Editor: Elizabeth Hamilton
Designer: Michael Worthington
Assistant Designer: Tracy Hopcus
Printer: Graphicom, Vicenza, Italy

© 2004 Rodney Graham; Art Gallery of Ontario, Toronto; The Museum of Contemporary Art, Los Angeles; and Vancouver Art Gallery, Vancouver

All rights reserved. No part of this book may be reproduced in any form by any electronic or mechanical means (including photocopying, recording, and information storage or retrieval) without permission in writing from the publisher.

Available through D.A.P./Distributed Art Publishers
155 Sixth Avenue, 2nd Floor, New York, NY 10013
tel: (212) 627-1999, fax: (212) 627-9484

ISBN 0-914357-88-3

Library of Congress Cataloging-in-Publication Data

Graham, Rodney, 1949–
Rodney Graham: a little thought / curated by Grant Arnold,
Jessica Bradley, and Cornelia Butler ; texts by Arnold... [et al.].
p. cm.
Published to accompany an exhibition held at
the Art Gallery of Ontario, Toronto, Mar. 31–June 27, 2004,
The Museum of Contemporary Art, Los Angeles, Jul. 25–Nov. 29, 2004,
the Vancouver Art Gallery, Vancouver, Feb. 5–May 1, 2005,
and the Institute of Contemporary Art, Philadelphia, Sep. 10–Dec. 23, 2005.
Includes bibliographical references.
ISBN 0-914357-88-3
1. Graham, Rodney, 1949—Exhibitions. I. Arnold, Grant. II. Bradley, Jessica.
III. Butler, Cornelia H. IV. Art Gallery of Ontario. V. Museum of
Contemporary Art (Los Angeles, Calif.) VI. Vancouver Art Gallery. VII. Title.

N6549.G73 A4 2004
709'.2—dc22
2003062917

Printed and bound in Italy
The use of Tintoretto Ardesia paper generously supported by
Fedrigoni Paper Mill, Italy

This publication accompanies the exhibition
"Rodney Graham: A Little Thought,"
organized by Art Gallery of Ontario, Toronto; The Museum
of Contemporary Art, Los Angeles; and Vancouver Art Gallery,
Vancouver; and curated by Grant Arnold, Jessica Bradley,
and Cornelia Butler.

This exhibition is generously supported by Carol and David Appel
(Toronto, Los Angeles) and Audrey M. Irmas (Los Angeles).

Art Gallery of Ontario, Toronto
31 March–27 June 2004

The Museum of Contemporary Art, Los Angeles
25 July–29 November 2004

Vancouver Art Gallery, Vancouver
5 February–1 May 2005

Institute of Contemporary Art, Philadelphia
10 September–23 December 2005

Art Gallery of Ontario, Toronto
The Art Gallery of Ontario is funded by the Ontario Ministry of Culture.
Additional operating support is received from the Volunteers of the Art
Gallery of Ontario, City of Toronto, the Department of Canadian Heritage,
and the Canada Council for the Arts.

Supported by The Canada Council for the Arts, through the Assistance to
Art Museums and Public Galleries program.

The Museum of Contemporary Art, Los Angeles
The Museum of Contemporary Art, Los Angeles, is generously supported
by the Board of Trustees, individual and corporate members, private and
corporate foundations, and government agencies including the City of Los
Angeles Cultural Affairs Department, the Los Angeles County Arts
Commission; and the National Endowment for the Arts.

Vancouver Art Gallery, Vancouver
The Vancouver Art Gallery gratefully acknowledges the ongoing support of
the Board of Trustees, City of Vancouver, the Province of British Columbia
through the BC Art Council, the Government of Canada through The
Canada Council for the Arts and the Department of Canadian Heritage-
Museum Assistance Program, and the Greater Vancouver Regional District.

JACKET
FRONT COVER: Production still from *A Reverie Interrupted by the Police*, 2003
BACK COVER: Production still from *Rheinmetall/Victoria 8*, 2003

COVER
Drawing by Shannon Oksanen

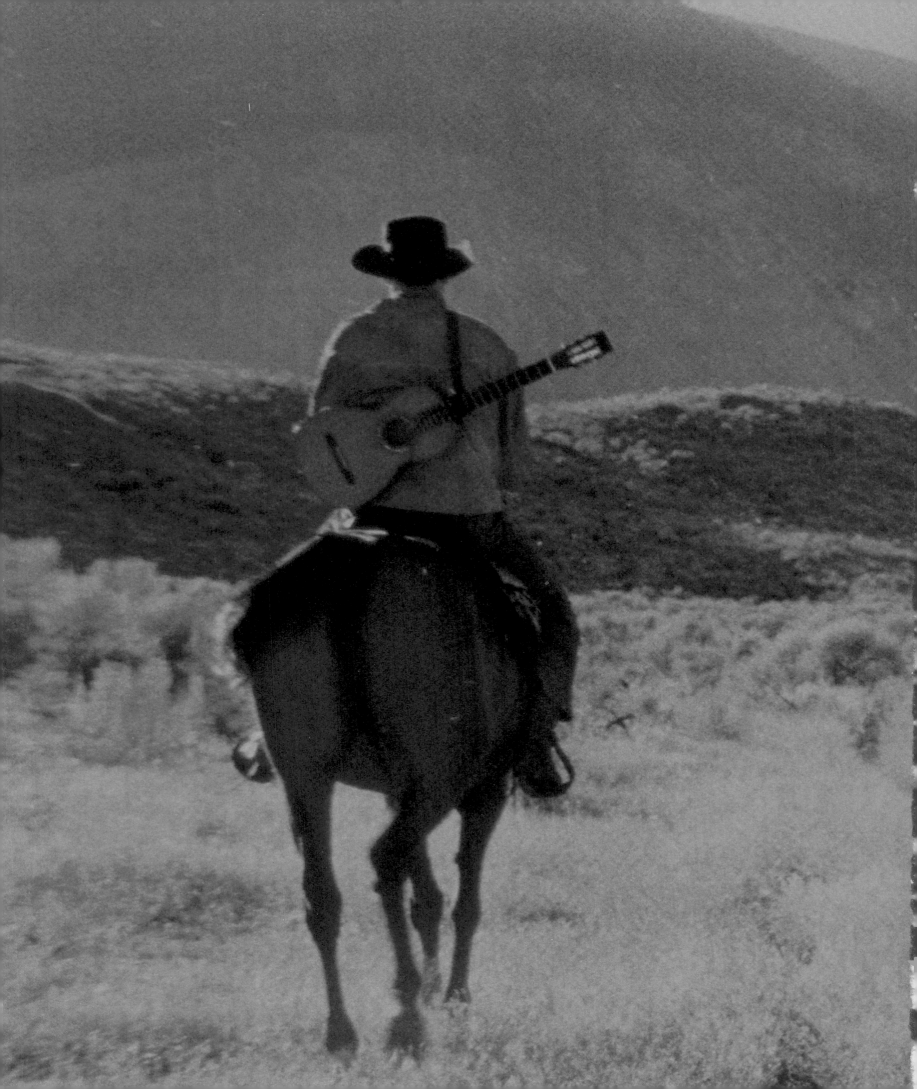